WET
Watercolour

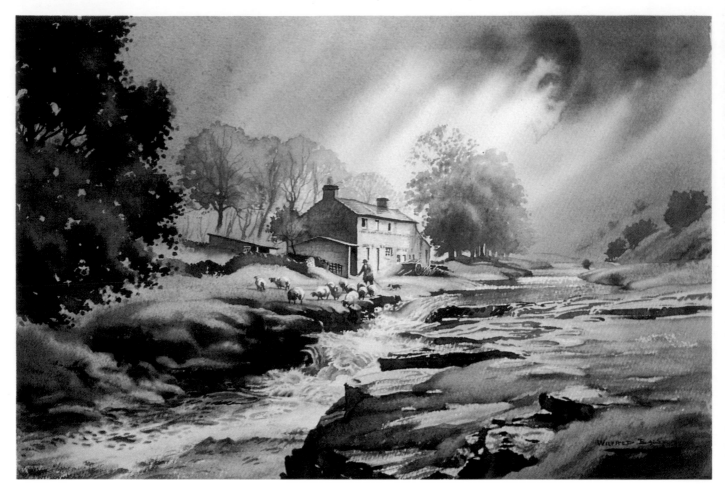

The frontispiece, The Wharfe after Rain, Langstrothdale, *displays to the full how much weather and atmosphere are dependent on a mastery of the wet technique. Before the typical stone farmstead the infant Wharfe, filled with flood water, rushes helter-skelter towards the wooden footbridge. The cataracts of broken water erupt in glistening white foam but are still coloured with the amber peat stains characteristic of storm water in moorland areas. A flock of Swaledales moves towards us in the hesitant sunlight.*

WET Watercolour

Wilfred Ball

B. T. Batsford Ltd, London

To Vickie

Black and white photographs by Les Parkin,
Raymonds Photographic Agency, Derby

ISBN 0 7134 5432 6

Printed in Hong Kong
for the publishers B.T. Batsford Ltd
4 Fitzhardinge Street, London W1H 0AH

Contents

Introduction

The adjective in 'wet watercolour' may seem superfluous, as watercolour is wet by definition, but I seek to differentiate between the two basic watercolour techniques of painting on wet paper and painting on dry paper. In the latter we can achieve great precision of edges, clarity of colour, a superb transparency as the light reflects back off the white paper through the pigment, and the sparkle that only comes through dry brush techniques, when the brush is dragged across dry, rough paper. It is most apt in painting the harsher landscapes of hot climes, when a clear blue sky complements pastel-tinted buildings and sun-baked fields. In this century abstract painters like Klee, and the Fauves like Matisse, have exploited to the full the intensity of saturated colour that is possible using this method.

But the tradition of British landscape painting is a romantic one full of space and softness, magic and mystery, mist and melancholy, light and luminosity. It reached its greatest heights with Turner, who was able to mirror the tragedy and nobility of the human condition in the landscape, blessed and transformed by the vagaries of the weather. This quality in landscape painting is poetic and emotive. It is matched perfectly by the potential of wet watercolour, which offers light and transparency, faded forms and fluidity, movement and metamorphosis, lost and found edges, and shapes that are fugitive or vaguely present. These qualities are inherent in the very nature of the medium, when used wet-in-wet, and this book explores the infinite possibilites of this area of technique and demonstrates its uses.

In my mind's eye I can picture the halo of creamy light around a full moon, or a coral red cloud trailing across a rose sky in the evening. Sheets of heavy rain slant down from weeping clouds. Lakeland crags hide their heads in low cloud and wisps of hill fog trail between the conifers. The river lies under morning mist above which stand tall trees on tiptoe. Crashing breakers spurt silver spray above inky rocks. Embers glow in the last of the bonfire while its climbing smoke veils the moon. These are all subjects that demand the use of wet techniques, as do all the most exciting and beautiful effects in nature.

But it is not only subject matter that makes its demands upon technique in contemporary painting: exploration of the full potential of the medium is expected, especially since the Abstract Expressionists of the Forties and Fifties. Since then, individual technique and style have often been regarded as more important than the subject matter itself, and so today's artists will find their techniques scrutinized as never before. Since watercolour is perceived as a lively medium, freshness and spontaneity are highly-regarded qualities. Experimental techniques are valuable in achieving these ends and I propose to examine some of these and the best ways in which they can be used to advantage.

When seeking to improve one's style one is usually encouraged to 'loosen up'; most art students will be familiar with this advice. Since wet techniques can be loose in the extreme I hope this volume will also help those painters who seek such development of style.

Paramount in my aims, however, is the exploration of mood and atmosphere in landscape painting. Let us develop those forms of expression which best achieve the magic and mystery which is at the heart of the English landscape tradition.

Finally, I shall discuss some of my more traditional painting procedures in order to show how the drier finishing touches are applied after the wet stages have been completed. Only rarely can a painting be worked entirely in the wet-in-wet method. I am inevitably reminded of Turner's procedure in this respect. His studio would be festooned with cords from which he had hung the soaking wet papers on which the basic background colours had been tinted in, fluid and free. After they were dry he would add those characteristic finishing touches in his inimitable calligraphy. Before the domes and towers of Venice, glowing under a golden sky, he would dash in a gondola and a few figures. With a finger-nail he would scratch a gleam of silver across the lagoon. Most of us use similar procedures nowadays; indeed, Turner still seems adventurous and modern today. Because of the legacy of adventurous attitudes and achievement he left us, modern watercolourists have enormous horizons. The ways in which watercolour can be used have encouraged a wide variety of methods and styles of which the wet-in-wet method seems the most significant and effective.

NB All painting dimensions refer to their complete unframed size, and do not take into account any minor cropping considered necessary for this book.

1
Materials

The only *essential* materials for a watercolour painter are brushes, paper, paints and water. The search for a wider range of means of expression has, however, added others, and a number of exciting new effects have become available to the modern watercolourist. Before looking at these, let us first examine the traditional materials.

Brushes

The choice of brushes is a personal one. Figure 2 shows a collection of my own. If your forte is the *trompe-l'oeil* technique then a collection of small sables will be essential. On the other hand, if your style is broad you will depend mainly on wash brushes – large and full. Whichever style you indulge in I'm sure you will cling to your favourites long past their best. I have one that has now lost most of its bristles, but it still makes interesting marks.

Always clean brushes properly after use; they are too expensive to be treated carelessly.

Paper

Papers are differentiated according to weight per ream. Anything below 200lb will need stretching before use. To avoid this rather tedious procedure I always use 300lb, usually Fabriano or Arches. A heavy paper such as this will stand up to all kinds of rough handling. Its surface is so tough that it will take a good deal more scrubbing with a stiff bristled brush to remove unwanted pigment than a lighter paper will. It can also be used on both sides, should your first attempt not be worth saving. Although expensive, therefore, it has economical attributes that make it well worth considering.

Watercolour paper is made in three surface textures: SMOOTH or *Hot-pressed*; NOT, which is slightly rougher, and ROUGH, which has a definite rough surface and suits the bolder style. I use Fabriano Rough or Arches Rough, both excellent surfaces. Fabriano has a more irregular biscuit-like texture which I particularly like, while Arches is even rougher but more regular. It is an excellent paper for dry brush work, when trying to produce the effect of light sparkling on water, for example.

Under normal washes they produce a slightly textured effect – even under a flat wash. When used with a granulated wash they are particularly effective (see Chapter 2).

Paints

I personally do not like pan colours. When they have not been used for a while they can become very hard, and it is rather tedious to soften them into a working consistency when you are eager to proceed with a painting. Moreover, they wear out sable brushes very rapidly. So long as you screw the tops on properly, tube colours are always fresh and ready to use in an instant. I strongly recommend them.

It is advisable to develop a palette of colours which suits your style and personality. This means that decisions are much easier to make when you are painting, and is one of those good habits you need to form so that you can concentrate on other problems. One can easily be seduced by the gorgeous hues in the colourman's charts, but these should be resisted.

Select the colours you use regularly and learn to forget the rest. I used to have a box full of hardened tubes of individual colours which I had used once and never needed again. These were finally thrown out of my regular watercolour box to create some space.

My palette consists of Yellow Ochre, New Gamboge, Burnt Umber, Cadmium Red, Alizarin Crimson, Winsor Green, Cobalt Blue, Ultramarine Blue and Cerulean Blue. I also use Burnt Sienna or Brown Madder (Alizarin). The latter is used when I wish to increase the warmth in a particular colour composition. This collection of twelve colours seems to solve all my essential problems.

The basic greys I use are mixed from Burnt Sienna and Cobalt Blue or Burnt Sienna and Ultramarine Blue for a more dramatic strength of tone. In colour jargon 'grey' is not a mixture of black and white, which is more properly called 'neutral' grey. There are innumerable greys in nature, made by mixing a cold colour with a warm colour from opposite sides of the colour circle. If you mix different reds with different greens, for example, you will produce an infinite variety of browns; and in the context of colour brown is just another grey.

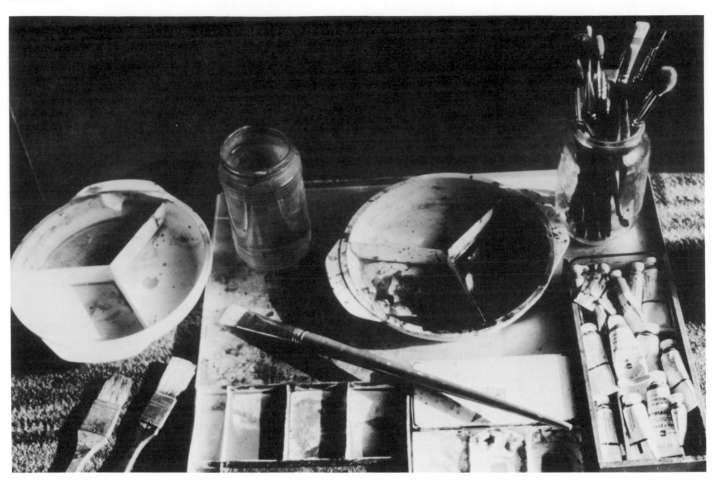

1 Basic equipment

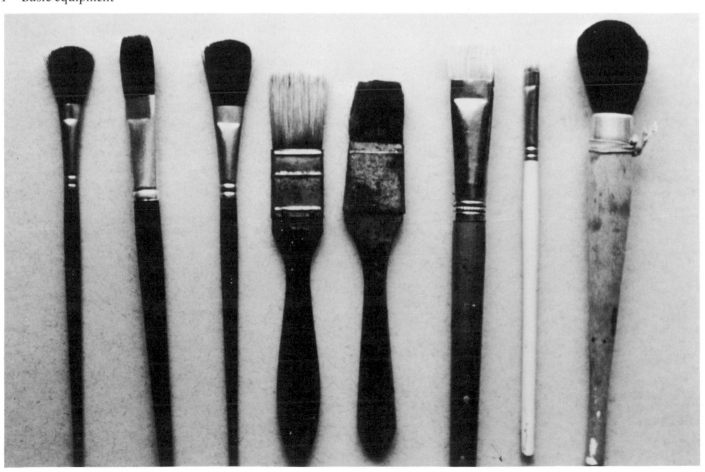

2 Brushes

As there is no black in the landscape, I do not use it. There are innumerable darks you can mix which will serve your purpose better. If you add black to another colour it kills its luminosity and produces an artificial-looking result. Nor do I use white, preferring the simple classic expedient of leaving white paper showing where I need it.

However, I see no objection to the use of white or other opaque colours, if you prefer them. There has long been a tradition of gouaches in the mainstream of watercolour painting. It is important to use what suits *you*.

Other materials

Looking at my studio shelves, I find all kinds of other media and tools which I have occasionally used in experiments with watercolour. Indian ink, coloured wax crayons, oil-based pastels, a candle end, salt and masking medium are the main ones. Besides brushes, I use a motley collection of knives, sponges, sandpaper, cloths, kitchen roll, sand, blotting paper and gummed paper tape, not to mention natural objects such as leaves and feathers. Chapter 3 describes some of the intriguing effects that can be achieved with these media.

2
Washes

The normal procedure is to start a painting with broad washes using a large full brush. I often cover the whole of the paper in this way, except for any previously selected highlights which are left as clean paper. This allows stronger colour to be added while the initial washes are in various stages of wetness, leaving the final strong accents to be put in when the paper has dried. It is a good idea to get into basic habits of procedure like this as it allows your mind to concentrate on the other myriad problems of technique and tackling the unexpected which watercolour always provides. All decisions about tonal composition should be clear in your mind before you start to paint.

I consider the basic broad washes to be the most essential skills; once you have mastered them properly the rest is comparatively easy.

Flat wash

This is rare in traditional, realistic landscape painting, as natural surfaces are never even in tone and texture. However, all other types of wash are variations on this basic procedure.

Take care to mix more colour than you expect to use so as to avoid running out of colour half way through a wash. It is virtually impossible to mix exactly the same strength and combination of colour again in an emergency, and the first part of the wash will probably have dried partly or completely by the time the second mixture is ready.

Be aware of how much lighter watercolour is when dry, and allow for this by always mixing your colour darker than you expect it to dry. This is the sort of decision that only experience can teach you to master.

Before starting a flat wash rest the drawing board on a book or some other support so that it is tilted at an angle of about ten degrees. (I never use an easel, not having found it necessary.) Fill a large wash brush with pigment and run it horizontally across the top of the paper. A pool of colour will begin to form at the bottom of the brush stroke. Make another brush stroke slightly overlapping the first, again with a full brush. Repeat this until the wash is completed when the surplus paint can be taken up with a damp brush or a sponge.

Graded wash

This is a wash that begins dark and gradually becomes lighter, though it can be in reverse. It is the sort of wash one would use for a cloudless sky. The procedure is very similar to that for the flat wash except that for the second and succeeding brush strokes the half-emptied brush is dipped into clean water, thus progressively weakening the pigment. This is repeated until the wash is completed.

Granulated wash (3)

One of the advantages of using Rough paper is that this type of wash is much more effective. Some colours are opaque and will therefore settle into the hollows, while the more transparent ones remain on the humps of the surface. This separation adds interest, particularly in a large wash.

Opaque colours in my palette include Yellow Ochre, Raw Umber, Cerulean Blue, Cobalt Blue, Ultramarine and Cadmium Red. The others are more or less transparent by comparison. When washed over a glaze of transparent colour the opaque ones will settle as sediment in the hollows.

If a wash made up of an opaque colour and a transparent one is put on with a full brush, the process of separation and granulation can be accelerated by shaking the drawing board gently from side to side while the pigment is still very wet.

Wet-in-wet wash (4)

This is the most frequently used by a landscape painter. It is the technique most suited to the medium, which is fluid and capricious and lends itself to the 'happy accident' more than any other.

First damp the surface of your paper with clean water, applied with a sponge or large brush, or even hold the paper under the tap. With a brush full of strong pigment coat the paper with your basic colour. Remember that the water already on the paper will dilute the pigment considerably. The way in which you apply the colour will allow you to vary its strength in different areas as you wish. Then apply forms with an

3 Granulated wash

4 Wet-in-wet wash

even stronger colour, to give the effect of clouds in the sky, for example, or misty trees. There must be considerably more pigment in these gestures or the colour will just merge into the background wash and disappear. By trying a few experiments you will soon find the required strengths. This procedure will produce vague forms, highly evocative of misty, atmospheric phenomena.

It is important to perform this technique with the board flat, otherwise the darker colour will drift down the paper and lose the shape intended. However, if you wish to make use of this tendency, the board can be tilted so that the cloud-like shapes can 'weep'

downwards like rain (see Chapter 5 for more detail on skies).

Other materials can be added to the wash, while in various stages of wetness, in order to add texture or form. A wide variety of implements may be used to remove areas of colour or make marks, again while the colour is still wet. It is most important to allow it to dry completely before superimposing another wash, unless you are positively seeking to create 'accidents'. In the almost-dry stage a watercolour wash is most vulnerable and ready to play its most devilish and devastating tricks on you. If in doubt, leave well alone!

3
Experimental Techniques and their Application

Developing a looser style

It needs a positive effort of will to accept that change is necessary in one's own work and to seek ways to improve it. The most important method of improvement is to devote a great deal of time to the practice of painting; there is still no alternative to enthusiasm and hard work. But it is possible to approach the problem intellectually and to make a list of new attitudes and approaches that could be tried. Most important is the acceptance of the need for change and the development of a questing attitude in both thought and action.

Here are a few practical suggestions recommended from personal experience.

Change your palette. Try a new colour and see what it adds to your style. I can well remember using Cerulean Blue for the first time and the way it improved my painting of springtime subjects in particular.

Work larger or smaller. When I started to paint full Imperial-sized landscapes it forced me to use much larger brushes than I had done before. Indeed it was not until then that I obtained some of the largest brushes I still use. This change alone served to loosen my own style more than anything else I'd tried before.

If by nature you are careful and painstaking and particularly interested in detail, then it may be useful to paint a few miniatures. However, such a style is rarely suited to the wet-in-wet applications considered in this book.

Try abstraction in order to free your painting from the demands of realism. Experiments with line, form, colour and texture are much freer if you no longer have to paint what you see but rather what you feel.

Paint on tinted papers. Although this will necessitate the introduction of white to your palette it may awaken unexpected responses in you.

Use mixed media. Working with inks, wax crayons, acrylics, etc. may put more variety into your work.

Taking up this challenge, the following section will introduce a range of practical developments capable of imaginative use.

A willingness to experiment

My intention is to incorporate the discoveries made in this chapter into the landscape paintings to which the second half of this book is devoted. Before attempting this, however, we must try these technical experiments in isolation.

Retaining or creating highlights

Retaining

The obvious and traditional way to retain highlights is to paint round them, leaving the white paper blank. However, if the highlight is delicate or detailed, this may be impossible, and in such a case masking medium might be the solution. Frost-covered seed-heads or the delicate tracery of a spider's web may be achieved in this way. A more vigorous use of the medium (frisket) is to spatter it vigorously onto the painting surface for textural effects of a free, uninhibited nature.

Another way of creating a lively and textured resistance to watercolour is to draw candlewax details before starting to paint. This is particularly suitable for the effect of light reflections in water. Spattering paint from a toothbrush round a stencil or chosen object can leave clear or ghostly white shapes.

Creating

If you need to create a highlight in an area already covered with wet paint it is possible to remove the paint in several ways. None of these will leave highlights as crisply as if you used the retention methods, but they take off most of the pigment and, if anything, produce a more natural effect.

The most obvious way is to remove the colour with a damp, clean brush. Soft-edged shapes are produced and this is one way of creating highlights on cloud formations. The sail of a distant yacht could be suggested in this way, too.

Other softer materials which can be used in a similar way are papers, tissues, soft cloths, blotting paper, lace or sponges.

Harder-edged shapes can be created by using harder materials such as brush handles, knife edges, even finger-nails (as Turner did). The clean edge of a piece

of stiff cardboard can be used as a squeegee to remove areas of colour, or on edge to create lines.

All these techniques have the valuable potential of being used vigorously and so can increase the apparent spontaneity of your work – a highly desirable quality these days. You may already have used some of them; if not, try them. It will add variety to your work. Finally, remember that the strongly staining colours such as Winsor/Thalo Red, Blue or Green, and particularly Alizarin Crimson, are not easy to remove by these methods.

Textural effects on wet backgrounds

Spattering clean water or strong pigment using paint brushes, toothbrushes or other tools can produce delicate spotted patterns. If larger drops of water are used by touching the paper with the brush, characteristic shapes called blooms are created. If sand or salt is sprinkled into wet paint, the opposite effect is achieved. Each grain of sand will attract a concentration of colour around it while the salt will absorb the pigment, producing forms reminiscent of snowflakes.

In addition to removing pigment with a clean sponge, it is possible to charge the sponge with strong colour and dab it onto the wet background. Any textured surface, such as the veined side of a leaf, can be coloured with pigment and then applied to the damp surface. Similar monoprint experiments can be carried out with manufactured textured surfaces.

It is possible to use Indian ink on wet paper and then tint it with watercolour. Alternatively, the paper can be tinted first, then the ink applied in various ways to the wet paper and allowed to spread in its characteristic textures which are the result of the gum-based ink's resistance to water. An underlying texture can be created by painting on paper crushed and creased before painting, so that the surface of the paper is cracked and veined. These cracks hold the pigment and create linear textures of stronger colour.

In taking advantage of what you discover from these trials, it is important to use the techniques sparingly and with discrimination. Surfaces completely covered with varied textural innovations will produce chaos rather than controlled excitement. It is important to balance texture with smooth surfaces, thus producing an artistic tension.

Do not be afraid that the use of such techniques will lead you into abstract painting, though if you find you enjoy using them and the results they produce you may wish to develop your style to this end. I am a traditional landscape painter and find it the most exciting skill in the world, and so have no wish to alter my path or style. All these adventures with paint are calculated to perform one important function – to show the wide range of effects of which watercolour is capable. I hope it will enable you to return to painting landscapes with a renewed sense of the medium's possibilities, of freedom with control and the courage to try something new in your method of painting.

When you are faced with producing a particular atmospheric effect in a painting you will be better equipped to choose a technique most suited to the task. Landscape is exciting in its variety and so is the art of watercolour painting. All students of art who undertake this voyage of discovery will continue on their way having learned something about creativity and materials.

Illustrations A to X (5, 6, 7, 8) are examples of some of these investigations.

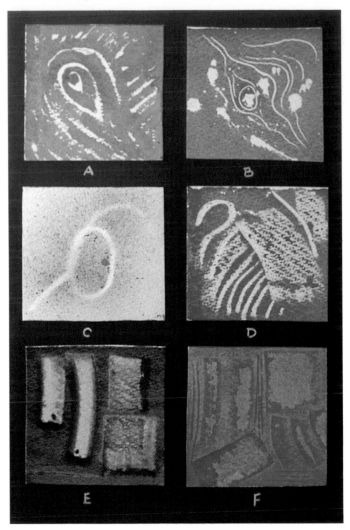

5-8 Experiments

A shows the traditional way of leaving highlights (without using body colour), using skill with the brush to paint round the white shapes.
B demonstrates the use of masking medium. First I applied spatter with a flick of the brush, then added pen lines to demonstrate the versatility of this medium.
C shows the faint shape of a loop of coarse string, outlined by spatter from a flicked toothbrush.
D was drawn with a candle before applying a strong wash over it.
E and *F* demonstrate the effect produced by using a straight-edged piece of card as a squeegee. *F* shows what happens if you try to remove the paint before it has had time to dry a little. Here the paint has gradually seeped back into the uncovered shapes because it was too wet.

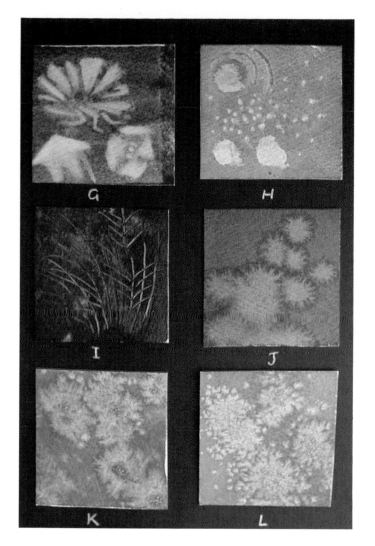

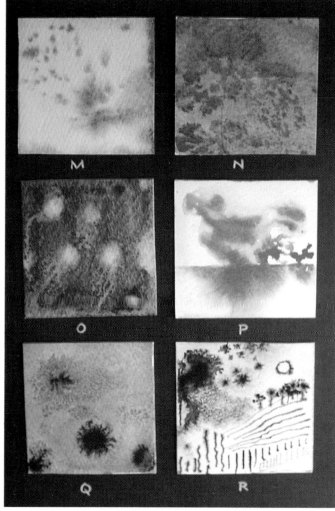

G Here the paint has been removed with a stiff-bristled hog hairbrush.

H These marks were made with a soft cloth. The three larger marks were produced with my forefinger wrapped in the cloth, and the smaller ones with a brush handle similarly wrapped.

I Linear shapes here were also produced by pressing with a brush handle, this time uncovered. As with *F*, it is important to allow the pigment to lose most of its wetness before drawing on it, otherwise the colour will seep back into the marks which will then become darker than the background, rather than the reverse.

J These feathery 'blooms' are the characteristic shapes produced by dropping water onto a drying wash. They are the most common source of the 'happy accident', when their shape resembles some natural phenomenon. Equally, when they spoil a perfect wash they prove to be the most common cause of the ruin of a painting.

K and L are effects produced by dropping salt onto a wet wash. *K* was produced as soon as the wash had been laid down, and this proved too soon. The extra wetness waterlogged the small piles of crystals and they attracted pigment rather than removing it, resulting in dark central shapes similar to those that grains of sand would have produced. With this technique the optimum time is just when the wet shine

is beginning to disappear. As shown in example *L*, it is then possible to see the effect produced even by a single salt crystal. The use of this technique in producing the simulation of snowflakes is quite common in American watercolour painting.

M This textural pattern was produced by spattering strong pigment onto a lighter damp background.

N Here a sponge charged with strong pigment was dabbed onto a damp background of lighter colour.

O By dropping spots of clean water onto a strong wet wash of Burnt Umber, the grainy texture of the pigment was separated out as the paper was tilted to allow the water to trickle downwards.

P The bottom section of this square was covered with clear water first. When the pool of pigment in the upper section touched the wet lower area, the paint bled into it and fanned out.

Q These ebony florets are the result of dropping spots of Indian ink into wet paint.

R Here the ink was applied by pen and from it can be seen how suitable it is for suggesting landscape forms.

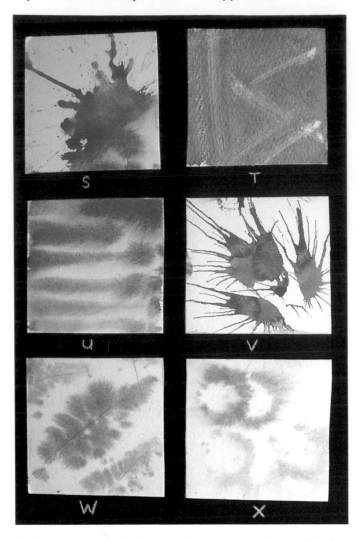

Application of techniques

Watercolour has been christened 'the English medium', chiefly because it has been particularly popular in this country. Generation after generation has considered it an essential part of their education. But there is another reason for seeing the medium so linked with Britain, and that is the unique ability of watercolour to render the vagaries of the English weather. Their characteristics match each other perfectly (and not just because they're both wet!): in the same way that the capricious English weather can always surprise you, so you never feel you can completely control a watercolour painting. Something unexpected is always likely to happen, which is one of the joys of using watercolour and also the reason that it provides the 'happy accident' so often. I must, however, add that it provides the *unhappy* accident even more often, and every experienced watercolourist has ruined hundred of sheets of perfectly good paper because of it. All the more reason then to try to discover what the medium will do in any given circumstance and conditions and, having made the discoveries, to apply them to one's figurative paintings.

Experimental techniques are normally employed with the intention of creating an impression of greater spontaneity. In practice they can actually reduce it, because more than usual care is needed in using them in painting the landscape in case they ruin an otherwise perfectly good painting. The solution to the problem is to take the extra care beforehand, in planning what you propose to do before putting brush to paper. Then, confident that you know exactly what you propose to do (and what the medium is likely to do) you can go ahead in a truly spontaneous way. Real liveliness of style only comes with adequate forethought and the confidence this brings that you are the master of the medium.

It is quite clear that most apparent 'happy accidents' are anything but accidental. The artist has contrived them, or at least has produced the circumstances in which they are most likely to happen. The medium most likely to permit such 'happenings' is the wet technique, where the water and pigment can follow their fluid inclination to create magic and excitement – or sometimes a mess. One has to accept the latter possibility: it is part of the tightrope we call watercolour painting.

What appear to be accidental happenings turn out to be fortuitous or 'happy' chiefly in circumstances where the artist has a considerable degree of control, acquired by practice. Although this may suggest subterfuge, I consider it a good idea for the student or beginner to produce the 'accident' first in the course of experimenting, and then to develop it into a figurative composition later. Certainly if you are restricted by the need to paint what you see you are unlikely to produce any felicitous accident.

Until you are experienced, your technique is likely to look quite hackneyed. If you perform experiments

S shows a pool of paint on drying paper being tilted to cause the runs to go in different directions.

T demonstrates the kind of marks made with coarse sandpaper on a damp wash. On a dry wash it can be used as a substitute for dry brush technique.

U Horizontal brush strokes have feathered out, but the end of each brush stroke, on the right in each case, has left a small pool of paint which bled into the background.

V Three pools of paint were blown on, vigorously. By blowing each in a different direction, these radiating tendrils were produced.

W These monoprints were made with the end of a small fern charged with pigment. On dry paper a clear representation of the fern would be produced; on damp paper these much more evocative shapes resulted.

X Another monoprint on damp paper, this time from a metal cog-wheel. The form has been transformed by the dampness into something quite unmetallic and flower-like.

These experiments with wet pigment show the interesting, often exciting results that can be achieved through an open-minded approach to exploring the characteristics of the medium. They are not an end in themselves, but do encourage a more unconventional approach for the times when the more traditional methods have lost their appeal.

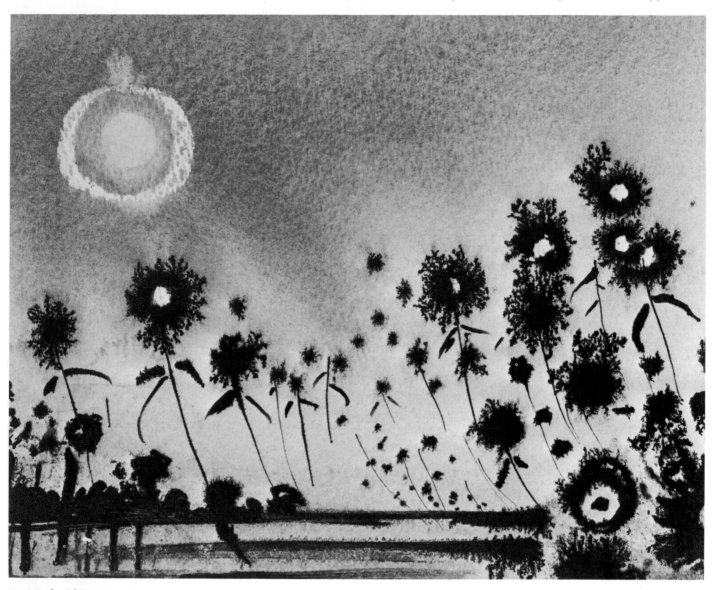

9 *Night Blossoms* (8 x 6in/200 x 150mm)

with watercolour in the bottom third of your sheet of paper, it is surprising how often you can add the sky, a figure, a cottage or a few trees to produce a pleasing composition that owes its virtues to the fact that you allowed the medium to speak for itself before adding your own little piece, as a postscript. When you have seen what it can do for you, you will have enough confidence to allow it a little more freedom when you tackle a planned landscape painting. Indeed, most experiments only need a sky to be added to give the impression of a landscape.

Imaginative use of the experiments

The following paintings are developments from the technical discoveries earlier in the chapter. They have been 'staged' to show the less-experienced painter how to follow the natural tendencies of watercolour in order to produce a picture, rather than try arbitrarily to force it to do the stilted things that limited experience may demand of it. I have used compositions based on my own sketches, but they attempt to show how the experimental wet-in-wet techniques can be used in traditional landscape painting.

Night Blossoms (9) is an example of the effects produced by using Indian ink imaginatively. Here a wash of Ultramarine Blue was painted across the moon and a few flower centres which had earlier been touched in with masking medium. While the colour was still wet, ink was applied with a brush to make the 'blossom' effects. The gum with which the ink is mixed creates a rich, intense concentration of black texture as it reacts with the water in the background wash.

It would be possible to produce many similarly imaginative compositions based upon the investigations earlier in the chapter, but the aim of this book is to apply wet techniques to traditional landscape paintings. The following examples demonstrate how non-traditional techniques have been used in some examples of straightforward landscape compositions.

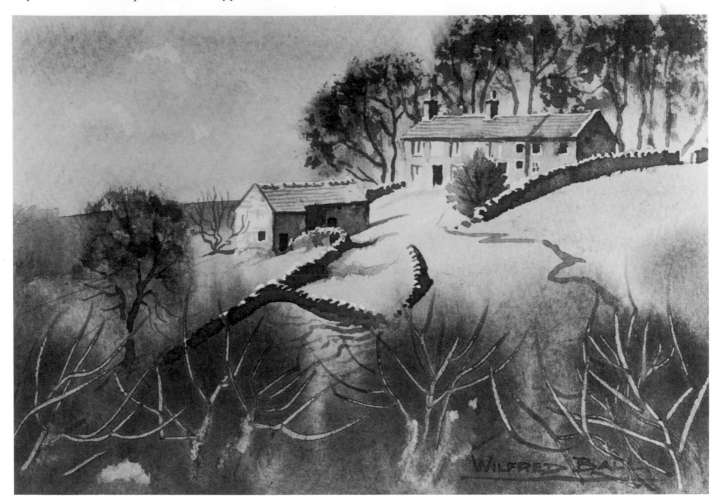

10 *Hill Farm, Derwentdale* (11 x 7½in/280 x 190mm)

Hill Farm, Derwentdale (10) is an example of using three of the experiments seen earlier. After the initial washes had been completed, faint cumulus clouds were produced by using a finger wrapped in a soft cloth to lift the colour, while a brush handle was used vigorously to draw the tree branches at the bottom of the slope. The foliage on the trees behind the farm and the single tree on the left was dabbed on with a sponge charged with dark pigment. All have been assimilated into a fairly traditional painting. Whichever technique you choose, it will produce a different result from any other.

The two paintings of Marrick Priory, Swaledale (*11, 12*) were begun similarly with a very wet treatment, but in Figure 11 the Abbey was put in beforehand with masking medium, while in Figure 12 the highlights on the buildings were taken out with a damp, stiff-bristled brush just before the background colours were completely dry. In both cases the dark trees were put in when I judged the background washes had dried sufficiently to allow them to bleed a little but not to run beyond control. A brush full of clear water, however, was dropped into the sky area of Figure 12 to show how it would run into the dark masses to create the effect of hill fog. Of course, such an effect does not allow for the kind of control which has achieved more topographical accuracy in Figure 11.

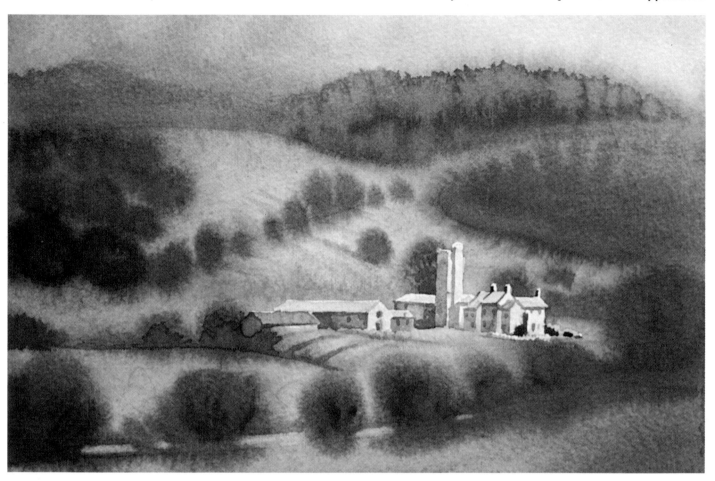

11 *Marrick Priory, Swaledale (Stage 1)* (11 x 7½in/280 x 190mm)

12 *Marrick Priory, Swaledale (Stage 2)* (11 x 7½in/280 x 190mm)

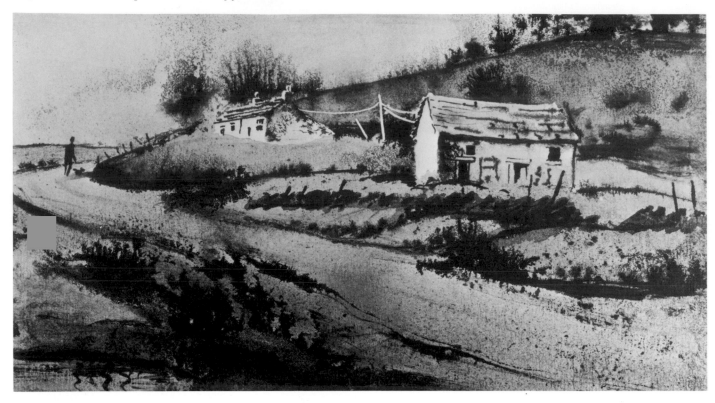

13 *Brand Side, North Derbyshire (Stage 1)* (11 x 7½in/280 x 190mm)

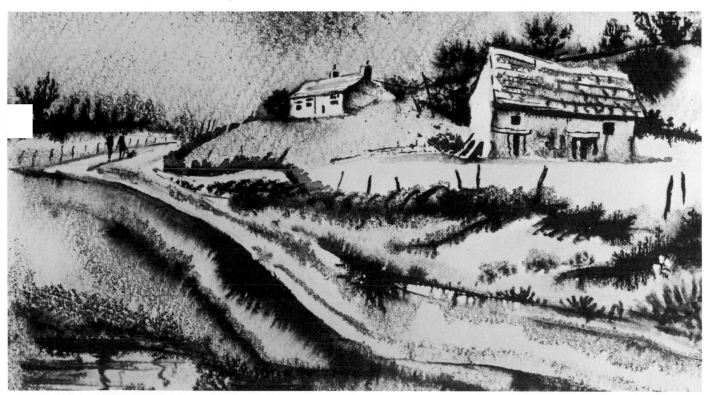

14 *Brand Side, North Derbyshire (Stage 2)* (11 x 7½in/280 x 190mm)

Brand Side, North Derbyshire (13, 14) are identical drawings made with Indian ink on wet paper. In Figure 13 the cottage and barn were painted in with masking medium before the paper was soaked in clean water, while in Figure 14 I painted around the buildings with a brushful of water, leaving them dry, so that the ink textures would not affect them. In the first example tints of blue, green and warm brown were dropped onto the damp paper before the brush drawing was completed with ink. No colour has been used in the second case, where the textural possibilities of the ink were exploited a little more. These two landscapes show how one has to be prepared to allow the ink to take control a little with this technique. It has a life of its own and has produced superficially different results texturally.

15 *Moonlight at Osmaston (Stage 1)* (8 x 6in/200 x 150mm)

16 *Moonlight at Osmaston (Stage 2)*(8 x 6in/200 x 150mm)

Moonlight at Osmaston (15, 16) was painted onto the graded wash described in Chapter 2. When it had dried I painted the cow parsley shapes with masking medium and then put the paper under the tap. With a stiff brush I took out the moonlight shapes in the sky and the reflections in the village pond before washing pale green onto the banks and the floating weed (15). As the background dried, stronger colour was used for the thatched cottages, trees and dark reflections (16).

17 *Stonethwaite, Borrowdale* (15 x 11in/380 x 280mm)

The next two examples (*17, 18*) of experimental techniques involve painting on crumpled paper. Here it is essential to use thin paper, as the heavy paper I usually use will not crease sufficiently. Having been soaked in the bath for twenty minutes or so, these sheets of thin drawing paper were crushed and squeezed until the water was removed, and then carefully opened out to reveal a network of creases. Any pigment washed over the paper soaks into the creases particularly and produces dark patterns.

Stonethwaite, Borrowdale (*17*) had tints washed in as the paper dried, to produce background tones. The strongest colours were put in broadly when it had dried. In this technique it is important not to put in too much detail, as the all-over background textures provide this. Similarly, the stones in the foreground wall were created by the angular textures of the creasing, without any effort from me. It is important to choose carefully which subjects you use for this technique. Essentially all you require are a few simple washes which emphasize the creases and allow the existing textures to provide both unity of treatment and detail.

22

18 Winter Morning (15 x 11in/380 x 280mm)

Winter Morning (*18*) is a blue-grey composition with a little creamy yellow dropped into the sky where the sun was eventually to be painted. Although Burnt Umber was used to suggest the bare earth in the foreground furrows, these were further emphasized with Indian ink, as was the twiggy bush along the edge of the ploughed area. Apart from the cast shadow the snow on the right was untouched paper, the creases providing unifying texture. Some colour was put onto the trees to provide their basic blue-grey shapes while the sky area was still damp. When the paper was dry the trunk and branches of the distant elm on the left were put in with a thin brush in watercolour, but the branches of the large tree were drawn in ink with a pen, as were the foreground twigs. This ensures that the ink treatment appears throughout the area, thus ensuring unity in this respect, to add to the unifying texture of the paper. A few distant birds and a pale yellow sun completed the subject.

It is important to allow experimental techniques like this to produce their own interesting effects freely and without too much control being imposed. If you are too aware of its limitations – as, in this case, the difficulty of painting accurate detail onto such a violently irregular surface – you will begin to expect from it qualities that are foreign to its natural behaviour, an attitude that is counter-productive.

Snow Flurry, Ashes Farm, Derwentdale (19) demonstrates how sympathetic the wet treatment is in the case of a snowstorm. The faint snowflakes were produced by pressing onto the damp surface the end of a brush handle wrapped in cloth, thus removing a little cluster of patches of pigment which suggest flakes. It is important to wait until the background wash has lost its wet sheen before applying this treatment. If the background is too wet the moisture will just seep back into the marks, as shown in Example *F* in this chapter.

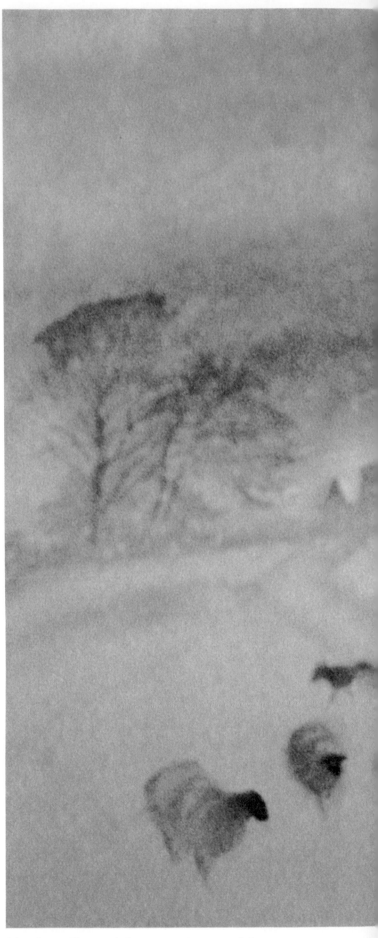

19 *Snow Flurry, Ashes Farm, Derwentdale*
(15 x 11in/380 x 280mm)

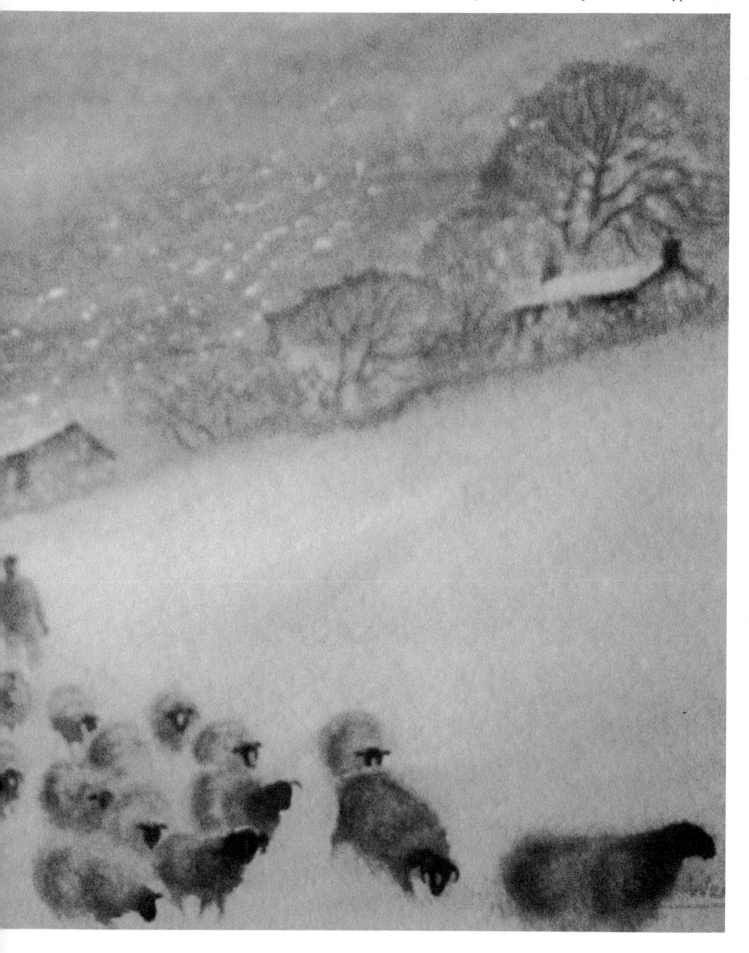

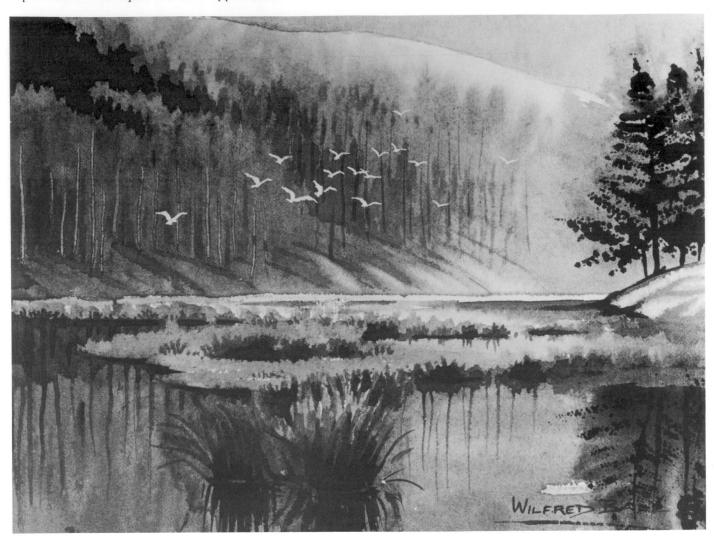

20 *Winter Flight, Howden Reservoir* (11 x 7½in/280 x 190mm)

Winter Flight, Howden Reservoir (20) demonstrates the use of a monoprint in a traditional landscape. After painting in the shape of the seagulls with masking medium, the whole paper was wetted, except the strip of snow at the top of the water area. After applying the pigment, a brush handle drew the dark trunks on the right side of the far slope. When the colour had dried a little more the same means was used to put in the light trunks on the left, producing opposite results because of the difference in wetness.

When the painting was dry the tufts of dead reeds in the foreground were clarified, particularly their dark reflections. The unusual technical innovation was the final touch. Coating the extremity of a small fern with strong pigment, I printed it onto the right side to create the dark conifers and their reflections. Only the trunks were drawn in by brush. The spores on the back of the fern can be seen quite clearly. This is surprisingly effective, and the use of this artificial device would probably have passed unnoticed if I hadn't drawn attention to it.

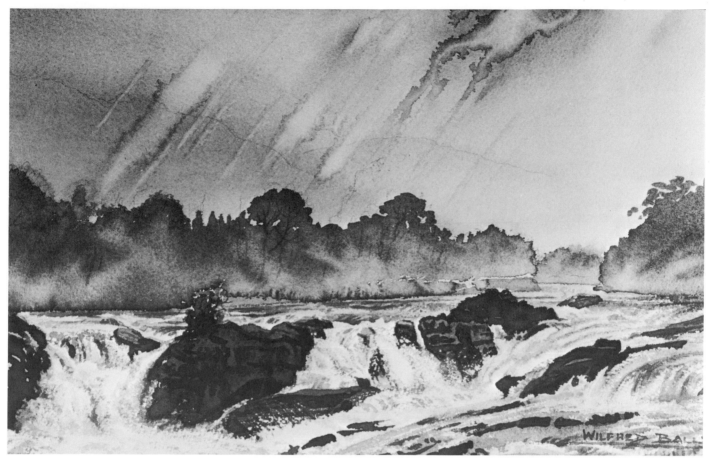

21 The Falls of Orchy (15 x 11in/380 x 280mm)

The Falls of Orchy (21) uses the technique shown in Example O in this chapter, namely dropping clear water onto a drying wash to create blooms. Originally I had put in a dark cloud on the right, dripping rain across the sky. It didn't seem strong enough as an image to compete with the vigorous torrents in the foreground, so I decided to risk dropping in some water just before it had dried. With the brush still damp I slashed it at an angle several times across the misty background, producing a much stronger effect of rain than before.

It is very important to realize that this is a considerable risk to take. You should only drop water into a damp background if you are quite prepared to accept that you are as likely to ruin the painting as to improve it. Here the result is only partially successful, but there is a pleasing misty quality and the treatment of the rushing water is quite effective.

Finally, Figure 22 is a painting by my brother Reg, a very fine watercolourist, entitled *Beach at Morfa Nefyn, Lleyn Peninsula*. It is as expert an example of the use of sponge as I've ever seen. The intended cloud area was dabbed with a wet sponge then colour was touched in with a brush, emphasizing the textural edges produced by the sponge. As it dried, more pigment was added to the darker areas. It has produced a pleasing unity of textures in the sky and the sandy beach.

As can be seen from all these examples, technical innovations can satisfactorily be used in painting fairly traditional-looking landscapes, so long as you accept their limitations while making the most of their positive and evocative qualities.

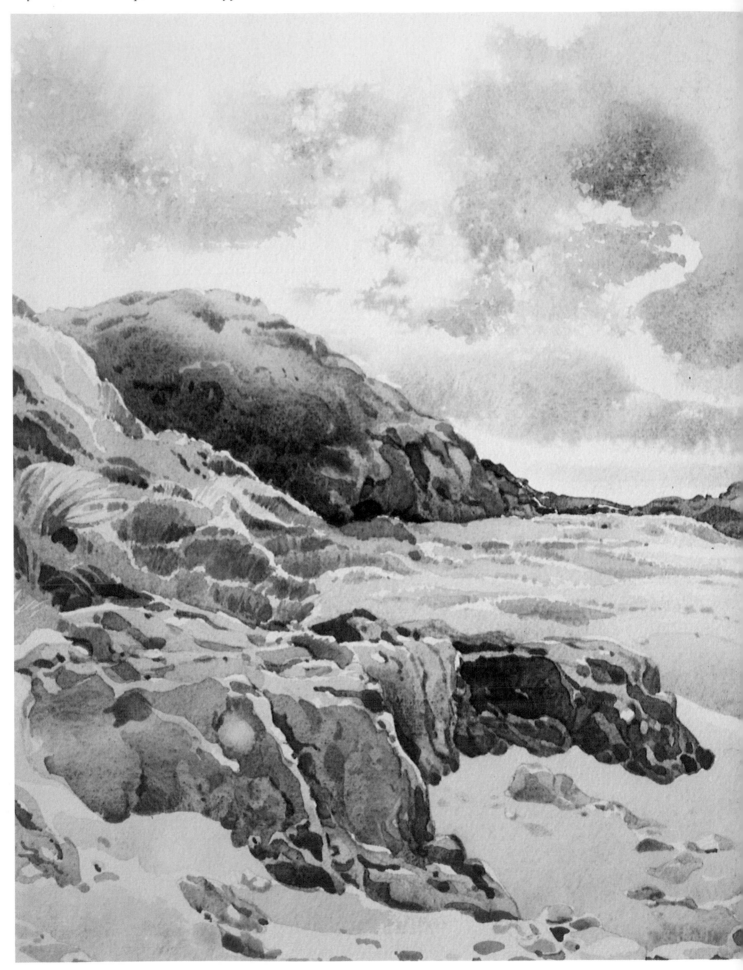

22 *Beach At Morfa Nefyn, Lleyn Peninsula* (22 x 15in/560 x 380mm)

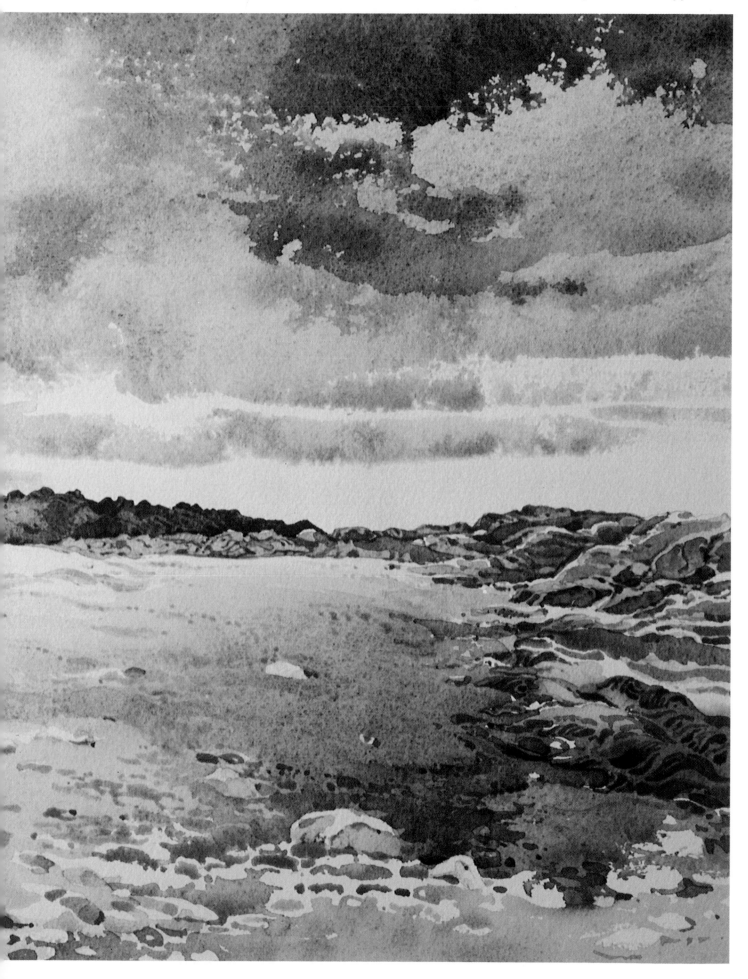

4
Creative Procedures in Landscape Painting

Design and practice

Every schoolchild is familiar with watercolour painting in school and most have experimented with it repeatedly. However, there can be no doubt that it is very difficult to paint extremely well in watercolour – more so than in any other medium. It also demands careful planning. With other media, any mistakes can be painted over, but the extreme transparency of watercolour makes it difficult to amend a badly-painted passage (though not always impossible).

The fluid nature of watercolour makes it essential that it be used quickly and with a certain amount of verve. Most of the thinking has to be done beforehand, because when you are painting your actions need to be so quick as to be virtually automatic. With this medium, therefore, the creative process leans heavily on the design stage. To illustrate this I propose to lead you through all the stages of planning and painting a hypothetical landscape – say a typical stone-built Yorkshire farmstead.

All the really major creative decisions are taken before picking up a brush. One needs to decide exactly what one is setting out to do. Am I going to paint this subject exactly as it looked when I saw it? Or shall I alter the weather conditions? As it was the group shape of the buildings that first struck me, would it be better to paint it against a snowscape and thus stress this quality to the maximum? Is it the potential for interesting local textures which might be the best aspect to emphasize?

What range of colours should I adopt? If I use the local colours to preserve a sense of place, which colour is predominant in creating that effect? Shall I stress that colour, therefore? As it is a hot sunny day shall I use a high-key colour range – or would it be more interesting to use strong tones to increase its dramatic potential? What is the mood that would best suit the subject? What time of day? What season of the year? This kind of mental investigation is enormously important in clearing one's mind so that one is absolutely certain of one's aims before beginning to paint.

Now I can begin the composition, starting with just a few pencil lines to indicate the essentials. What size of paper: a quarter, half or full Imperial sheet? A high or low skyline? Is that interesting tree too near the edge

of the composition? Shall I move it nearer to the middle – or leave it where it is but make it smaller? The horizontal wall in the foreground is too much of an obstacle to the eye. Shall I leave it out . . . make a gap in it . . . put in a half-open gate?

Does the mood demand a figure? If so, where? Doing what – driving sheep? Or does the quiet mood suggest leaning contemplatively on the gate? Or shall I just put in a few chickens scratching in the manure heap? What about blue smoke drifting across in front of the trees from a bonfire? Or is that too suggestive of autumn? Why not make it autumn anyway? One idea leads to another.

Would the emphasis on texture and pattern be enhanced by using the extra textural possibilities of Indian ink in the washes? Perhaps not – it does tend to dominate and take over. In any case I'm aiming at something quiet, not busy. I don't want black in a misty colour scheme. What techniques would best produce the quiet textures I'm aiming at? Spatter? Spots of water dropped into drying washes resembling the pattern of lichen on the stones in the wall?

What type of sky? Do I need a dramatic one with interesting masses of cumulus cloud? A fairly busy landscape really needs a quiet sky. This would allow me to subdue the colour in those background hills and trees – a misty blue-grey bleeding slightly into the sky? That darker area of hazy cloud could allow sufficient watery sunlight to filter through onto the buildings to create a pleasing focus for the composition. How strong a light? Perhaps only a soft one as it is really a misty subject. If that is so, then the idea of any emphasis on texture and pattern wouldn't fit. A much simpler, soft treatment is needed – soft, pearly colours with a glow of creamy yellow for the light?

All this planning must be done before starting to paint; but at least we now know exactly what kind of painting we're aiming at.

First I mix the sky colour with Cobalt Blue and Yellow Ochre – as I intend to show a creamy yellow light filtering through it – with the slightest touch of Burnt Sienna to grey off the mixture. Having wet the upper part of the paper with clean water, I use a large wash brush to put in the graded wash of the sky. When the wash becomes paler as it nears the horizon, more Yellow Ochre is added. Touches of a stronger grey are put in at the top right of the sky for heavier cloud. Just

below it a large brushful of weak yellow is dropped into the wash and the board tilted to allow it to run down diagonally towards the buildings as a faint streak of light. The sky colour has been brought down over the distant hills and the large trees beyond the farm. Just as the sky wash had lost its wet sheen, the hills are put in with a slightly bluer grey than the sky and it bleeds slightly into it. A little later, when this is almost dry, the mass of trees is put in in the same way, the edges feathering against the background. A little pale Cobalt Blue is dropped into the base of the wood to increase the impression of low mist.

With a large brush I wash over the whole of the foreground with various tones of pale grey with some Raw Umber and a little green dropped into it. The only warm colour is a touch or two of Burnt Sienna by the wall where the dead bracken is. Only the sunlit part of the farm is left untouched; I make a habit of leaving the centre of interest until last, when it can be tinted in just the right strength to achieve the optimum effect against the rest of the tonal composition. The green of the field in front of the farm is too heavy, so I drop in a brushful of clear water to dilute it. As this is not sufficiently effective I remove some of the colour with a damp brush.

The track to the farm is rather uninteresting – too straight – so I develop it into a sweeping curve. How did I manage to miss that at the design stage? With strong colour I put in deep ruts in the foreground where the track passes between the gateposts, thus emphasizing the effect of recession. By this time the

mood of the painting is created and all that is left is the painting in of detail.

Contrary to what most non-painters believe, the final details are the easy part, and to an experienced painter the process is virtually automatic. Indeed, although thousands of little decisions are being made as one works, they are made so swiftly that one is hardly aware of having made them. The artist's mind is conditioned by previous experience, so that subconscious as well as conscious influences affect him in the making of the hundreds of tiny brush marks which bring the painting to a conclusion. When a good idea about some passage or other occurs to me in the late stages of a painting, it rarely seems to be the result of conscious thought. It is through a chain of thousands of such creative acts and decisions that a painting is ultimately completed. But by far the most important ones are those that precede painting, and a thorough understanding of the potential magic of the medium is at the heart of all of them.

Control of form

In complicated or detailed compositions the major difficulty with wet techniques is control. For obvious reasons, the wetter the medium is the more unpredictable it becomes. As I have already mentioned, many of the most useful techniques depend upon being able to judge fairly precisely how

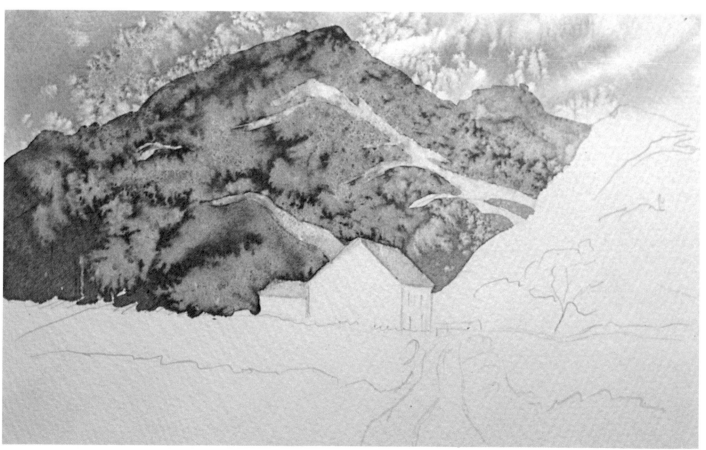

23 *Snow over Moel Hebog, Snowdonia (Stage 1)* (11 x 9in/280 x 230mm)

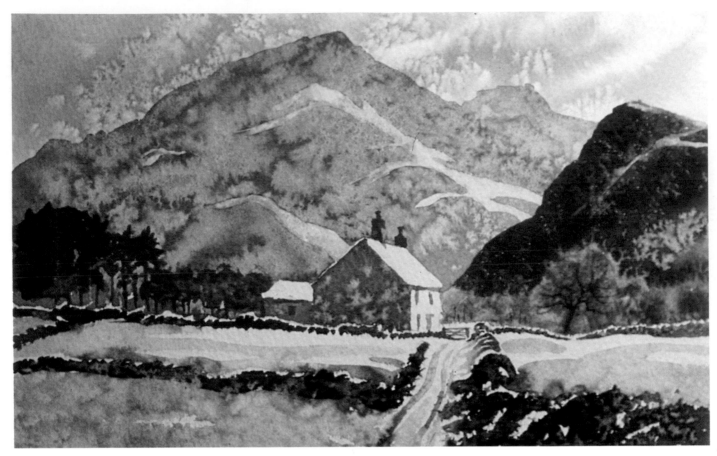

24 *Snow over Moel Hebog, Snowdonia (Stage 2)* (11 x 9in/280 x 230mm)

far a wash has dried before making marks in it that are not likely to metamorphose or be lost in vague wetness. Only with a good deal of practice can you feel confident of being able to judge what stage of drying out a wash has reached. The next painting is a good example of this, involving as it does the use of salt on damp washes to simulate snowflakes.

As well as skill in using techniques that require a precise degree of dampness, it is possible to use other devices to overcome the natural tendency of wet paint to run and lose shape. Essentially, they depend on dividing up the picture space into areas large enough to work on wet-in-wet but not too large to make control impossible. Each wash is then allowed to dry before beginning the next. Within the area of each wash as much modulation of the pigment is carried out as is possible while it is still damp. When the whole of the picture area has been covered, the normal finishing touches can be applied, either dry or after re-wetting some parts where necessary.

Snow over Moel Hebog, Snowdonia (23) was painted in this way. Masking medium was painted over the cottage roof. Then the sky was painted and some sea salt dropped into it. By the time this was almost dry, the mountain was covered in a quickly-applied wash of blue-grey, leaving white paper for slopes and edges catching the light, in order to give some modulation. More salt was sprinkled onto this wash when it had dried slightly. Clean water was then washed over the dry white areas so that a slight

amount of pigment could seep into them and make them less prominent.

In the next and final stage (24) the dark crag on the right and the whole of the foreground were painted in. Again, salt was sprinkled when the washes were considered suitably damp. Finally, the masking medium was rubbed from the roof and a few dark details strengthened. The painting is very atmospheric and demonstrates the effectiveness of this particular wet technique.

Rock Faces, Cratcliffe, North Derbyshire (25) was painted in a similar way. After the simple sky had dried, a wash of warm grey was painted across the rocky cliff, omitting the areas of light where the more complicated detail was. The wash was varied by dropping in touches of Raw Umber and green. Then the foreground cottage and tree were washed in onto a damp background.

In the next stage (26) the light rock faces were tinted, as was the ground beyond the cottage, the latter in Yellow Ochre, green and Burnt Sienna for the slopes of dead bracken. Finally I put in the small dark accents on the rocks and cottage. What had attracted me about this subject was the resemblance of the crag on the right to the Easter Island heads. I was able to see two other less obvious faces, on which I used a little artistic licence to make them more recognisable (thus making a pun on the title). By using what amounts to two large modulated washes I could paint the whole picture quite wet, except for the small areas of facial detail.

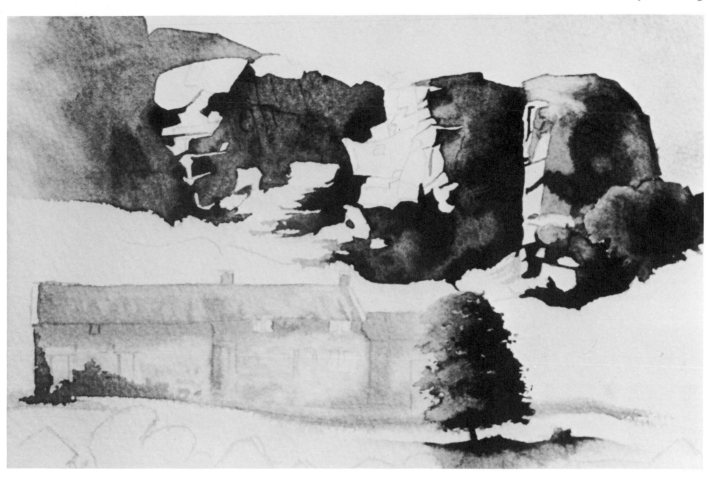

25 *Rock Faces, Cratcliffe, North Derbyshire (Stage 1)* (11 x 7½in/280 x 190mm)

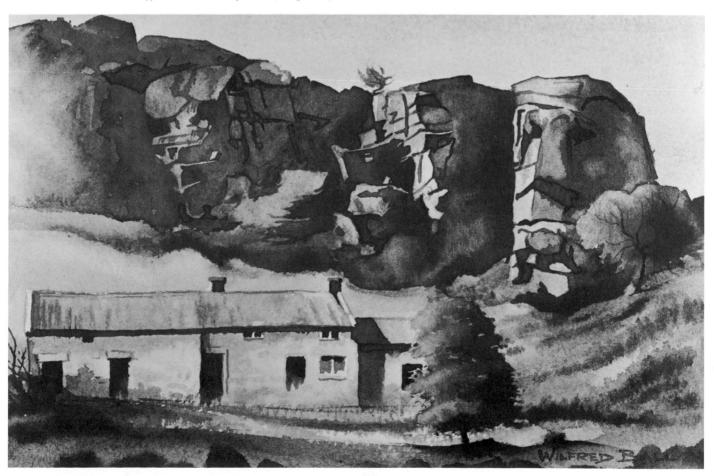

26 *Rock Faces, Cratcliffe, North Derbyshire (Stage 2)* (11 x 7½in/280 x 190mm)

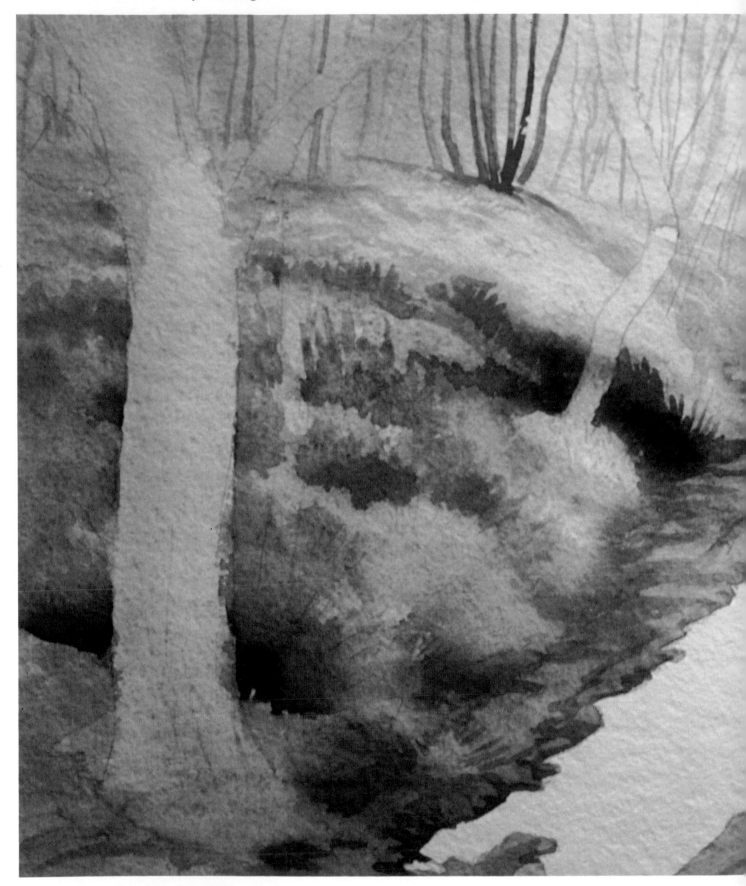

27 *Wet Track At Horsley Woodhouse (Stage 1)* (15 x 11in/380 x 280mm)

Rocks are not the most apt subjects for wet techniques, as they have to look hard rather than soft. The next example (27), however, *Wet Track at Horsley Woodhouse*, lends itself well, in spite of being very detailed. However, in the dimness of a wood much of the detail will be indistinct anyway. The dark marks in the muddy track and the reflections in the pools lend themselves equally to a wet approach.

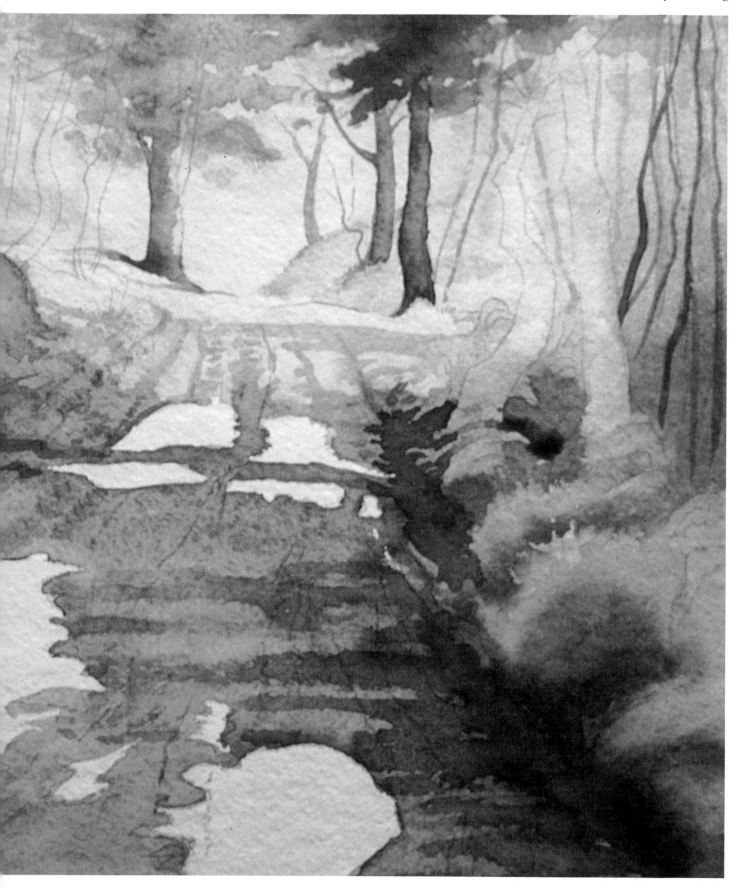

A wash of pale Gamboge was painted across the upper part of the painting to create the sunny area at the head of the track. With the exception of the pools the rest of the picture surface was covered with Yellow Ochre to provide the wet surface into which I could paint the basic tonal areas before touching in the stronger accents. By leaving the pools until later it was possible to control the whole of the rest of the picture surface until it had dried enough to put in the more precise shapes such as tree trunks and mossy walls.

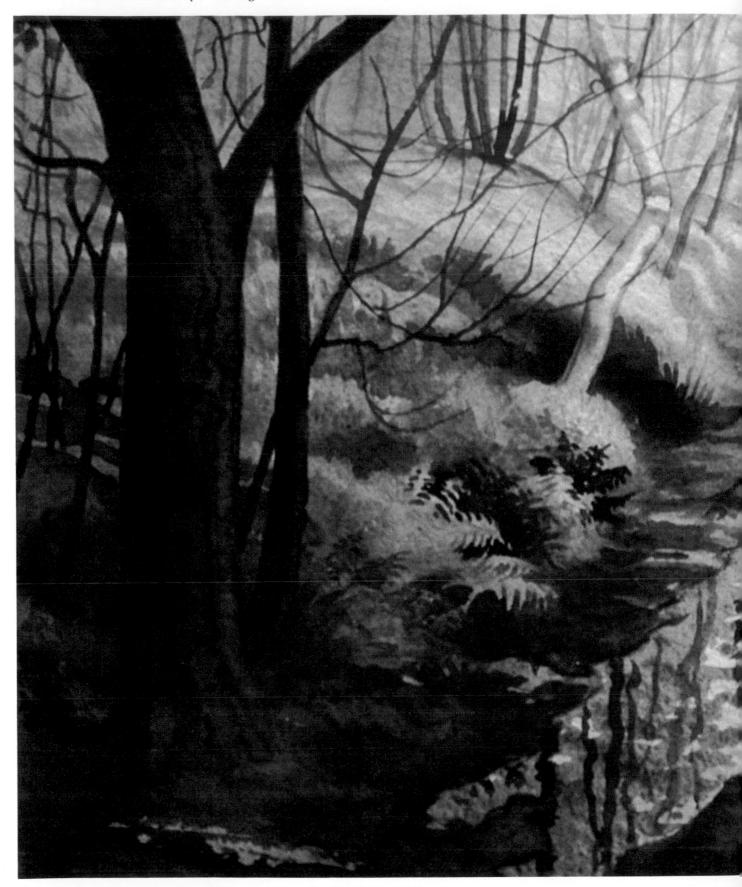

28 *Wet Track At Horsley Woodhouse (Stage 2) (15 x 11in/380 x 280mm)*

A warm grey covered the track, strengthened in places to suggest cast shadows and with more Yellow Ochre dropped in for the sunlit area (*28*). Ruts and other dark, muddy marks were put in as it began to dry. Yellow, Umber and green details suggested the slopes of bracken before the trees were painted with techniques I have detailed in Chapter 5.

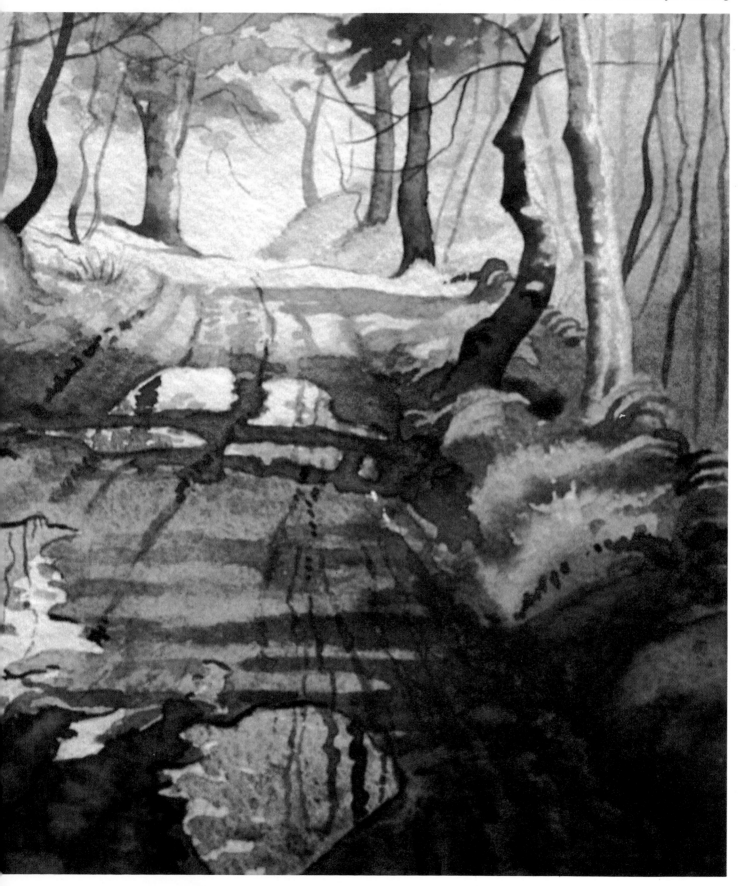

When the pools were filled with the brilliant yellow and green reflections they gleamed all the more jewel-like for being enclosed by the dark tones of the wet, muddy track.

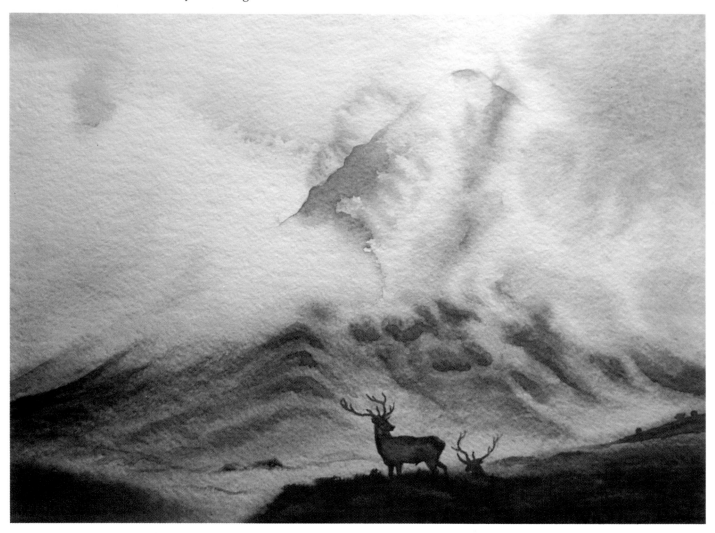

29 *Buachaille Etive Mor under Cloud* (15 x 11in/380 x 280mm)

I must confess that any essential clarity of form has to be ensured usually by using more obvious traditional means, by painting around the shapes or by protecting them with masking medium before beginning to paint. The exception to this is where the important shapes can be painted in a strong tone against a paler background, as in the final painting in this section, *Buachaille Etive Mor under Cloud* (29). Here the dark shapes of the deer serve to emphasize recession. This subject was painted onto a streaming wet surface, with the clear intention of allowing the wet pigment to flow as freely as it wished. You could not have a subject better suited to wet techniques. Only deer and the merest touch to clarify one or two edges of the mountain, seen through the cloud, were put in after the paper was dry.

Although *Rock Faces, Cratcliffe* has made limited use of wet-in-wet methods within very rigid forms, it is clearly not the sort of subject best suited to such techniques. I think one has to accept that compositions including a significant number of precise forms or edges cannot be tackled with wet watercolour without losing their essential characters. However, most landscape background can be painted effectively with these methods, as well as a significant proportion of the foreground area. All the paintings in the rest of this book will demonstrate this, and more. A considerable number will be painted almost entirely by wet techniques, and a few completely.

5
Features of Landscape and Weather

Trees

Wet techniques are obviously most suited to the depiction of vague, diffuse forms such as weather phenomena, but they have their uses in representing hard shapes – within limitations. I have used wetness very effectively in creating the crusty qualities of bark on rough tree trunks, for example. The method I use most commonly, and the most simple, is shown in *Trees in Winter* (30). Here, after the lightest tone of each tree had been applied, a stronger colour was drawn down the left hand side of each. The extra

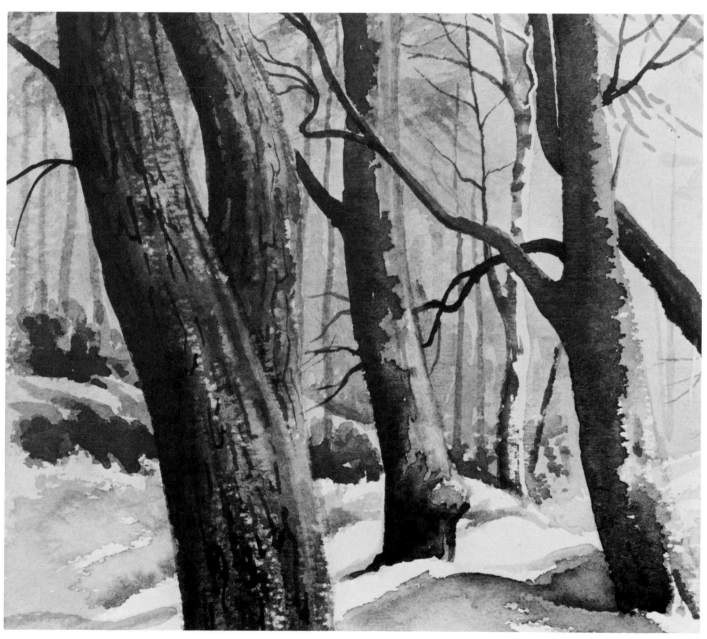

30 Trees in Winter (11 x 15in/280 x 380mm)

wetness meant that the light tone on the right dried more quickly. If more shadow colour is then added on the left, the junction between wet and dry areas is an accidental, irregular edge which gives a pleasing rough effect. The large double trunk on the left had some linear detail applied after it had dried, to simulate even rougher bark.

In the second example, *Beeches in the Dane Valley, North Staffordshire (31)*, I tackled a young and an old beech tree, side by side. Here I used the same method, covering the trunks with a pale greenish grey, then darkening the right side with a strong brownish green. Then, however, I brushed a fluid pale green into the left side and along the light modelling running vertically down each trunk, being particularly pronounced at the base of the tree, merging into the gnarled, uncovered roots. This watery colour drove the darker pigment back in a kind of linear bloom which adds texture to the emphasized contrast in tone. With a very strong colour I darkened the grooves and hollows on the bottom right. A wet brush was drawn along the damp light surface between these darks, and the moisture bled slightly into the darks creating a subtle textural effect. Both trees were finished by putting in the strong darks in the hollows between the sunlit roots.

This method provides a pleasing alternative to the usual dry brush method of imitating the roughness of bark. Of course, the use of rough paper helps, whichever technique you may use.

31 *Beeches in the Dane Valley* (22 x 15in/560 x 380mm)

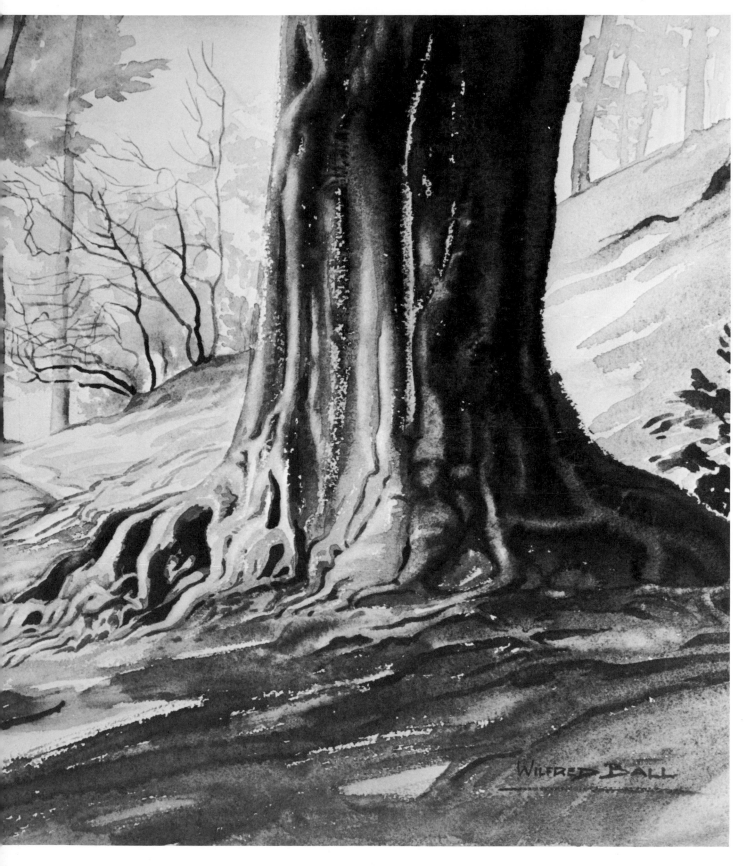

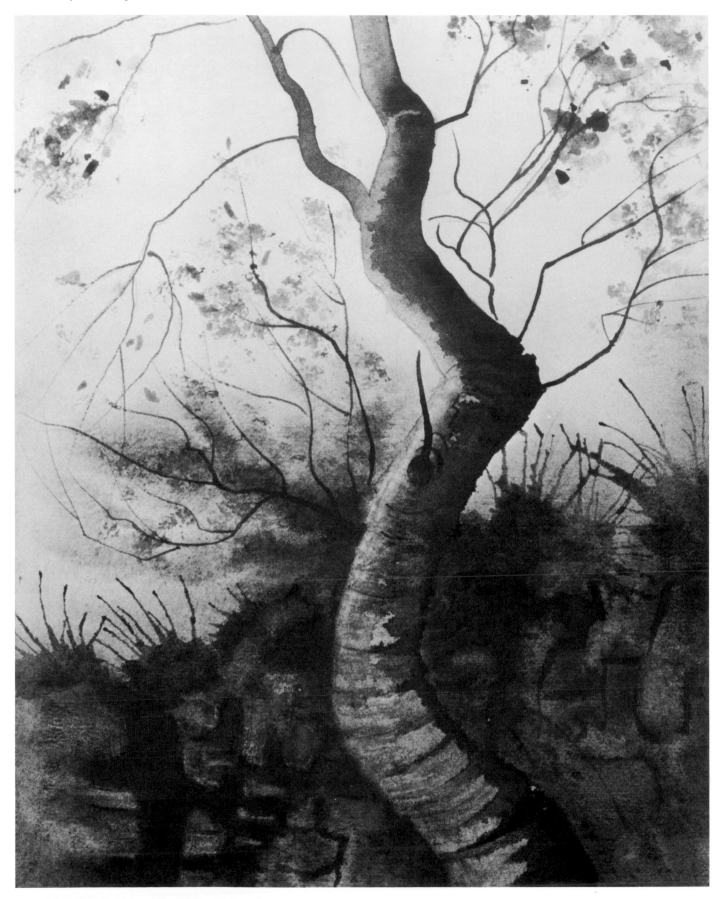

32 Silver Birch (11 x 15in/280 x 380mm)

Silver Birch (32) demonstrates the use of two of the techniques discussed in Chapter 3. The characteristic bark patterns were produced by using the cardboard squeegee technique, as were the suggestions of stone shapes in the turf wall. Then the long grass was produced by blowing on pools of paint to produce tendrils.

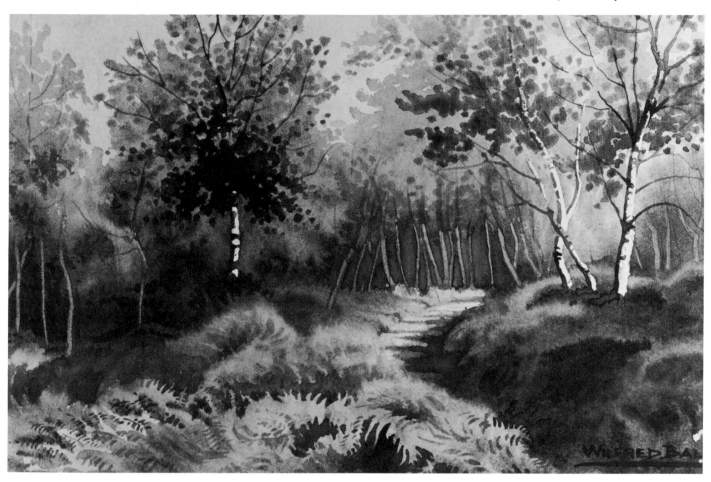

33 *Autumn, Horsley Woodhouse* (11 x 7½in/280 x 190mm)

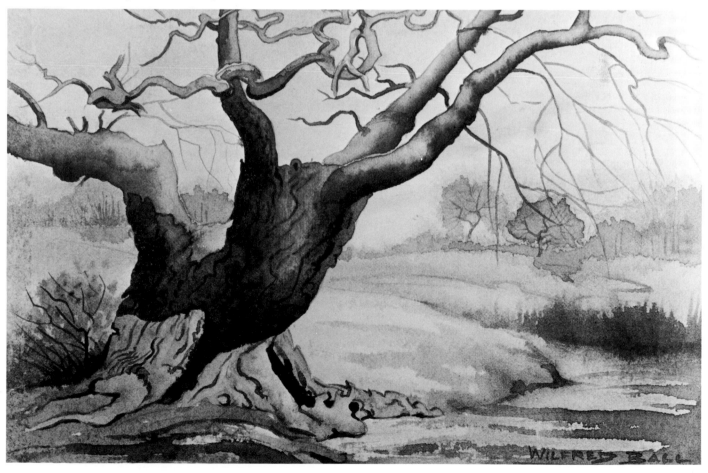

34 *Old Oak in Bradgate Park* (11 x 7½in/280 x 190mm)

Autumn, Horsley Woodhouse (33) also demonstrates two different ways of producing birch trunks. While the foreground trees were treated with masking medium the ones in the distance were drawn into the dark background pigment with the handle of a paint brush. This works very well in suggesting distance.

Old Oak in Bradgate Park (34) tackles a different problem from any of the previous examples. Here the bark had been lost from the branches and only remained on the massive trunk. The task of differentiating between the bare, grey wood and the richly crusted bark was an interesting challenge.

The bare dead branches were painted grey, then pale yellow was touched in on the side facing the sun to produce a gradual, fairly smooth tonal change. The bark was painted in greens and browns and then dark grey painted into it on the left, shadowed side. Sand was sprinkled onto these dark areas to produce a rough texture. Sand attracts the pigment and thus dark, crusted textures can be produced.

Winter Flight, Howden Reservoir (20) in Chapter 3 is an example of the treatment of conifers by a monoprint technique.

Skies

No subject is more obviously related to watercolour than cloud formations. Moisture is the basic component of both. Since the mood of any landscape is set by the sky, it is essential for every landscape artist to study it in all its vagaries. Even in a landscape painting where the horizon is so high that no sky can be seen, it is my contention that you can tell what the sky is like from its effects on the landscape. If you cannot do this, then it's likely to be a poor painting.

I have mentioned moisture specifically and my first example is of a sky fairly dripping with it. *Above Glencoe* (35) is a wet painting in every sense. The whole of the sky, trailing mist, was painted on wet paper. When it was almost dry a little clear water was put into the lower part to react against the grey pigment in places and produce a more definite edge than the feathery tendrils. As soon as it was almost dry the mountains were painted in, the far ones fainter and bluer, receding into the mists, the foreground crag fading into the hill cloud above. Touches of stronger colour were used while it was still wet, to suggest the forms within the crags, and Scottish versions of Sour Milk Gill tumble icily between the rocks. The similarity of the rhythms of the streams to the tendrils of mist adds to the unity of form and movement.

I subdued all detail to create the effect of dim mistiness and indeed to ensure that it is patently a painting of sky and space. Anyone who walks the fells will recognize its sense of place.

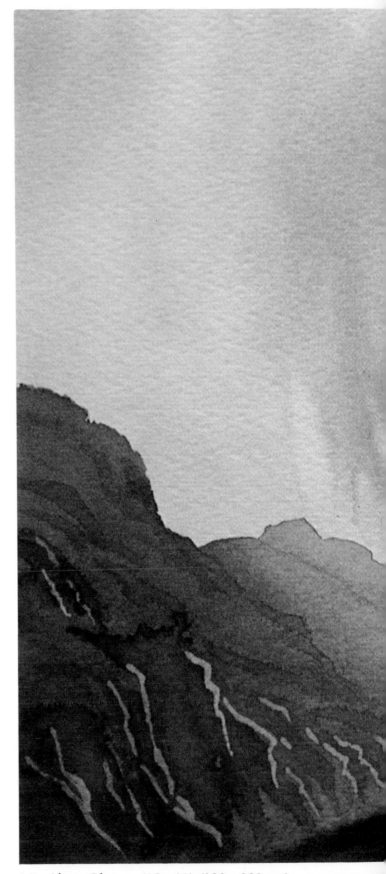

35 *Above Glencoe* (15 x 11in/380 x 280mm)

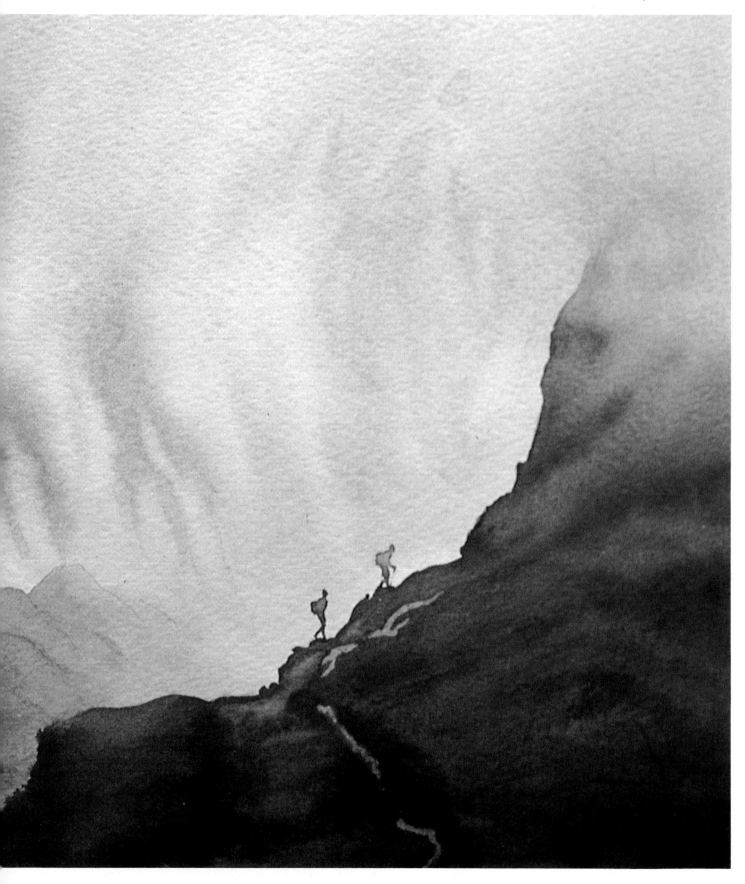

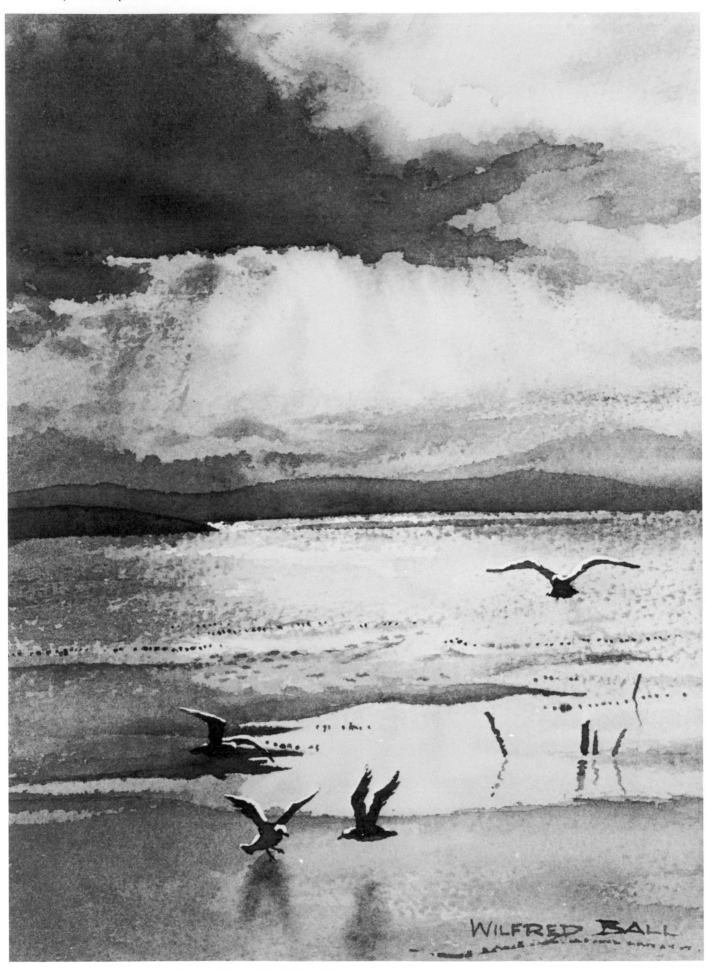

36 *Sunlit Sea, Grange-over-Sands* (7½ x 11in/190 x 280mm)

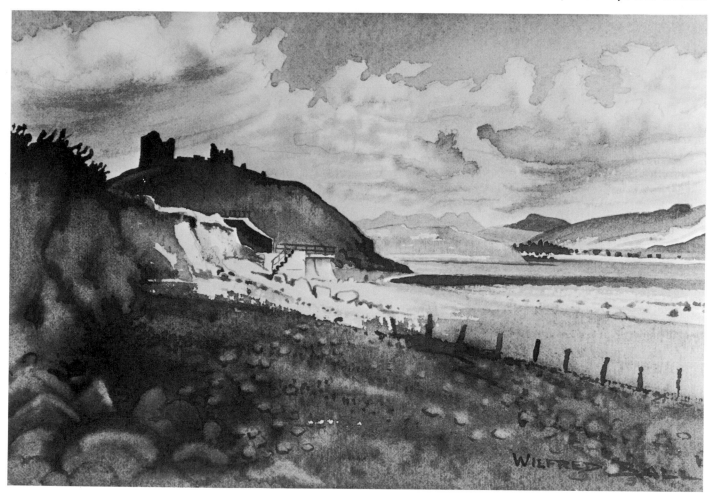

37 Criccieth Castle (11 x 7½in/280 x 190mm)

The next two paintings demonstrate the afore-mentioned relationship between the sky and the ground, including in this case the sea. *Sunlit Sea, Grange-over-Sands* (36) shows the midday sun behind a dark cloud. The brightness in the sky is reflected in a soft gleam in the sea and the wet sand. Pearly grey tones were brushed onto a damp background until the paper was almost dry, when the final strong tones were put in for the main cloud and the darks above the horizon. The soft light in the sky, the gleam on the sea and the glistening sand are all of a piece and the tonal treatment had to be carefully judged. Even the little dry brush work I risked on the sea was put onto a slightly damp surface so that even that was softened.

The painting was finished by putting in the tiny seagulls dotted along the edge of the shoals and the more active ones in the foreground which provide some tonal contrast and emphasize recession.

Criccieth Castle (37) shows a typical Welsh summer sky – cumulus cloud against azure. It demonstrates how the clouds cast shadows on the landscape, in this case particularly on the castle. This phenomenon is a godsend to the landscape painter, as it allows him to use this light and shade as an aid to composition. I could have painted the castle in full sunlight, for example, as it really was shortly after I'd shaded it in on this sketch. By putting an area of dark, stormy sky behind it, I could have produced the same kind of tonal contrast in reverse.

The clouds were painted wet-in-wet and their shapes were later emphasized by the Cobalt Blue of the sky. Clouds are soft-edged, being made of suspended moisture, and are therefore best painted wet. However, in a sky as brightly lit as this there is some excuse for hard edges as the clouds really do seem to have defined shapes.

The same light and cast shadow is repeated in the treatment of the sea. This is the kind of subject that does not naturally lend itself to wet techniques. Bright sunshine produces clarity. Shapes are distinct, colours bright and strong. However, most of the painting *was* treated wet. After the clouds I wet the whole of the shadow area, both on the castle headland and on the foreground beach, before putting in the grey pigment. This area was modelled by putting strong colour into selected places, then pale Raw Umber and Burnt Umber were dropped in to give local colour to the sand, as well as giving the effect of reflected light in shadows.

When almost dry, a brush charged with clear water was touched onto the upper edges of the foreground boulders and pebbles. These blooms added to the effect of complex textures common to stony beaches. A few final darks, to suggest shadows between the stones, ended the painting. The relationship between sky and ground is quite clear.

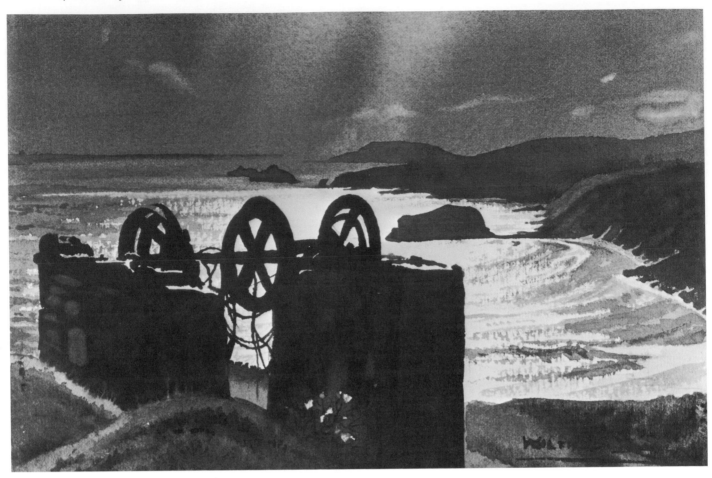

38 *Old Mine Workings on the Lleyn Peninsula* (11 x 7½in/280 x 190mm)

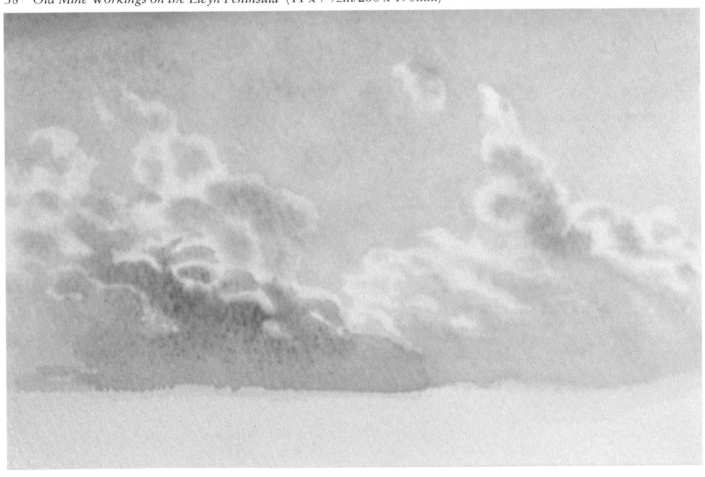

39 Three cloud studies (8 x 6in/200 x 150mm)

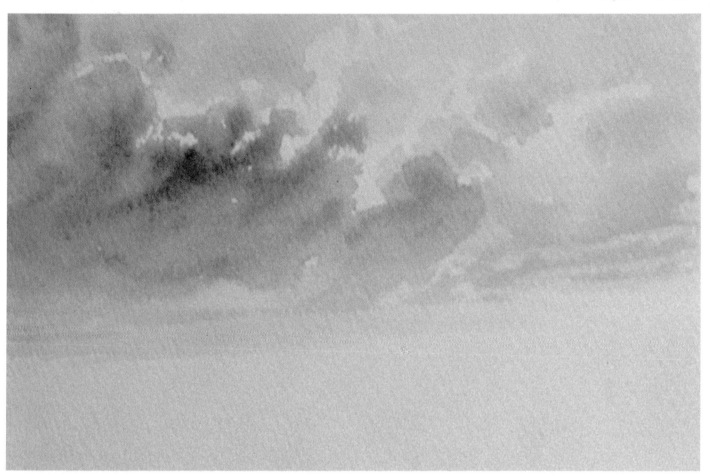

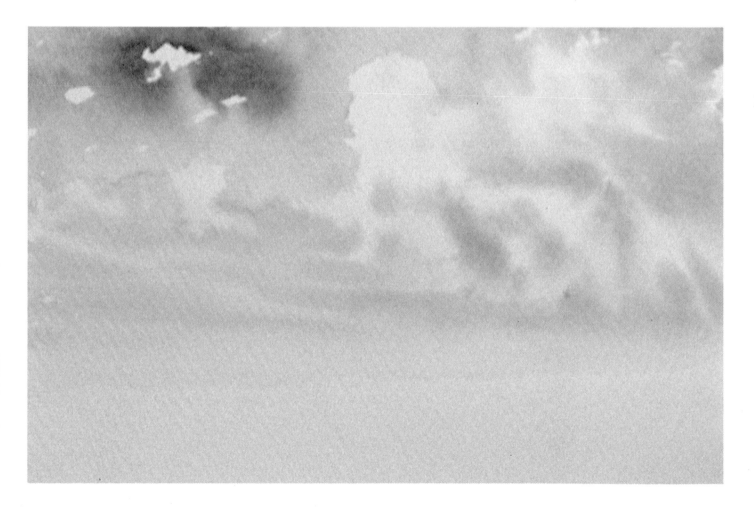

Old Mine Workings on the Lleyn Peninsula (38) further demonstrates this relationship on a much heavier hazy day. As the storm moves in from the sea, its shadow moving forward beneath it, the high sun is breaking through the haze to touch a few dim clouds and to silver the sea in the bay, which emphasizes the stark shapes of the winding gear. The effect of light filtering down from above was produced by touching pale yellow into the top edge of the sky, then tilting the paper to allow it to carry down towards the horizon. When the sky was almost dry I used a damp brush to lift a little paint off the upper curves of the faintly lit clouds. Of course the sparkle was produced by dry brush technique, in contrast.

An understanding of painting skies is essential to all landscape painters. In a previous book I have recommended the habit of painting one sky a day. My own habit is not as regular as that, but I frequently stop what I am doing to paint an interesting sky through the studio window. Cloud studies painted like this usually have the virtue of being painted quickly and therefore in a lively way, so I save them for future use. Three such cloud studies, painted quickly and wet are shown in Figure 39.

Evening on Bleaklow (40) is an example of a moorland landscape which was added at least two years after this quiet sky was painted, its rich reflection rendered jewel-like by the contrast with the dark heather surrounding it. If you leave room for a low-horizon landscape you will usually find that a subject will eventually crop up that fits the mood of the sky very well.

40 *Evening on Bleaklow* (15 x 11in/380 x 280mm)

Sunsets

There are two main problems in painting sunsets. Firstly, the most spectacular ones are virtually impossible to depict satisfactorily. In contrast with the low-key landscape they will appear positively gaudy. Personally, I settle for the quieter evening sky as often as not, although I am sometimes unbearably tempted by a noble sunset. If only I could control them as sublimely as Turner did!

November Evening, the Salt Cellar from Dovestone Tor (41) is the sort of quiet evening sky I recommend. The sky and its reflection in the moorland pool were painted in tints of peach rather than orange and scarlet. It was a fine November evening on Derwent Edge, but the mist was beginning to settle in the distant hollows. The sky was painted completely wet and the landscape in three easily distinguishable washes. In the

41 *November Evening, the Salt Cellar from Dovestone Tor*
(22 x 15in/560 x 380mm)

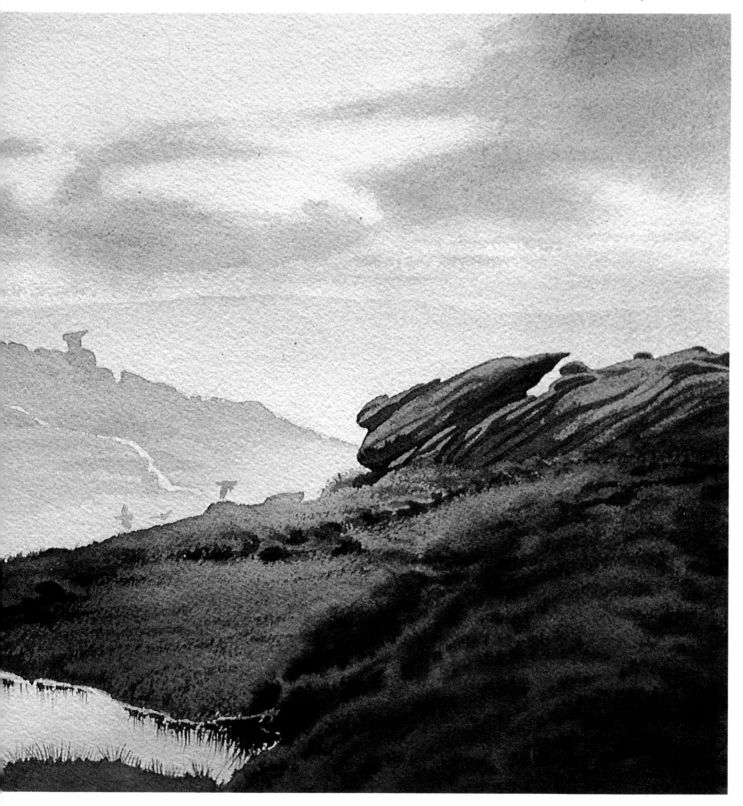

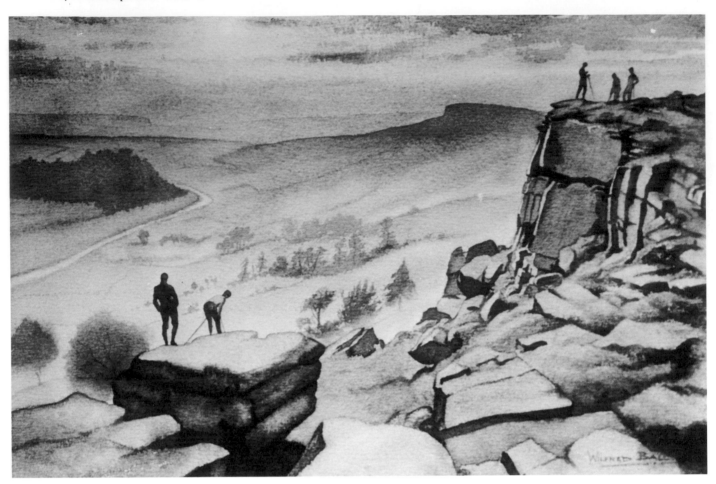

42 *Climbers on Stanage Edge* (22 x 15in/560 x 380mm)

twilight the foreground heather was suitably hazy so that all the foreground was painted wet-in-wet except for the spiky red grasses and the detail on the rocks on the skyline.

The Derbyshire moorlands are perhaps my favourite subject, and *Climbers on Stanage Edge* (42) is one that particularly appeals to me. The climbers and crags stand out against the setting sun. Below them the evening mists are collecting in the valley. This painting is an example of how to deal with the second difficulty with sunsets, namely the tendency to reduce the landscape to a stark silhouette against a brightly coloured sky, a most unsubtle, inartistic effect. A photograph only emphasizes this fault.

I had taken a photograph of this subject, which was useful for the lovely colours in the sky; but fortunately I had also sketched it. When I came to paint the rocks, virtually no modulation of form was discernible in the photograph and I used my sketch entirely. This is a good example of one of the many deficiencies of the camera – which doesn't stop me using it for its other virtues. It is surprising how much more flexible is the human eye. I have made dozens of sketches at twilight, once even in moonlight, when a camera would have been useless. Yet I was able to record enough detail to make a worthwhile sketch.

In the Stanage Edge painting not only was I able to clarify the rocky structures adequately, but was at pains to do the same for the figures. It was important to make the distant group obey the laws of atmosphere as well as linear perspective. I was able to hint at the clothing and climbing gear of the nearer climbers to prevent them looking too much like cardboard cut-outs.

Low Tide at Combe Martin (43) uses a slightly more detailed evening sky, but the boats, patterns of wet mud and seaweed are the real subject of this painting, which is wet in more ways than one. It was founded upon a basic wet-in-wet start, but the glistening beach demanded a little dry brush work in the final stage to create the effect of glistening wetness. The ropes trailing along the beach serve to emphasize the linear perspective.

This painting has the additional attraction that all sunsets at sea possess, in the gold reflection from the sun which cleaves the dark surface of the water *en route* to the observer.

Loch Linnhe from Glencoe Village (44) demonstrates the same phenomenon. I have included it, however, principally because of the markedly horizontal banks of cloud which are a characteristic of evening skies. After a day of solid mist and steady rain it was nice to see the break in the bad weather that the high clouds indicated. The clouds were painted onto a damp surface, as were the foreground and the first washes for the waters of the loch. To soften the effect, even the dry brush work was put onto a dampened background, so that the sparkle is somewhat reduced.

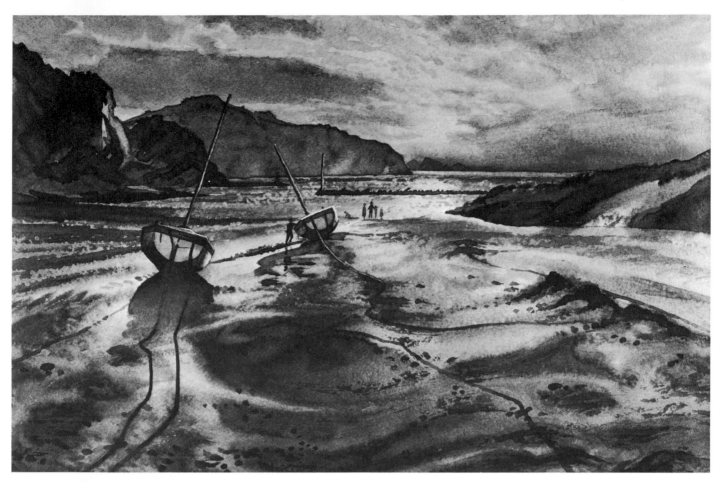

43 *Low Tide at Combe Martin* (15 x 11in/380 x 280mm)

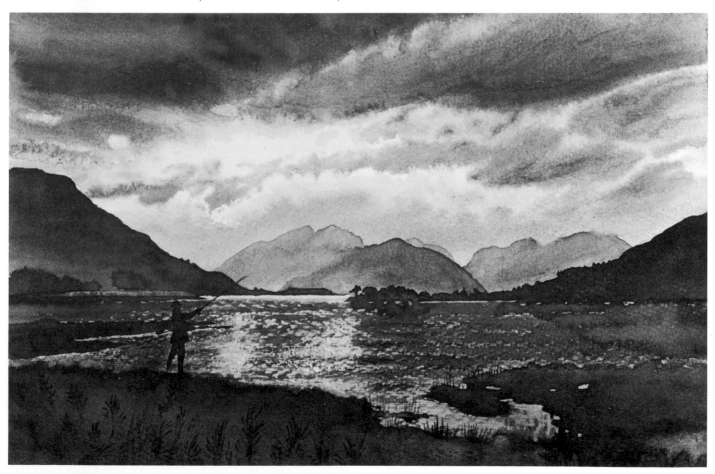

44 *Loch Linnhe from Glencoe Village* (15 x 11in/380 x 280mm)

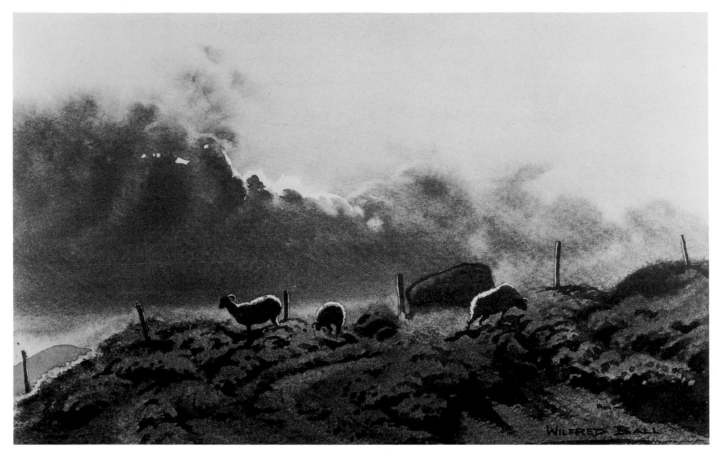

45 *Evening Cloud, Hathersage Moor* (15 x 11in/380 x 280mm)

Evening Cloud, Hathersage Moor (45) is a good example of the difficulty of painting a dark foreground without allowing it to become a dark silhouette. However, it is also a particularly good demonstration of two important ways of retaining highlights in a wet wash. First of all I wet the whole surface with a large wash brush, being careful to paint around the small area of silver light near the sun, which was hidden behind the cloud. This patch of dry paper could thus remain untouched while the whole of the warm sky and the bank of cloud were completed.

The gilded backs of the three sheep had been protected by masking medium until the painting was completed. When it had been rubbed off I tinted them with creamy yellow so as to leave the bright cloud unchallenged as the supreme highlight of the composition.

While the foreground was still damp I applied areas of green, purple and Raw Umber for the grassy bank and clumps of heather. The only parts painted when dry were the posts, the large boulder, the three sheep and the shadows below the cushions of heather.

46 *Evening near Waterhouses* (22 x 15in/560 x 380mm)

Evening near Waterhouses (46) is included particularly to demonstrate the use of a long horizontal painting to emphasize the essential horizontality of evening skies even more. This is an example of trying something different, as suggested in Chapter 3. This format, containing no thrusting verticals of any signficance, is psychologically suggestive of the calm restfulness we associate with evening.

After wetting the paper I dropped Yellow Ochre onto it, into which a little Cadmium Orange around the sun and some suitably warm greys for the cloud strata were put in quickly. The fields and foreground were strengthened with Raw Umber and a little dull green before the waterside reeds were suggested with Burnt Umber. By the time I touched some orange into the foreground pool the paper had dried sufficiently to leave the clear reflection of the sun. Before this stage had dried significantly I was able to put some pale blue-grey into the distance to give the effect of low-lying mist. Finally I used a very strong grey for the shadowed banks of the pool and especially the reflections of the clumps of reeds.

As the paper was now beginning to dry out I was able to commence the detail, first suggesting the distant hill and some isolated trees, before painting the trees and buildings in the middle distance with greys that were not too strong to destroy the effect of them standing in the evening mist. I used a cool grey of similar strength for the shapes of the cows in the middle of the field.

When I painted the tops of the stone walls I emphasized the gate and the sturdy gateposts by strengthening the colour a little in the centre. A few strokes of Burnt Umber with a thin brush emphasized the habit of growth of individual clumps of reeds in the foreground. The carefully-positioned posts along the margin of the pool completed the subject.

Water

Although water, in the shape of the sea, is capable of great drama and violence, it is usually as a reflecting surface that the landscape painter makes use of it. Though it can provide the subject – the centre of interest – itself, it is most commonly used as a device for introducing repetition and thus rhythm into a composition.

As a young man I favoured sunlight, with its strongly contrasting values of light and shadow, and rarely sketched in poor weather. The acquisition of a little maturity and the desire to introduce a little more subtlety into my work compelled me to try other weather conditions. I then realized what I had been missing! Although on a wet day, low-key compositions with little tonal contrast may seem to be inevitable, you have only to introduce wet roads, pools and rain-filled ruts to introduce strong contrast and the possibility of highlights at will. I now prefer wet weather, although sunshine after rain is probably best of all.

Let us examine the role of water as a reflecting surface. When smooth and still, showing no evidence of wind-blown ripples or currents, a perfect reflection can be produced. But I find this a little precise and repetitive. In *Approaching Sheldon Mill* (47) the surface of the River Wye is moved by currents which break up the reflections of the trees along the snow-covered banks.

47 *Approaching Sheldon Mill* (15 x 11in/380 x 280mm)

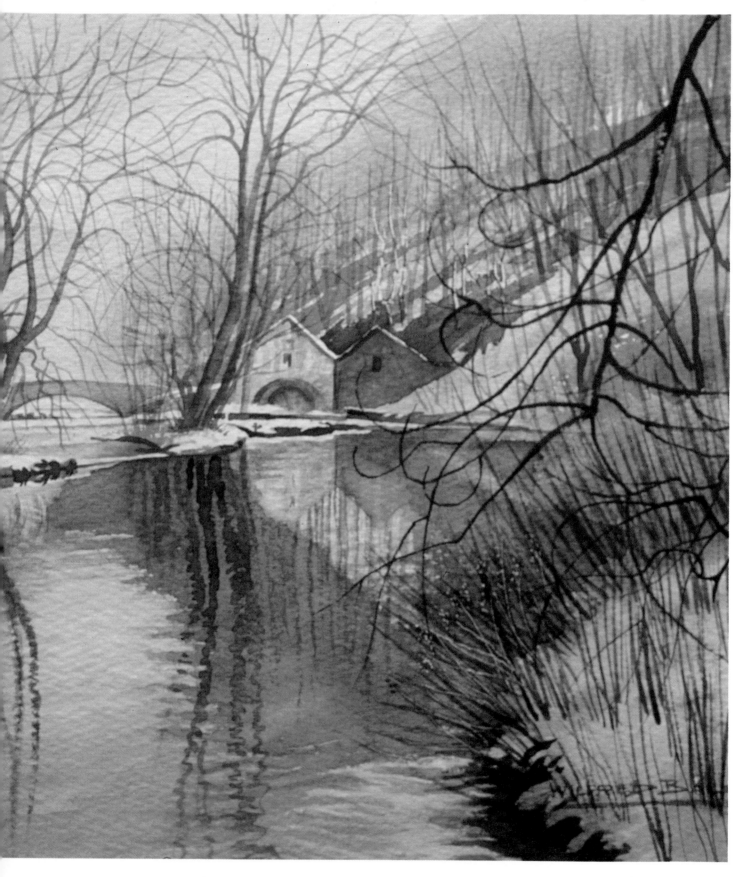

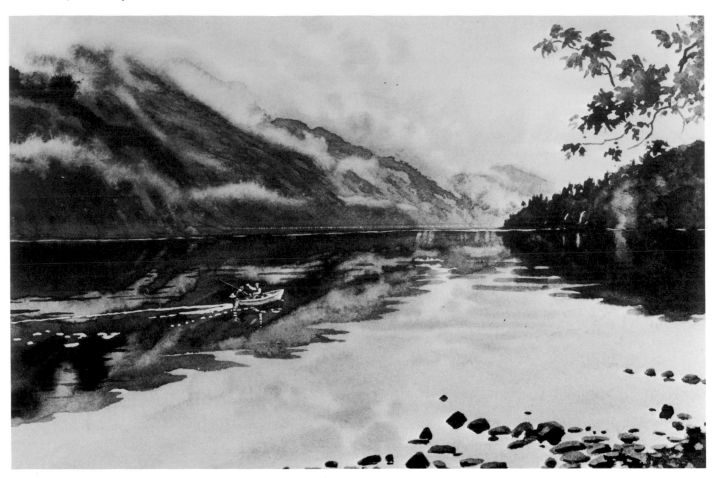

48 *Loch Ness in the Morning* (15 x 11in/380 x 280mm)

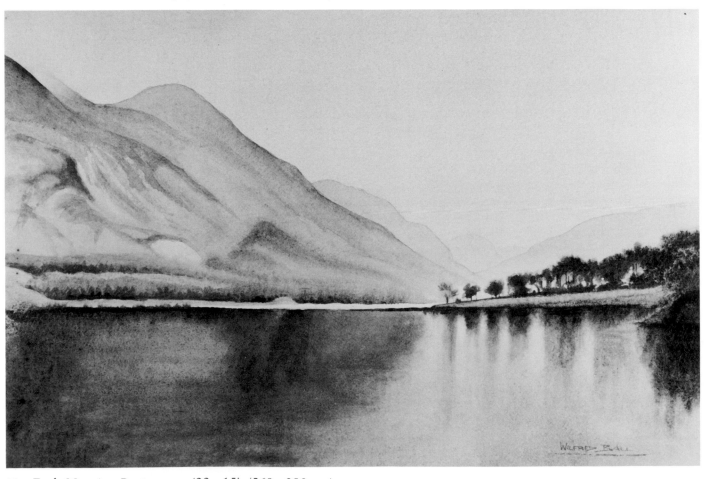

49 *Early Morning, Buttermere* (22 x 15in/560 x 380mm)

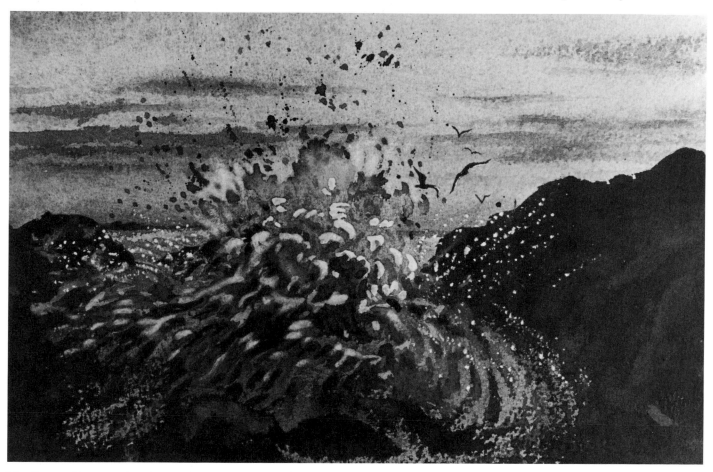

50 *Sunset Spray at Porth Dinnlaen* (11 x 7½in/280 x 190mm)

Loch Ness in the Morning (48) is another good example. The morning mist still trails below the fells but a very clear reflection is provided – still varied, however, by the way the edges are broken by the smooth ripples on the surface. Within the area of the dark reflection the boat with its two fishermen is quite clearly mirrored, in spite of the fact that it is moving.

Early Morning, Buttermere (49) is an example of reflections in still water. Most of it was painted wet, as the creamy morning light softened the detail on the fells, and thus the reflections were also soft. I put in the reflections of the trees by touching strong colour to the wet wash and tilting the paper to allow the pigment to trail down the surface.

Let us now move on to rougher water. I have always been fascinated by the sea, like most islanders, and in particular it is breakers and spray exploding on rocks that appeal to me. The technical challenge in reproducing it is considerable. To illustrate this I have chosen two examples of different techniques of painting bursting spray.

I have spent hours studying the sea breaking high in front of an evening sky. The chief impression is of the weight and great solidity of water, as opposed to the effect of airy spray reflecting light, as seen in the following painting.

Sunset Spray at Porth Dinnlaen (50) is an evening subject. Though facets of the breaker reflect the warm pinks and oranges of the sunset, the high-flung droplets are dark against the light. The gleams of reflected light were put in first with masking medium,

to be tinted later. After wetting the whole of the paper, the colourful sky was put in and the blue-grey brushed over the breaker and rocks. The exploding spray was spattered onto the sky from a full brush of colour, then clean water was dropped onto the lower spots, to imitate the semi-translucent effect this screen of water creates. A strong warm grey was used for the rocks, with green brushed in to provide a complementary colour to all the warmth. Finally the masking medium was removed and pale, warm tints painted in for the subdued highlights. With a damp stiff brush I lifted a few shapes from the dark base of the breaker, leaving some cooler reflected lights to break up the swirling dark water. It is certainly a very different effect from the previous subject. When I had completed it, I felt it needed a more explosive quality still, so I scratched a few strokes with a sharp knife in front of the rocks to represent wind-blown spume. The dark masses and solid-looking spray emphasize the sheer weight of the water.

Breakers, Lleyn Peninsula (51) shows spray lit by the midday sun. I approached it by dealing with the sky and left-hand side of the sea first, before putting in the dry brush treatment on the brightly lit sea to the right. While the breakers were still damp, I dropped clear water into them to run up into the sky as I tilted the paper. In the middle of these 'blooms' a little pigment had to be removed with a damp brush. The odd spots at the top were produced by a flick from a brush full of water, adding a little more vigour to the appearance of spray lifted high into the air.

61

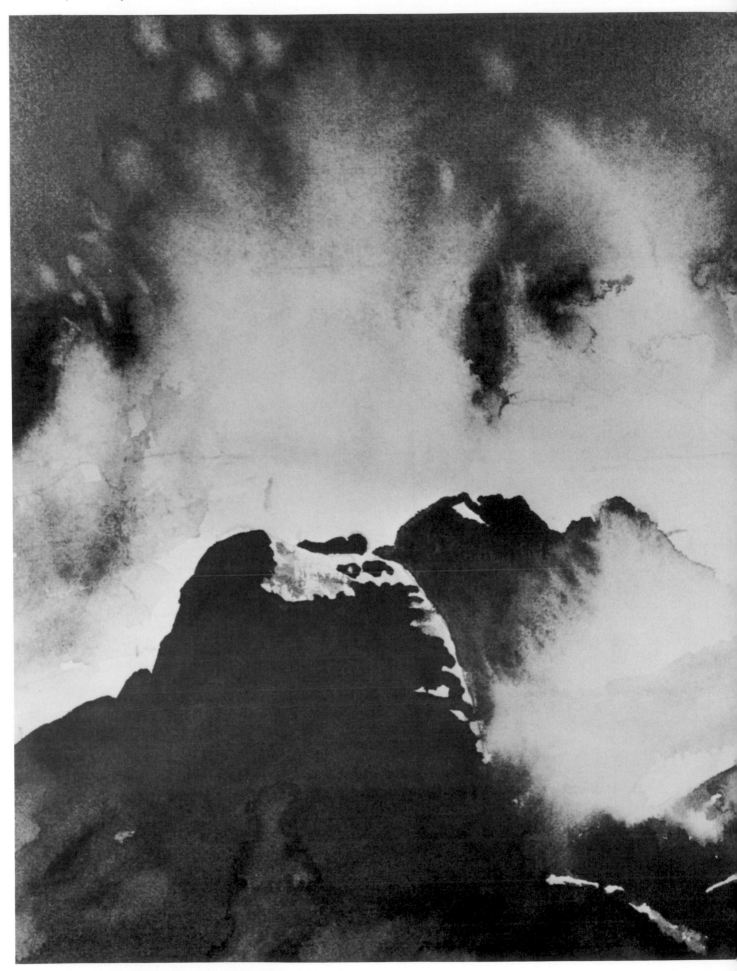

51 *Breakers, Lleyn Peninsula* (11 x 7½in/280 x 190mm)

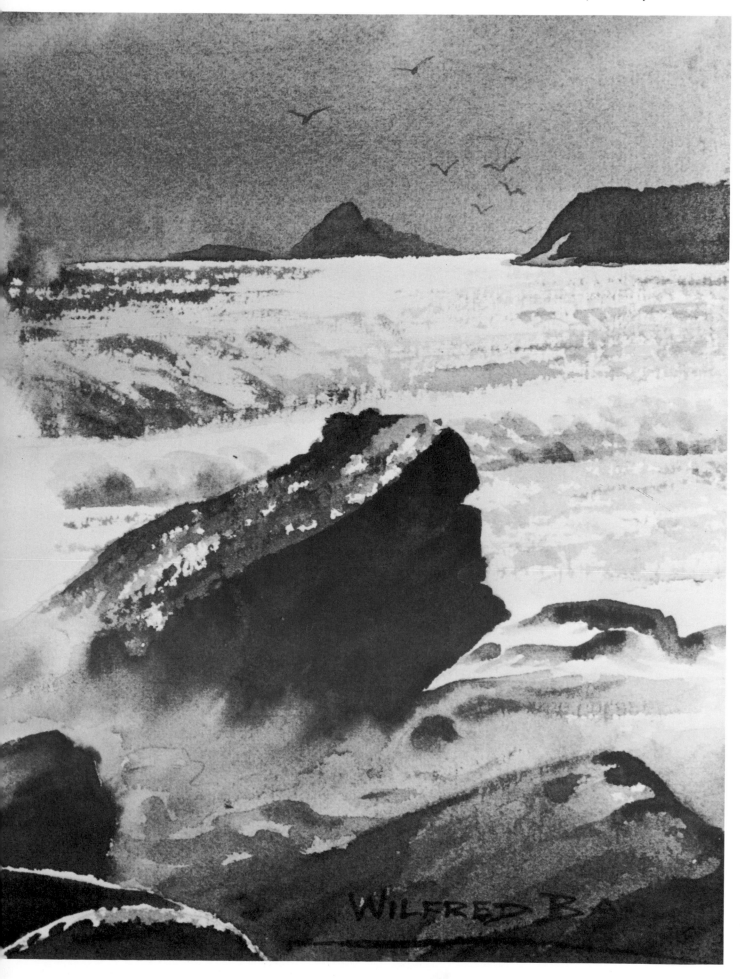

Mist and fog

Mist can manifest itself in many ways, obliterating or softening shapes and muting colours. It can be faint or virtually solid. Hill fog in particular can be quite startling, even frightening if you are caught in it in unfamiliar surroundings. I remember climbing from Edale up the beginning of the Pennine Way above Grindsbrook onto Kinder Scout, in brilliant sunshine all the way, although it was January. But on the top was a different world. Cold, clammy hill cloud cut visibility to a few yards, driving us back down into the dale and the sunlight. Usually, however, mist hangs in hollows, while objects standing high above it can be in full sunlight. Sometimes, as in *Loch Ness in the Morning* (47), wisps of cloud can spread their horizontal tendrils half way up a slope, before the sun gradually disperses them.

The following paintings illustrate these phenomena, beginning with *Borrowdale from Sour Milk Gill, Seathwaite* (52). In this the effect of atmospheric perspective is characteristically emphasized by the mist, the foreground being clear while the far slopes of Glaramara gradually disappear from view. As I have already mentioned, mist is extremely useful for emphasizing distance.

52 *Borrowdale from Sour Milk Gill, Seathwaite*
(15 x 11in/380 x 280mm)

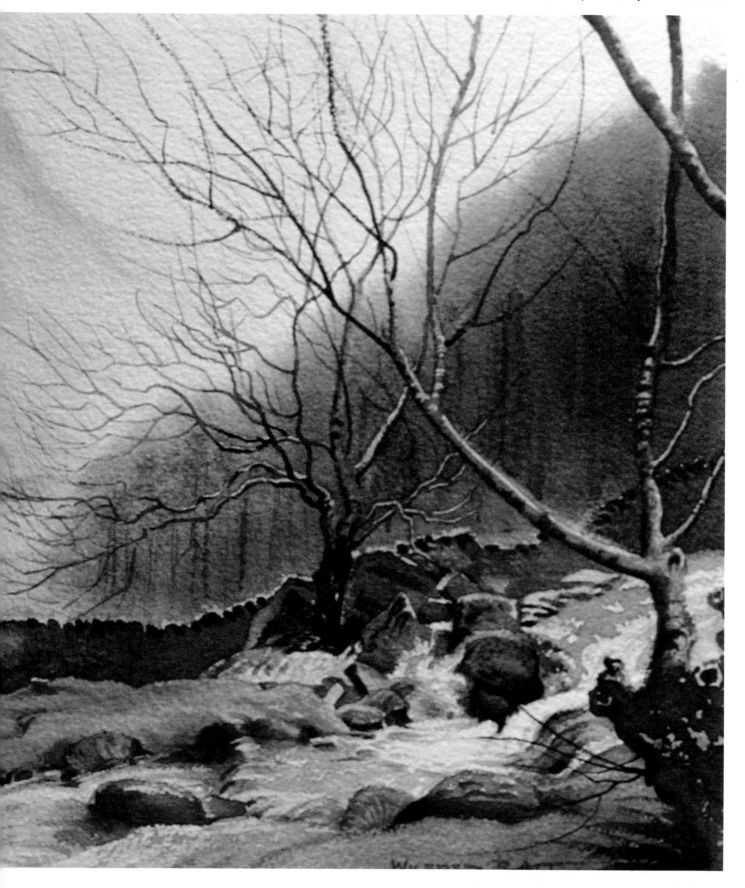

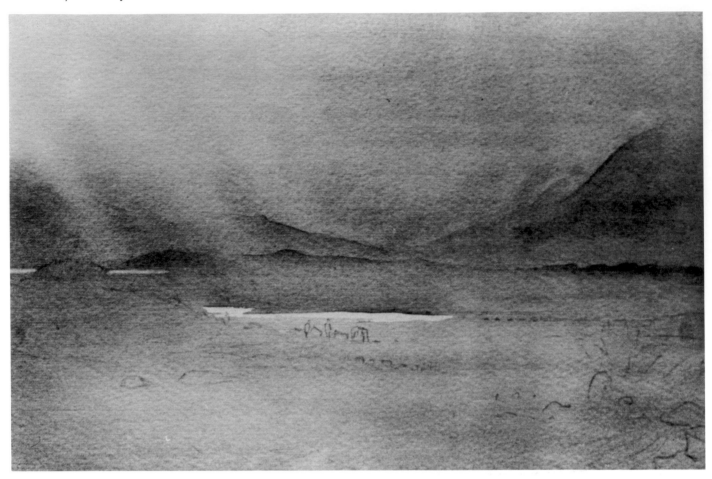

53 *Rannoch Moor (Stage 1)* (15 x 11in/380 x 280mm)

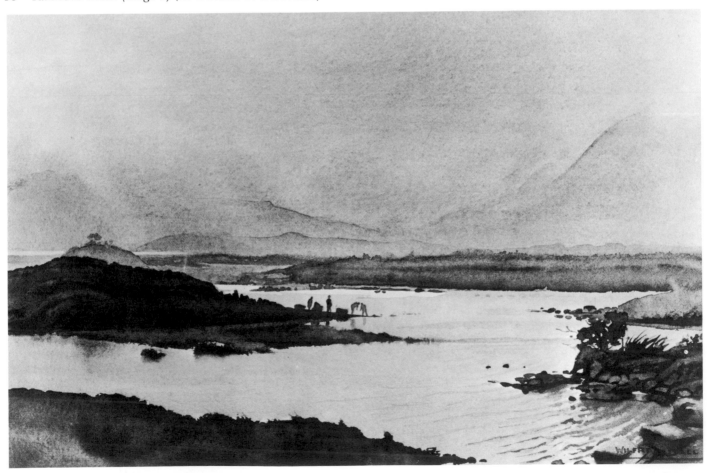

54 *Rannoch Moor (Stage 2)* (15 x 11in/380 x 280mm)

55 *Cairns on Burbage Moor* (15 x 11in/380 x 280mm)

Rannoch Moor (53, 54) shows the sun beginning to filter through the mist and on the waters of the lochan. It is in this misty mood that most people will remember the moor, so it creates a sense of place immediately. The sliver of silver gleaming out of the mist was produced by leaving that little area of paper dry when I wet the rest, as can be seen from Stage 1 (53). The more distant water, above and to the left, was taken out with a stiff brush after the paint had dried. In the second stage, the forms were painted onto fairly dry paper but edges were softened with clean water where it was necessary to retain the effects of mist (54).

Cairns on Burbage Moor (55) shows the trail markers on which fell walkers depend for navigation when they are travelling through hill fog. Here it is only evening mist in the hollows that affects the visibility, the crests of the slopes standing relatively clear above them. Clear water dropped into the wet background effectively created these mist-filled hollows below the heather-fringed path, although I often use a brushful of weak Cobalt Blue for this purpose in order to create a colder effect.

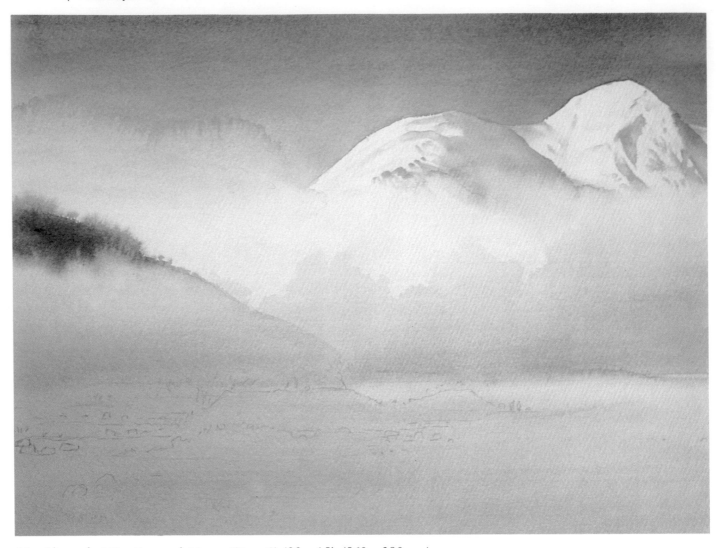

56 *Above the Mist, Rannoch Moor (Stage 1) (22 x 15in/560 x 380mm)*

Above the Mist, Rannoch Moor (56, 57) shows the marvellous transformation that took place a little later, when the sun had driven off some of the mist and the snow-capped peaks became visible above it. In Stage 1 (56) I wetted the whole of the paper, except the area of snow-capped mountains which was left dry. Yellow Ochre was added to this damp area, then blue-grey was touched in to modulate the background. A stronger greyish blue was painted into the sky, deeper on the right. A dry cloth was then used to dab off wet colour where the upper surface of the mist was lit by the sun. On the left, clear water was dropped into this

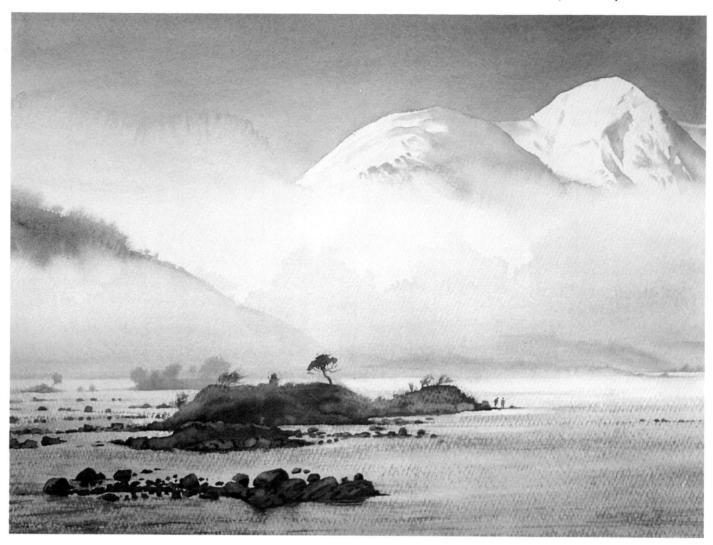

57 *Above the Mist, Rannoch Moor (Stage 2) (22 x 15in/560 x 380mm)*

upper layer of mist, to bleed into the colour of the
lower sky. This produced a suitably soft edge which
defined the top of the cloud satisfactorily. Before the
first stage was completely dry I touched pale Yellow
Ochre into the top edge of the water on the right to
create a relatively light accent on the mist-veiled water.
This stage was continued by putting the detail onto the
snowy summits, crisply to contrast with and emphasize
the misty softness of the rest of the painting. Finally a
strong grey, for the crest on the left, was allowed to
bleed into the mist. Stage 2 (57) was painted a little
drier in order to produce the detail more effectively.

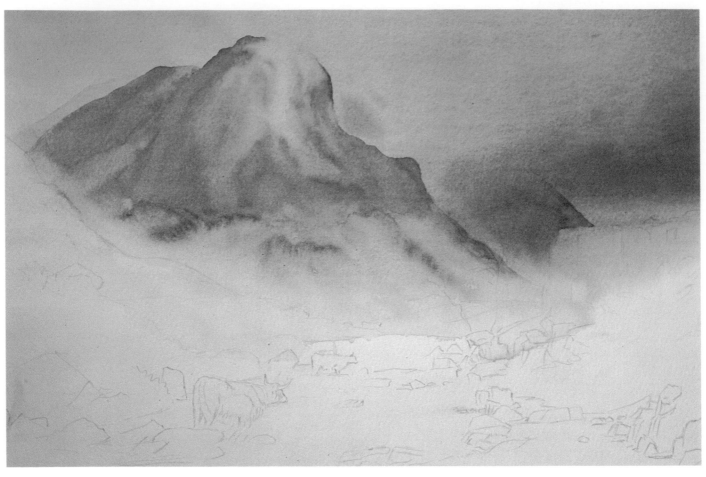

58 *Mist in Glencoe (Stage 1)* (22 x 15in/560 x 380mm)

Mountains

It is natural to follow mist and fog subjects with a series of mountain paintings, as the two overlap – literally. Any fell-walker knows how cloud clings to mountain tops. *Mist in Glencoe (58, 59, 60)* shows this, as well as the mist from the glen climbing up the lower slopes. The subject was painted in three parts. Firstly the background area was covered with water into which blue-grey was painted to represent the sky and the mist. Pale Yellow Ochre, Cobalt and Alizarin Crimson were then dropped into the top of this wash and the paper tilted to allow them to run down diagonally across the mountain. When this had dried I painted the mountain shapes with blue-grey, softening the edge in places and darkening it in others. Clear water was run into this at the bottom to create the effect of mist in the valley. Finally a brush loaded with clear water was touched into the damp top of the peak to create the tendrils of cloud snaking down over the crest.

The more distant part of the foreground was painted wet-in-wet, so that I could drop a little grey-blue mist into the hollows to create a unity with the lower reaches of the mist-filled glen. After that the rest was straightforward. A couple of highland cattle, knee-deep in the stream, were added for local colour.

Living in a lowland area, as I do, means that I have to travel to find mountains, and so I am drawn to the fells of Lakeland, to Wales or Scotland for such subject matter. The majesty of great peaks under clear skies can be breathtaking, but such clarity does not come within the scope of the wetter techniques. As you will have understood by now, it is important to choose the right subject matter if you are to get the best out of these methods. So the following paintings of mountains emphasize atmosphere, skies and the general impression that mountains make within the surrounding landscape. The more detailed structure of individual crags is not really a suitable subject for the wettest methods, much though I always enjoy painting such subjects.

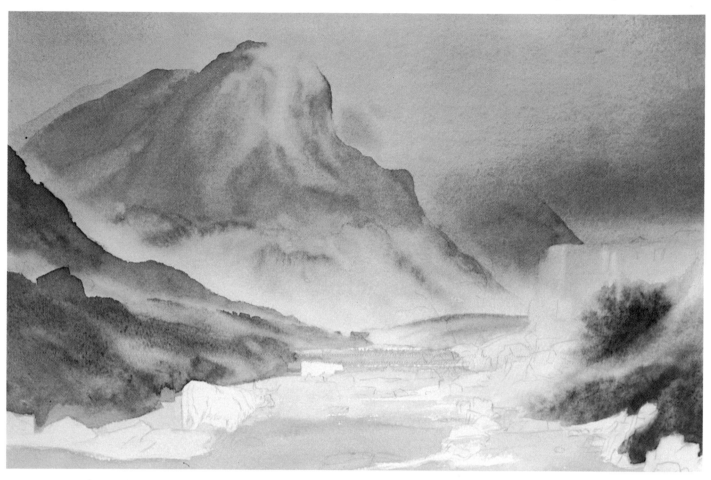

59 *Mist in Glencoe (Stage 2)* (22 x 15in/560 x 380mm)

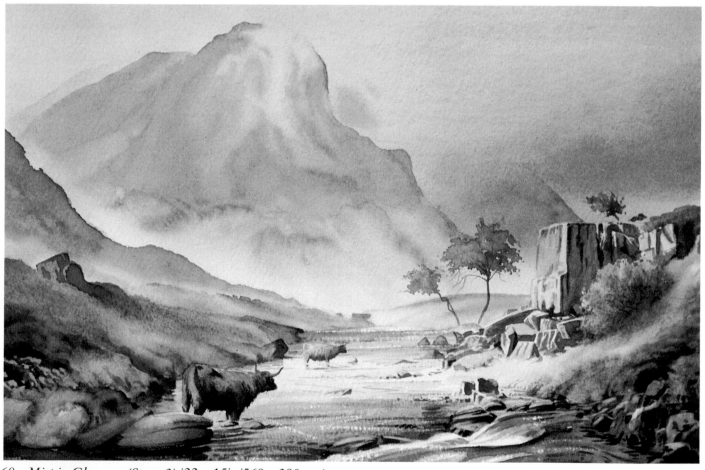

60 *Mist in Glencoe (Stage 3)* (22 x 15in/560 x 380mm)

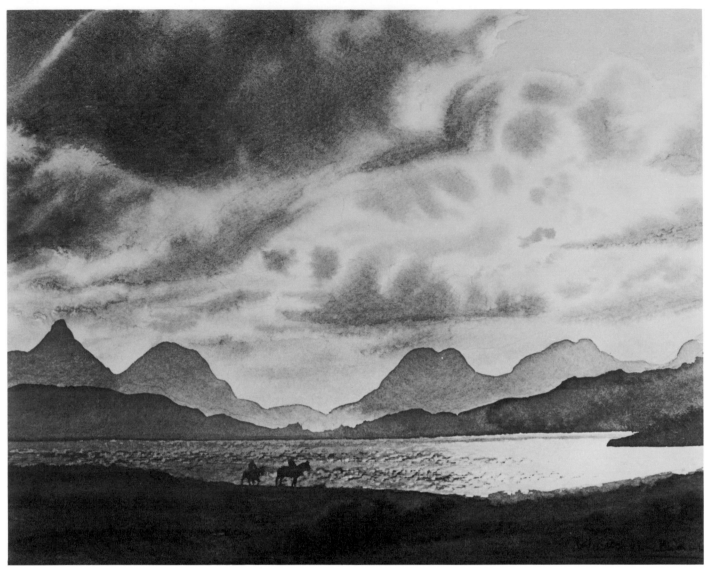

61 *Coigach from Inverpolly, Ross-shire* (15 x 11in/380 x 280mm)

Coigach from Inverpolly, Ross-shire (61) is typical of this lovely part of the Highlands. Although the peaks are overshadowed by heavy cloud, the sun overhead is silvering the loch in a dazzling blaze of light. *Achmelvich Bay, Ross-shire* (62) catches a similar effect of light, this time upon the sea. Glowing through the curtain of cloud, the sunlight sends long gleaming fingers of silver along the distant waters. Again, an accurate relationship between sky and landscape is essential to this kind of subject matter. Similarly, *Quinag from Inchnadamph* (63) is as much a painting of sky as it is one of landscape. I was interested in the way in which the enormous cumulus clouds dwarfed this great mountain. One is inclined to forget how tiny the land is in relation to the endless spaces represented by the sky.

Sparkling Sea: Canisp and Suilven from Achmelvich (108) is a larger painting of the lovely area around Lochinver. The famous peaks loom against the summer sky, heavy with cloud. Through it the sun glows on the sea and the heather-clad slopes above. Mountains are at their best in sunshine and shadow, one minute blue, the next minute golden, while the cloud patterns pass across the landscape in an infinite variety of lights and darks. It is another magical subject that would fully deserve a place in the next chapter about such rare subjects in landscape painting.

Mountains make marvellous backgrounds by enhancing whatever is in the foreground, as this last painting shows. I was further reminded of this last week when I spent three lovely late autumn days in Snowdonia. The colours of the foliage – birch, beech, chestnut and sycamore – were richer than I can ever remember. And what a bonus when such carnival colours were topped by the pure white of the sunlit snow on the peaks! My eyes were positively gorged with visual sensations that I longed to paint, and soon did. *Cnicht from Croesor, Snowdonia* (64) is one of the results. There was just enough snow on the 'Welsh Matterhorn' to add emphasis to the rich autumnal colours of the foreground.

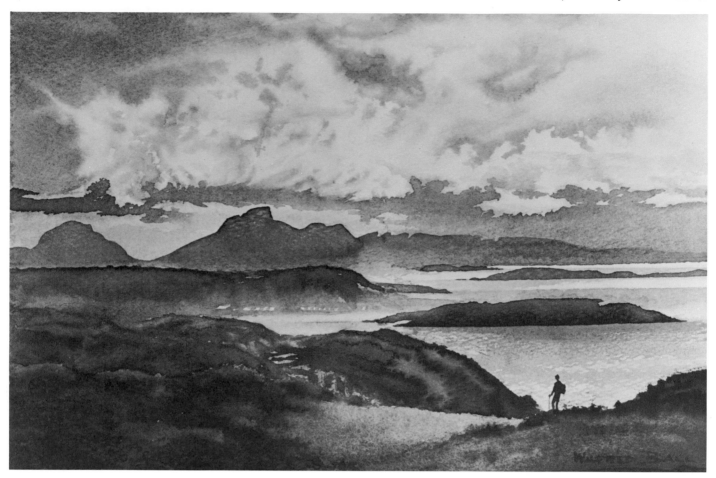

62 *Achmelvich Bay, Ross-shire* (25 x 11in/380 x 280mm)

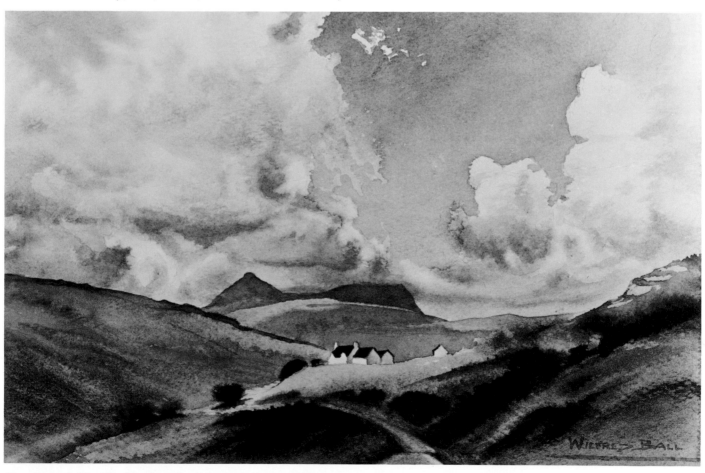

63 *Quinag from Inchnadamph* (15 x 11in/380 x 280mm)

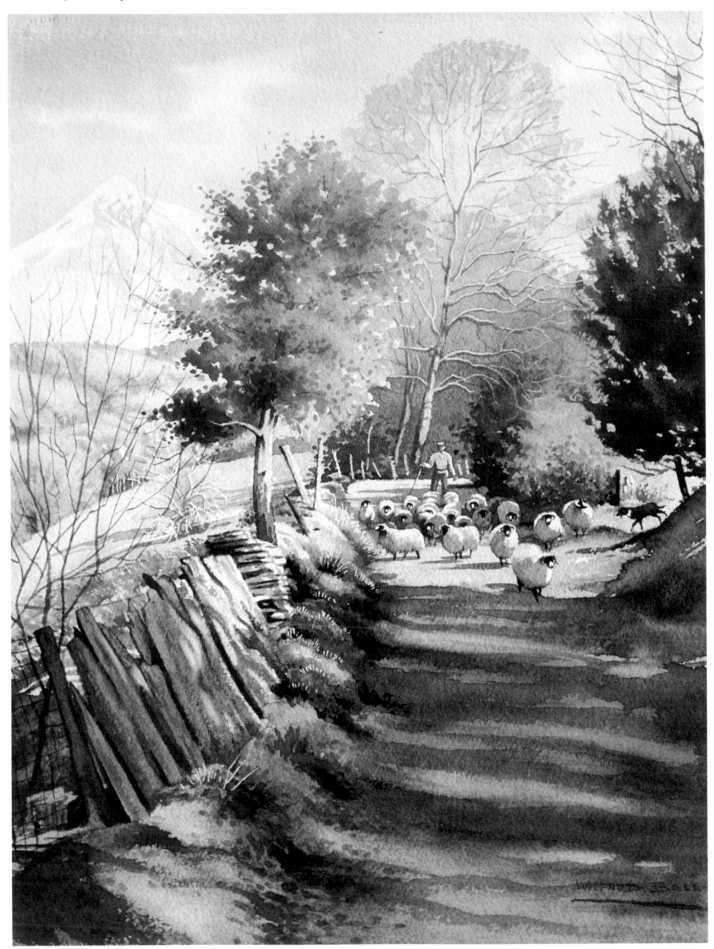

64 *Cnicht from Croesor, Snowdonia*
(15 x 22in/380 x 560mm)

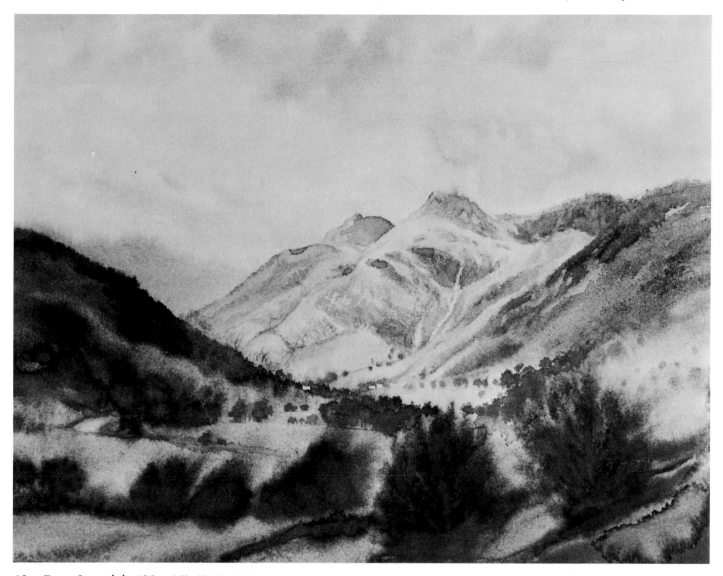

65 *Great Langdale* (22 x 15in/560 x 380mm)

Open landscapes

I find panoramic views of the landscape particularly suited to a wet approach. It is conspicuously successful in creating a unifying atmosphere over any area so wide that the detail is dwarfed by its size. With such a subject the overall impression is obviously paramount. *Great Langdale* (65) is a typical example. As it was a half-Imperial sized painting I found it impossible to complete it before many parts of the surface had dried out. However, this is not critical, as it is extremely easy to re-wet all or part of the subject. It can be plunged into a bath if it is felt necessary to wet it all, or individual parts can be lightly sponged to facilitate further work on them.

In this case, I had managed to complete the painting in one stage of wet-in-wet treatment, with the exception of the central area. This I had left till last deliberately as it was to be the focus of the composition, the Langdale Pikes themselves. A little final selective dampening enabled me to touch in the necessary detail to explain the form of the crags.

Good strong paper is essential for this technique, as poor paper tends to be absorbent and therefore dries very quickly. The more efficient surface glaze of good-quality paper ensures that it remains wet for quite a long time and in the case of anything smaller than a half Imperial sheet only one wetting should prove necessary. Incidentally, *Great Langdale* demonstrates one of the pitfalls of wet-in-wet painting, which is the difficulty of producing strong tones on a wet background. I had somewhat underestimated the strength of mixture used for the foreground trees, in spite of my having used the technique so frequently. However, I decided not to alter them so that the fault could be noted and learned from.

Evening Mist, Hathersage (105) is another half-Imperial painting that was painted almost entirely wet-in-wet. Only a few details of the farm buildings, such as chimney stacks, were left until the paper was virtually dry. It can clearly be seen, however, that wet painting demands an extraordinary amount of skill and judgment to avoid losing control. On dry paper the paint stays put and you can produce precisely calculated shapes and effects. But on wet or damp paper the amount of moisture on the paper and the amount on the brush are both critical if you are to achieve the effects you seek.

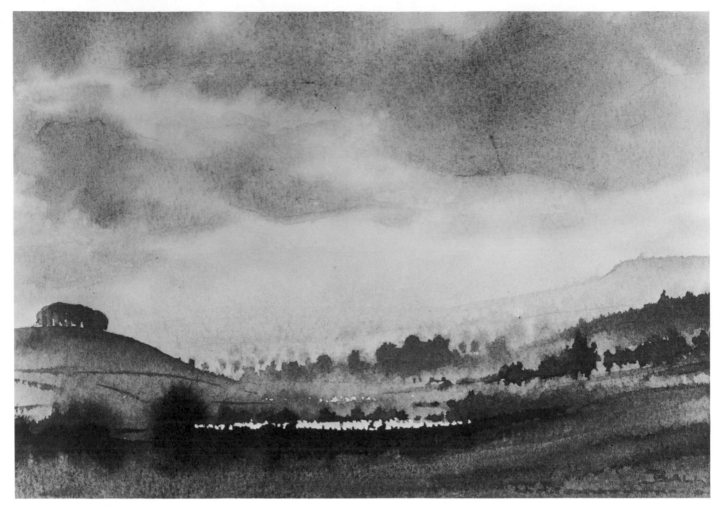

66 *Langstrothdale, Sunshine after Rain* (11 x 7½in/280 x 190mm)

It is much easier to complete a wet-in-wet painting in one sitting – or one wetting – if you use paper sizes of quarter Imperial or less. The sheer physical task of covering such an area is obviously much quicker, and speed is essential. Before starting, you must know exactly what you plan to do, for there is no time to sit back and think about an unexpected problem half way through. By the time you've decided what to do the paper will probably be too dry to do it. For this important reason the following examples were painted on quarter Imperial paper (15x11in [380x280mm]). Indeed, the first two, *Langstrothdale, Sunshine after Rain* (66) and *Wensleydale* (67) are only half that size. All are essentially paintings of skies and weather, which allowed for very simple treatment of the landscape. As I have mentioned earlier this is the subject area to which the technique is most suited and where, with a bit of luck, the medium will fully demonstrate its magic. The compositions are all open, airy and with little precise detail except for the final one, which is a little clearer and sunnier.

The small painting of Langstrothdale has caught very well the effect of the sun glowing yellow on the mist rising from the rain-soaked dale. Using such a small format enabled me to calculate with a degree of comfort when to add the dark accents to the drying foreground. In the other painting, of a break in the cloud over Wensleydale, I used pink instead of yellow

for the blush of warmth in the sky above Addlebrough. Here the strong, overshadowed foreground was used to emphasize the watery light on the far shapes of the dale. I painted them both in little more than an hour, after a single wetting, and felt completely in control, which I rarely do when I tackle a half-Imperial painting by the fully wet technique. The first was completed well before the paper had dried completely, and in the case of the second one I only painted the skyline and the dark roof of the farm after the rest had dried.

Although the rest of the paintings in this section are on paper twice the size of these last two, it is still a format which allows for the successful completion of an entirely wet-technique painting. Only the last one has any significant amount of detail, put in after the paper had virtually dried.

Wet Morning at Oughtershaw, Langstrothdale (68) captures the golden glow of the sun through misty cloud. The rain clouds were dropped into the top of the wet sky and then the paper was tilted to suggest the rain slanting down over this tiny hamlet in a remote part of Yorkshire. I ignored the buildings until the rest was completed, then I removed paint from the wet roofs with a damp, stiff-bristled brush. After the paper had dried I put in the darks on the chimney stacks and the shadowed walls of the cottages and barns.

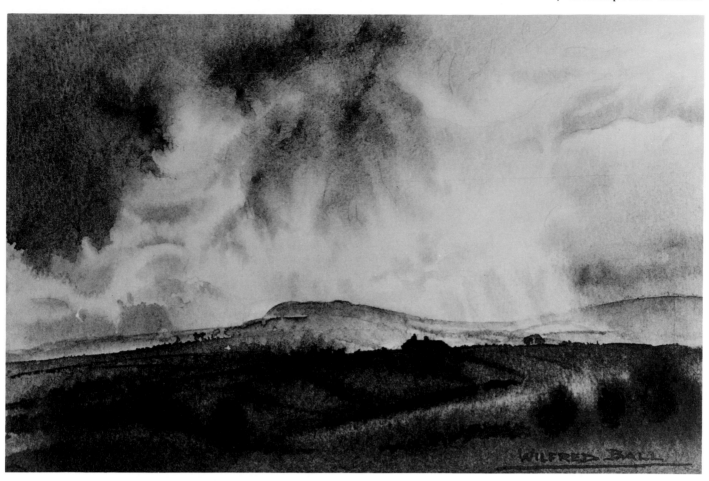

67 *Wensleydale* (11 x 7½in/280 x 190mm)

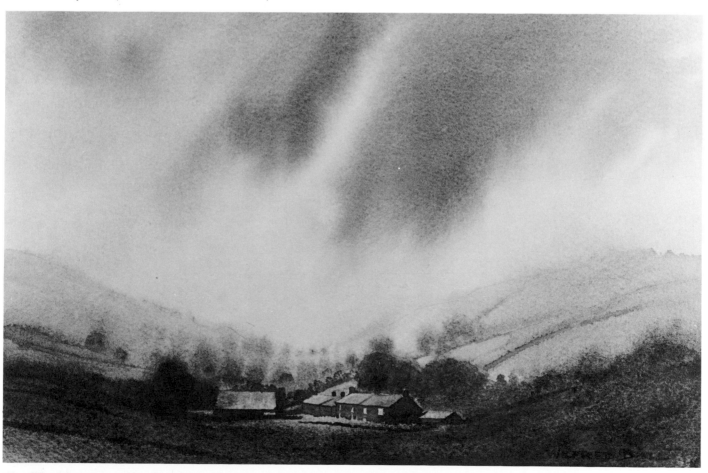

68 *Wet Morning at Oughtershaw, Langstrothdale* (15 x 11in/380 x 280mm)

The next two paintings are further examples of the essential relationships between the sky and the pattern of light and shade on the landscape which I mentioned earlier. In *Bishopdale from Wensleydale* (69) the great clouds have opened to light up the distant dale, while the rest of the hills remain in shadow. I ignored the faint rays of light filtering through until the painting had dried, then I fetched them out with a few strokes of a damp, stiff brush. *Swaledale from the Buttertubs Pass (70)* illustrates a similar phenomenon. Here the light is coming through the cloud in several places so that the far-shadowed slopes are dotted with jewel-like patches of sunny green beyond the dark moorland.

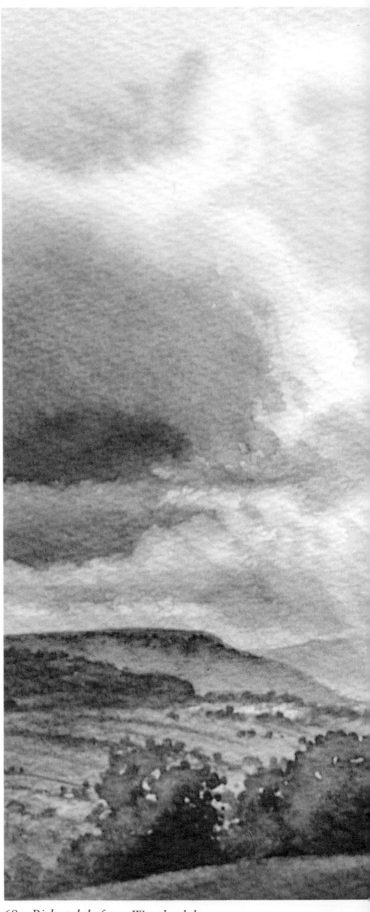

69 *Bishopdale from Wensleydale*
(15 x 11in/380 x 280mm)

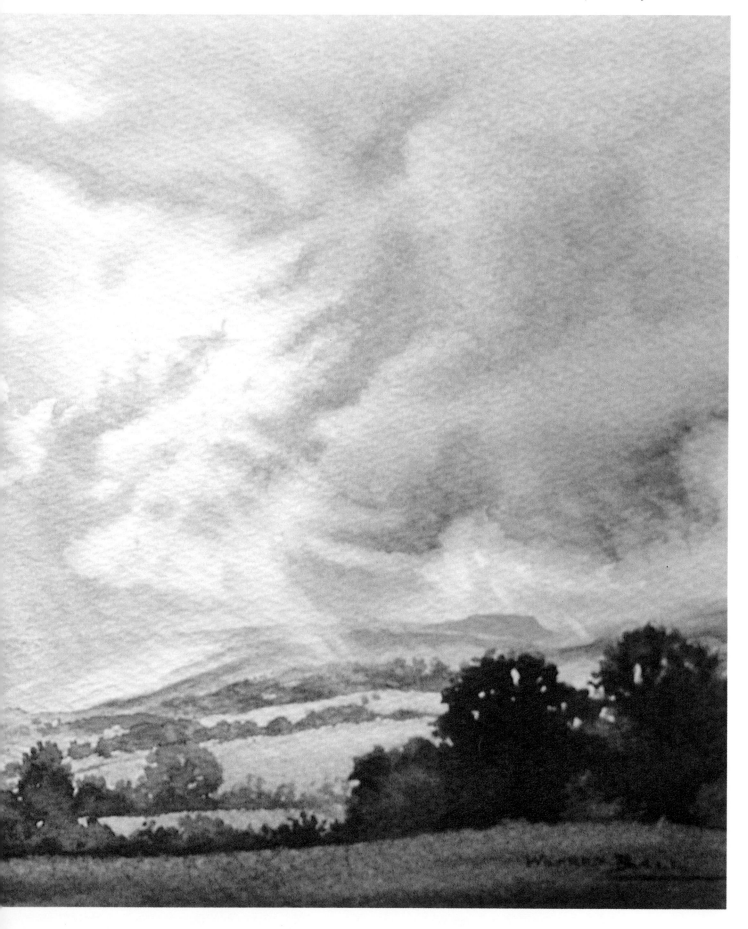

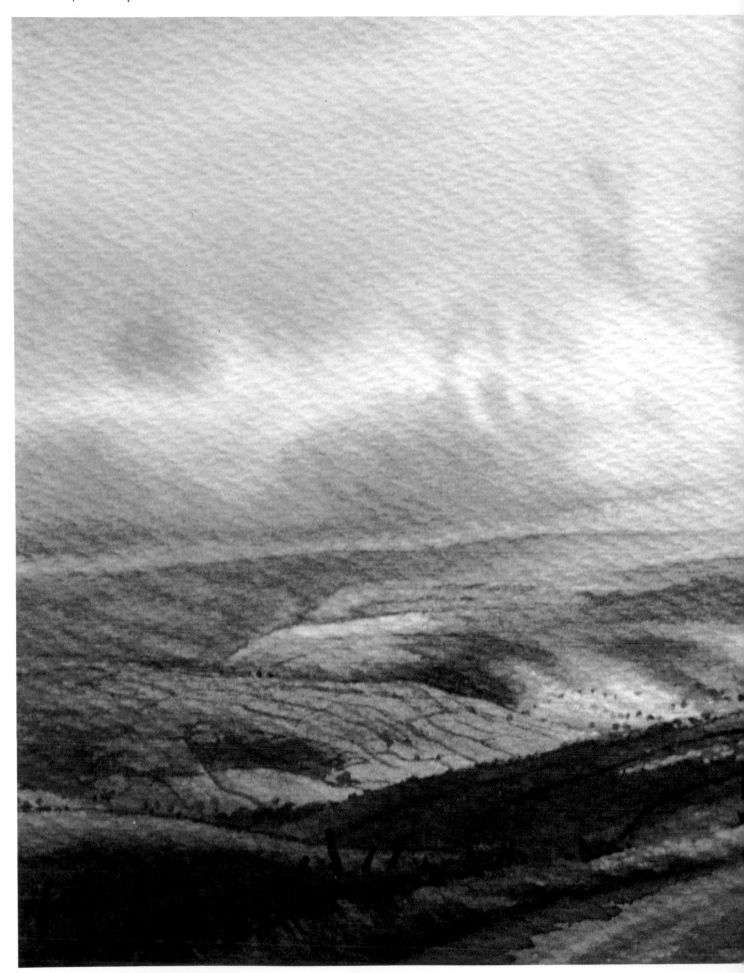

70 *Swaledale from the Buttertubs Pass* (15 x 11in/380 x 280mm)

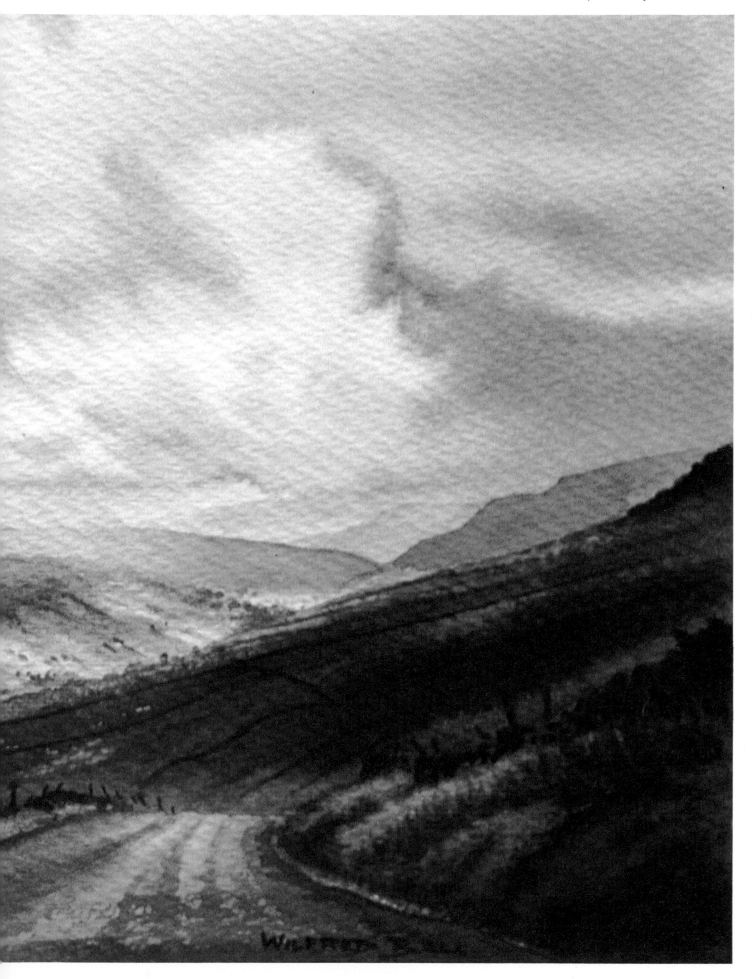

You may have observed that the paintings in this series have become progressively more sunlit. *Addlebrough, Wensleydale* (71) goes a step further and shows the fields completely sunlit before a backdrop of rain cloud that had been drenching the dale a few minutes earlier. Just before the sky had dried I added a strong mixture to the bottom of the heavy cloud on the right, thus achieving the ragged edge I was aiming for. The whole of the foreground except the blue-grey road was washed over with pale yellow-green to create the sunny effect required to contrast with the sky. Shadowy tones were put in while this was damp, including the heavy shadow on Addlebrough and the skyline on the right. Finally the barns were painted so as to stand boldly against the sunlit fields, while the pattern of walls emphasized the same effect. But note how obviously these last few paintings are skyscapes as much as landscapes.

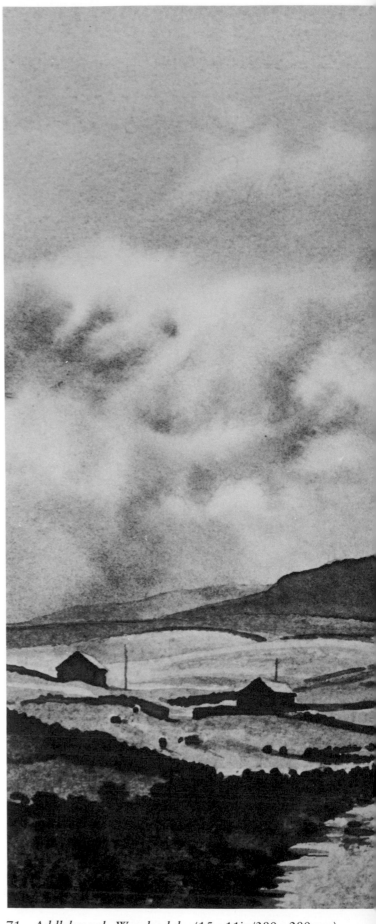

71 *Addlebrough, Wensleydale* (15 x 11in/380 x 280mm)

72 *Snow below Suilven* (Stage 1) (22 x 15in/560 x 380mm)

Snow

There are few sights to beat sunshine on virgin snow, with crisp shadows emphasizing folds in the ground, and trees and fences making bold patterns against it. I love painting snow scenes of this type, but crispness and clarity are not characteristics of the wet technique. However, with a little preliminary planning, a major part of most subjects can be tackled by this method. To demonstrate this I chose a sunny scene below Suilven in the Western Highlands. It is essentially a painting of a snow-clad river bank with the famous mountain in the background. Making full use of low-lying mist in the background, it was possible to treat the majority of the picture space while wet.

Snow below Suilven (72, 73, 74) was begun by applying masking medium to the sunny edges of snow on the two trees, then wetting the whole paper before tinting in the sky with Cobalt Blue and Yellow Ochre, allowing this mixture to come down over the mountain and into the warmer misty distance. The light area on the flanks of Suilven was produced by dabbing off the pigment with a forefinger wrapped in a clean rag. When this stage was dry the shadows and other faint modelling were used to clarify the form of the mountain.

When wetting the paper I had carefully painted water around the upper edges of the curves of the snow-covered banks and the tops of the stones in the water, leaving them dry. This allowed me to apply the cool blue-grey for the shadows on the snow in the foreground without losing the crisp edges so important in portraying sunlit snow. I carried this shadow over the whole of the water, to be used later as the lightest tones in the dark stream, representing the reflections of the sunlit snow above.

This first stage had been completed on wet paper. The second stage encompasses all the central detail and was carried out by dampening individual areas, before adding the stronger tones, on the dark slopes to the right, on the shadowed snow on the trees and on the river bank. A much stronger cool grey was used in the final stage for the darks in the water, which were also painted onto a damp background. Only the tree trunks and branches, together with the darkest accents on the banks, were painted onto the paper after it had dried. Thus I was able to keep the shadows on the foreground snow soft-edged, while at the same time creating crisp edges for the brilliantly-lit snow on top of the banks. This suggests the essential softness of snow and the clarity of the sunlight at one and the same time.

73 *Snow below Suilven* (Stage 2) (22 x 15in/560 x 380mm)

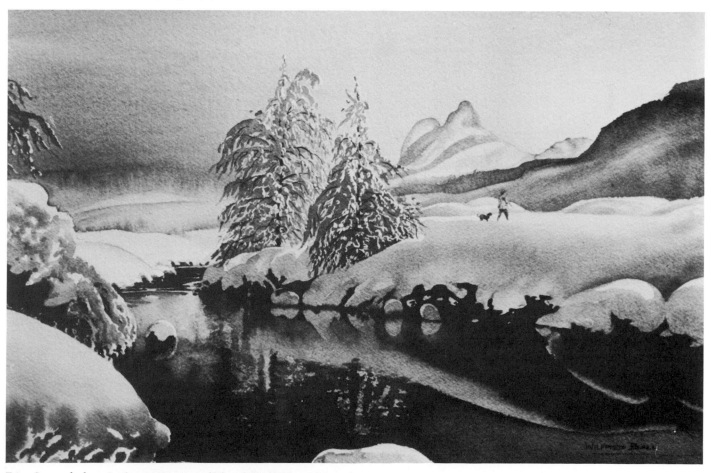

74 *Snow below Suilven* (Stage 3) (22 x 15in/560 x 380mm)

75 Sudden Snowstorm At Lingcove Bridge, Upper Eskdale (Stage 1) (22 x 15in/560 x 380mm)

Obviously the wet technique is more suited to the blurring effects of snow flurries, such as was demonstrated in *Snow over Moel Hebog, Snowdonia* (24) in Chapter 4. *Sudden Snowstorm at Lingcove Bridge, Upper Eskdale (75, 76, 77)* is an even more dramatic use of coarse salt to produce the effect of snowflakes. Like the Welsh painting I was compelled to treat successive areas separately to keep control of the forms, but I began by wetting the whole surface before painting in the sky, the background slopes, the river and its snow-covered banks with blue-grey mixtures and a little pale Yellow Ochre. I added a strong reddish-grey to the upper right corner to simulate the kind of ominously heavy sky that so often threatens snow. Apart from that, it is necessary to use fairly dark background areas so that the snowflakes can be discernible against them. Onto this wet, vaguely-modelled background I sprinkled salt, slanting across the paper vigorously from right to left to give the effect of strongly driven snow.

For the second stage I dampened the central area and used stronger greys to paint in the stone footbridge so

famous among the walking fraternity of the Lake District. More salt was sprinkled onto this area while it was still wet, to blur the shape. It was then necessary to re-wet small areas so that I could paint the shepherd and the sheep as recognizable shapes, even though with soft edges. Again, salt was sprinkled over these shapes while they were still wet enough to react to it. The subject was completed by adding dark accents where necessary, being careful not to interfere with the vague forms of the snowflakes produced by the salt crystals. For example, the crevices between the stones of the bridge were suggested by a few dark marks between the snowflakes.

While the magical effects are produced by the action of the salt, you will realize that the careful selection of colours and tones on which the salt will work is the key to the success of such subjects. In all paintings the final balance of tone and form in a planned composition will always be the means to a successful outcome, however expressive the methods used may be. This painting is a good example of this balance.

76 *Sudden Snowstorm At Lingcove Bridge, Upper Eskdale (Stage 2) (22 x 15in/560 x 380mm)*

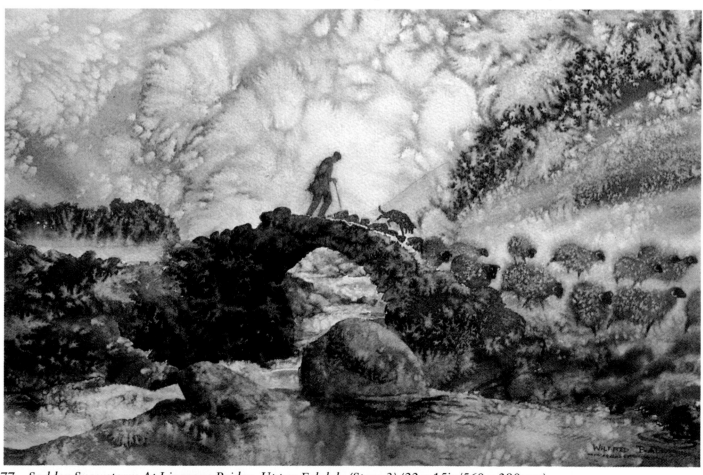

77 *Sudden Snowstorm At Lingcove Bridge, Upper Eskdale (Stage 3) (22 x 15in/560 x 380mm)*

Woodland

The last part of this chapter has dealt with a good many examples of wintry weather and similar subjects demanding a fairly sombre treatment. You might be forgiven for coming to the conclusion that wet techniques are only effective in such subject areas, but this is not so. While the clarity of colour and form of a sunny day in a hot, dry country might not be suitable, there is plenty of scope in sunny subjects in more temperate climates, whose watery, variable sunlight contributes to this. Of course, one cannot produce hard-edged shapes like buildings by wet methods, but it is possible to paint virtually the whole of simple architectural subjects by these methods, adding the few edges needed at the end when it is dry, or nearly so.

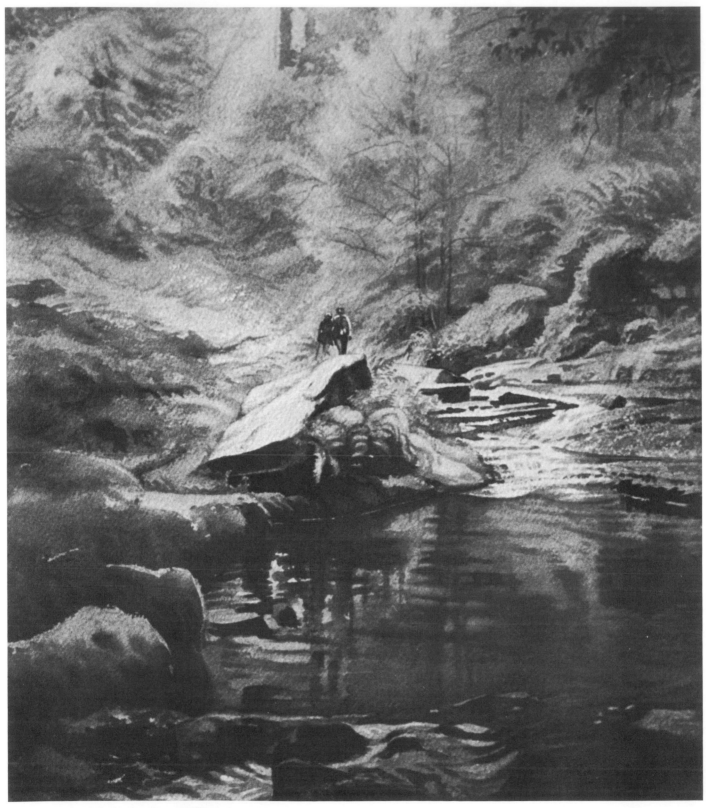

78 *October Afternoon, Goyt Valley* (15 x 22in/380 x 560mm)

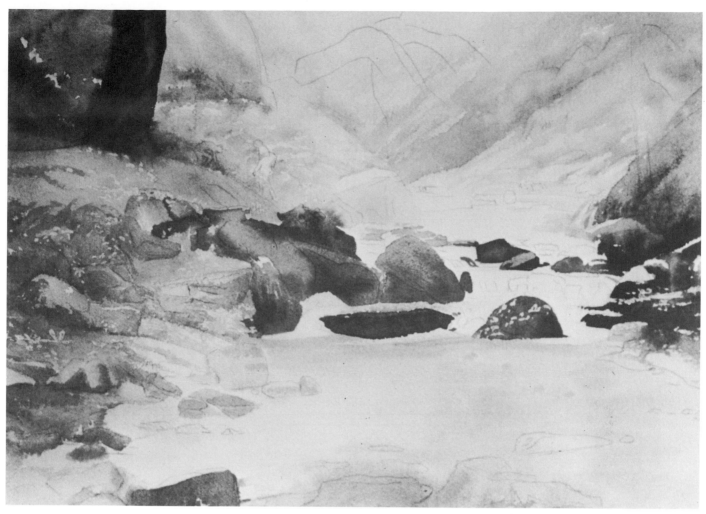

79 *Looking for Conkers, Goyt Valley (Stage 1) (22 x 15in/560 x 380mm)*

Most landscape forms (trees being a good example) can be represented perfectly well wet-in-wet, and being sunlit does not significantly affect this in most circumstances. Woodland subjects are particularly suitable to demonstrate this, as can be seen from the two paintings that follow (*78, 81*). Both show trees in bright sunlight and, as they are autumn scenes, they are very colourful indeed. *October Afternoon, Goyt Valley* (*78*) is of a woodland glade through which the stream runs between grassy banks bedecked with rust-coloured bracken. Its upright format makes it easy to understand why so many artists and poets have described the woodland glade as a natural cathedral.

Looking for Conkers, Goyt Valley (*79, 80, 81*) shows the same stream a few yards further on, this time flowing beneath a large horse-chestnut tree whose fallen leaves had formed a warm, golden carpet on the banks below. The sunny, bright hues were easy to deal with wetly in the background, and the deep pool in the foreground. Naturally the boulders and the tree trunk required a more precise treatment.

To begin with I held the paper under the tap, waited a little for the excess moisture to drain off as I held the sheet vertically, then applied the basic background colours. Only the distant stretch of the stream, glistening in full sunlight, was left untouched so that it could be dealt with later. By the time the rest of the

surface was tinted all over I found that it had almost dried in some parts, so it was a suitable time to put in some of the more precise shapes like the large stones and the tree trunk. As I have said previously, it is very difficult indeed to complete a half-Imperial picture with one wetting, so another was necessary.

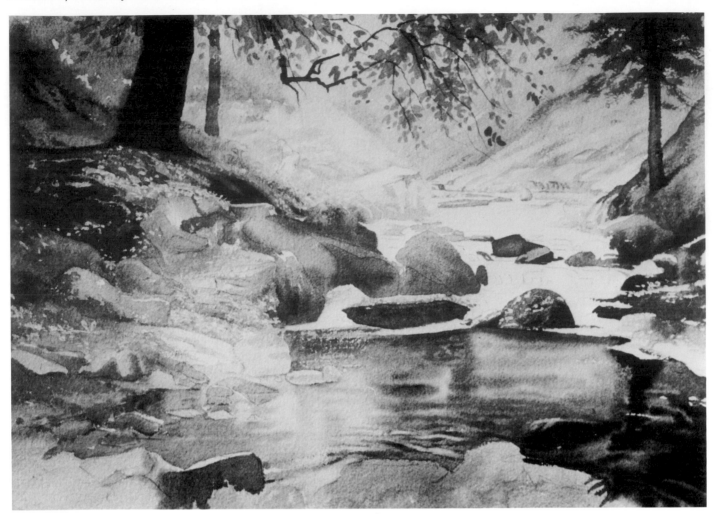

80 *Looking for Conkers, Goyt Valley (Stage 2)* (22 x 15in/560 x 380mm)

In Stage 2 (*80*) I concentrated on the distance and the
large pool in the foreground, dampening each in turn
with a moist sponge. These were the main areas left
which were suited to a continuing wet treatment. In
order to keep the distant stream and its sunlit banks as
high-key as possible I was careful to use only pale tints
and as little detail as possible, to create the effect of a
real blaze of light there. Finally I painted in the backlit
foliage of the horse-chestnut and the interestingly-
shaped dark branch which made a striking accent
against the blaze of light.

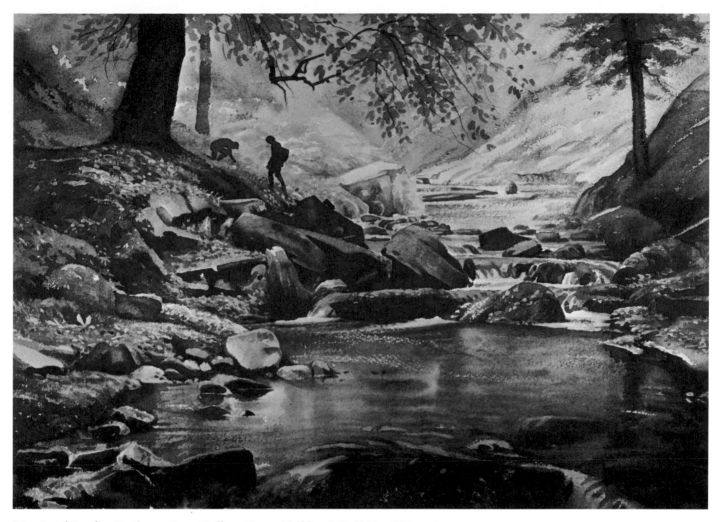

81 *Looking for Conkers, Goyt Valley* (Stage 3) (22 x 15in/560 x 380mm)

I began Stage 3 (*81*) by putting in the figures of the two boys, thus completing the focal area of the painting. Only the stream and its array of boulders remained. These were completed with a combination of wet and dry techniques. Two-thirds of this bright, lively painting had been carried out wet-in-wet, and although the nature of the subject demanded a good deal of detail in the final stage, it was the wet areas that set the essential mood.

It is clear from the many demonstrations in this chapter how versatile wet methods are, particularly for backgrounds. Even when the subject is as detailed and bright as the last, it is perhaps surprising to see how great a proportion of the procedures is wet-in-wet. I believe the contrast between forms produced on a wet background and those painted on dry is one of the major contributions to artistic tension in any watercolour. A very good example of this is *Autumn in Aberglaslyn* (*82*). A detailed composition of rocks, trees and broken water, brilliantly lit in places and in dense shadow in others, it had most of its basic colour areas treated wet-in-wet. Its main appeal for me was that colourful phenomenon when water is in cool shadow which greatly emphasizes, by contrast, the rich reflections of the gold and flame foliage from above. Engulfed in blue, the mirrored glow is breathtaking.

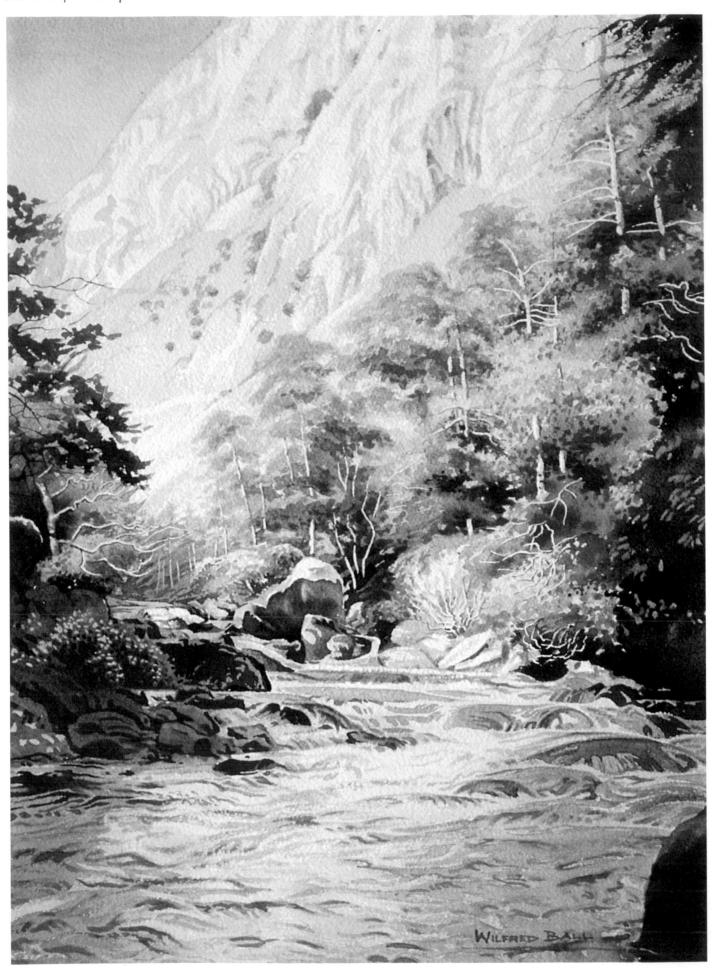

82 *Autumn in Aberglaslyn* (15 x 20in/380 x 510mm)

6
Mood, Mystery and Magic

The significant appeal of wet watercolour in my opinion is that it encourages the viewer to participate. By leaving a certain amount to the imagination the technique involves the spectator far more than any precise, hard-edged painting can. *Trompe-l'oeil*, photo-realism methods can display a remarkable skill in depicting what one sees, but they are unlikely to encourage imagination or stimulate the emotions as Turner's masterpieces did, and still do. The evocative quality of wet watercolour is what sets it above all other techniques in its universal appeal.

What the onlooker is called upon to imagine and add to the meaning of a painting, because of suggestions and implications born of the vaguely evocative shapes, makes all the difference. It allows each viewer to see something different and thus to participate in what becomes a mutual activity.

The involvement of the onlooker's imagination stretches past the bounds of painting and can be seen effectively in works of literature and in films. Most of us have probably been terrified by some expertly-written horror story, which induced fear through hinted-at terrors and imaginary gruesome happenings. As readers we were also participants, and the effect of the tale was influenced by our individual personalities. Compare this with the impact of a bloodbath horror film of the same story. When every detail has been portrayed, and every ghastly potential fulfilled, we cannot participate but can only accept a complete experience (which doubtless reflects the film director's *own* fears!). So wet watercolour, with its lack of precision, presents every possibility for such personal involvement and communication. It is at its best when tackling subjects related to the weather and to poetic areas of experience, full of mist and mystery.

Moisture makes magic

Painting on wet or damp paper is what creates the significant mood and atmosphere in any watercolour painting. Carefully controlled tone values, accurate colours, good drawing – all these qualities are important but, put together, what they add up to is verity. The thing looks real. But art is more than reality – it is reality plus. To produce art, reality must be moulded by imagination, mixed with magic, heightened by mysterious means. It is my belief that the wet watercolour technique, by its fluidity, its excitement and unexpectedness, its poetic softnesses and evocations, is the magic ingredient which does most to create mood and atmosphere. Moisture makes the magic, in other words, where watercolour is concerned.

The paintings reproduced in this chapter attempt to illustrate these qualities of mood, atmosphere, magic and mystery. These are terms which are widely used in the arts, often quite vaguely, even inaccurately. I have considered it worthwhile defining these terms, so that their precise relevance is appreciated; and these definitions appear as headings to two small groups of paintings which illustrate these qualities. The dictionary definitions of mood and atmosphere bear obvious resemblances, as do those for magic and mystery. I propose, therefore, to link the paintings accordingly.

I photograph all my paintings on colour transparencies, in case they may be suitable for publication at some later date. This habit was proved enormously valuable because, as they are exhibited and usually sold, I would not have any record of my best work. To produce the examples in this chapter I have been able to select from a range of past work as well as painting one or two specially for the book.

Mood and atmosphere

Mood: A prevailing atmosphere or feeling
Atmosphere: A general pervasive feeling; the prevailing tone or mood of a painting.

Early Morning, Buttermere (49) catches very well a mood of calm tranquillity which is characteristic of this time of day. The colour scheme of creamy light over a range of bluish and warm greys contributes considerably to this.

Misty evening, Thulston (101) also catches a mood, that of a warm evening after a hot, hazy day in July. While poppies glow in this corner of a field of ripening barley, the haze still persists among the trees in the distance. On the right the elderflowers are beginning to ripen and signs of the fruit stand high against the

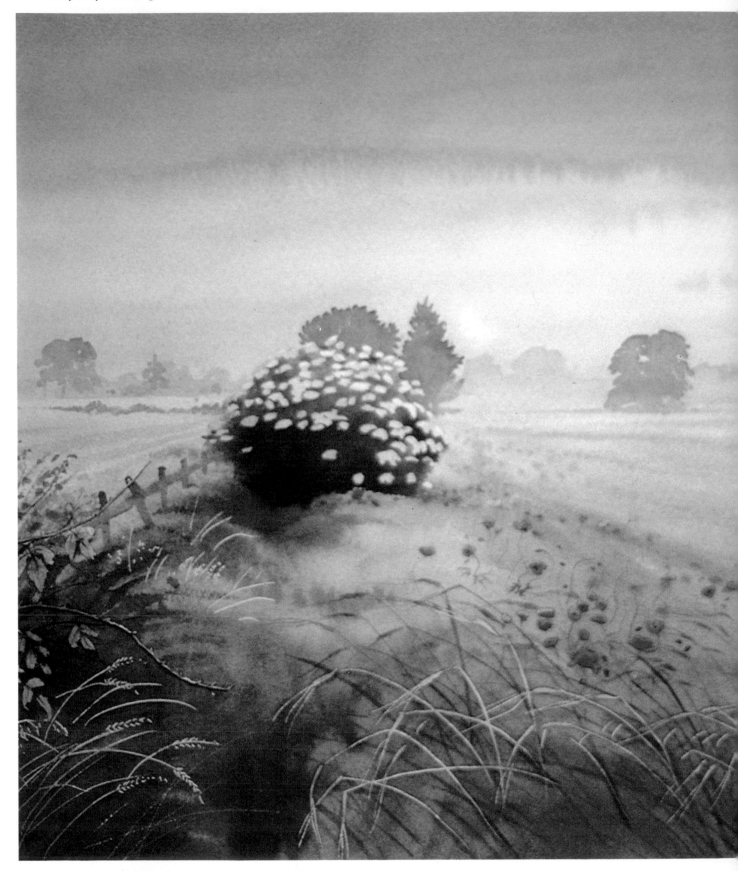

83 *Poppies, Early Morning* (22 x 15in/560 x 380mm)

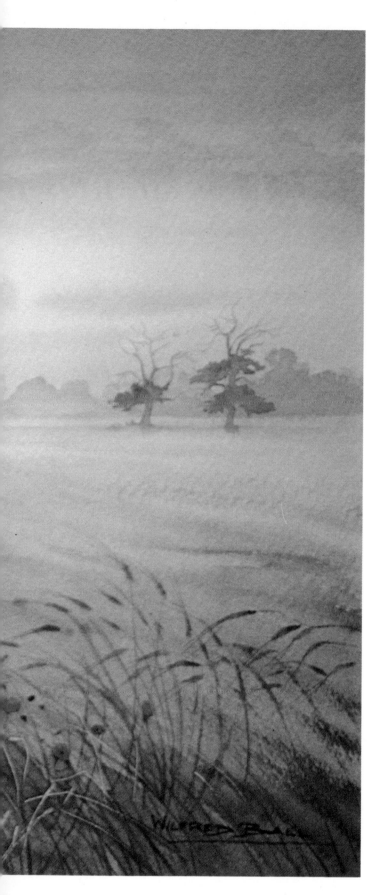

glowing sky. The rich foreground colours against the misty distance enhance the sense of a warm, languid, happy summer evening. Its mood is one of warmth and wellbeing, even nostalgia.

Poppies, Early Morning (83), on the other hand, is cool in colour and yet the same summer mist is evident in it. The unripened green barley complements the scarlet poppies under a blue-grey sky, only slightly warmer just above the misted horizon. After the elderflower, poppies and foreground swathes of barley had been put in with masking medium, the whole of the sky, the mist and the barley was painted wet-in-wet, as·were the most distant, hazy trees. There was surprisingly little detail left to paint after this first stage had dried. The air of tranquillity is owed not least to the wide open horizontality of the composition.

Again, the atmosphere is calm and peaceful, with a sense of quiet expectation of what a fine new day will bring: the crops yellowing, great petals falling from heavy-headed poppies drooping in the warmth of the afternoon; perhaps a sparrow falls. It evokes such thoughts as these – hopeful yet vulnerable.

Monsal Dale from Monsal Head (84) is a painting of an Indian summer's day in Derbyshire. The painting is made most effective by the heat haze that shrouds the far reaches of the dale. Highlights on the soft clouds were lifted from the damp surface of the September sky by my finger wrapped in an old handkerchief. The unexpected warmth, postponing the onset of winter, lifts the spirits and creates an atmosphere as warming as the weather.

I hope these examples justify my conclusions about mood and atmosphere in painting. It is the atmosphere that creates atmosphere. The dust and moisture in the belt of air immediately above the earth's surface determines the appearance of the landscape. Heat haze, mist and drifting rain will produce their emotive effects; clear sunlight will not. Clarity of form and colour will provide you with a precise reality. This clarity and precision are foreign to that atmospheric and Romantic art which is the basis of English landscape painting, particularly in watercolour. We are moved not by precision, but by memories, suggestions, imagination, subtleties, the marvellous possibilities that our past experience can interpret from the vague forms and relationships perceived by our internal as well as our external vision. If we are sure of it, it will not move us. What a painting means is not half as intriguing as what it *could* mean.

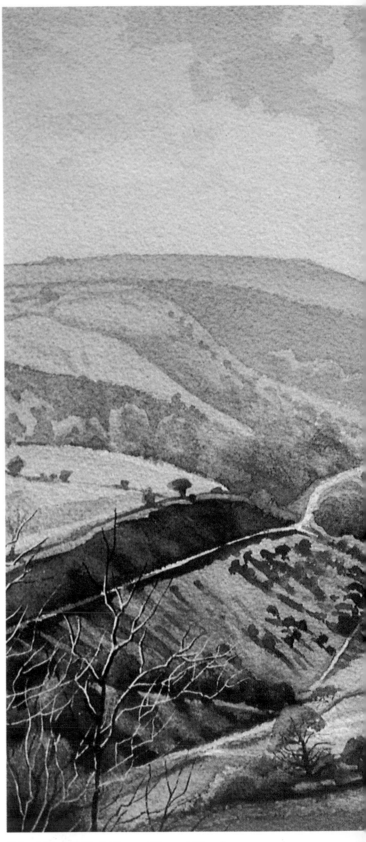

84　*Monsal Dale From Monsal Head*
(22 x 15in/560 x 380mm)

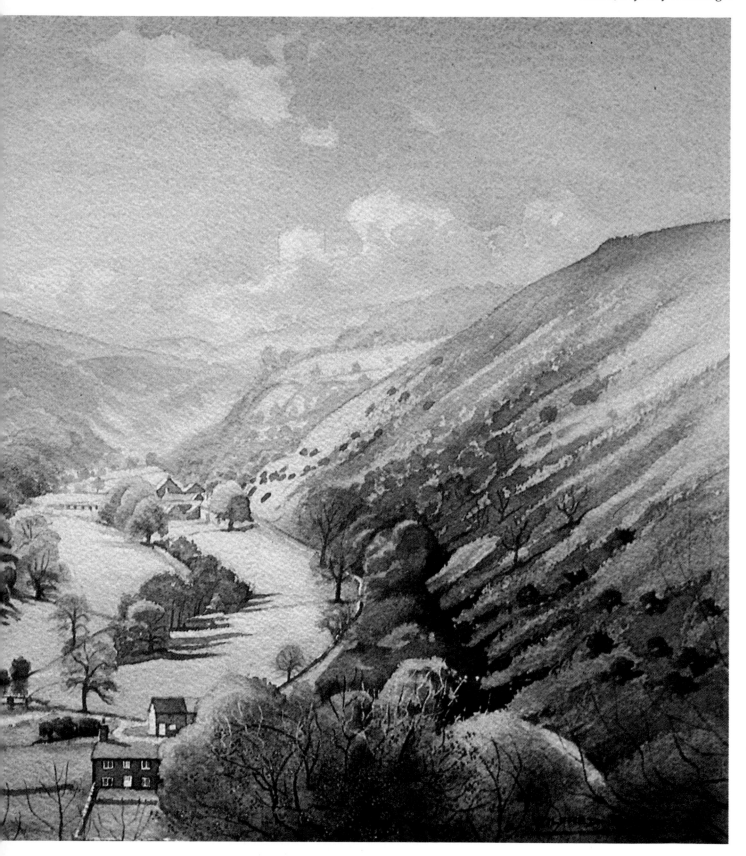

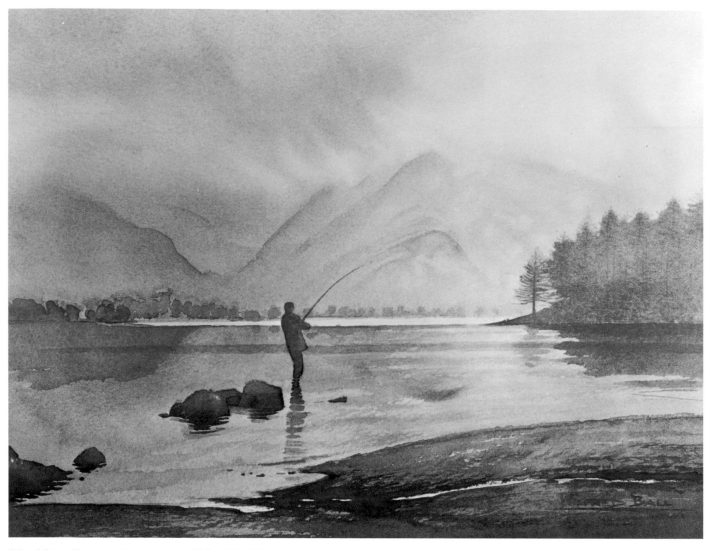

85 *Misty Evening, Buttermere* (15 x 11in/380 x 280mm)

Magic and mystery

Magic: Any mysterious or extraordinary quality or power; unaccountably enchanting.
Mystery: The quality of being obscure, inexplicable or enigmatic; which arouses suspense and curiosity.

In the same way as mood and atmosphere are determined partly by the earth's atmosphere – the scientific composition of the air – so mist makes mystery. What we cannot see clearly allows our imagination to work on it, to imbue it with extra meaning. This is at the heart of Romantic art as opposed to the literary and sentimental paintings we associate with the Victorians. We all make interpretations – whether in painting or poetry – of words, shapes, colours or appearances that are personal to us. This is where the magic dwells, and mystery. And it is in this area of the unclear, the vaguely suggestive and the poetically possible that the wet technique is at its best. The two examples that follow are excellent demonstrations of this.

Misty Evening, Buttermere (85) catches this famous lake at a golden moment. The early evening sun is glowing through the mist on the right of Fleetwith Pike in a most evocative way.

86 *The Cat and Fiddle Windmill in Heavy Snow* (15 x 11in/380 x 280mm)

The Cat and Fiddle Windmill in Heavy Snow (86) was used in my book *Weather in Watercolour*, but is worth another look. Technically and romantically I feel it is the most satisfying snow scene I have ever produced, capturing so well that silent magical world that deep snow and huge whirling snowflakes produce. Instead of using salt crystals to obtain the effect of snowflakes, I used a brush handle wrapped in a clean handkerchief to dab off the individual flakes as the wet background was drying.

Both paintings depended on wet techniques to produce the essential quality of the experience.

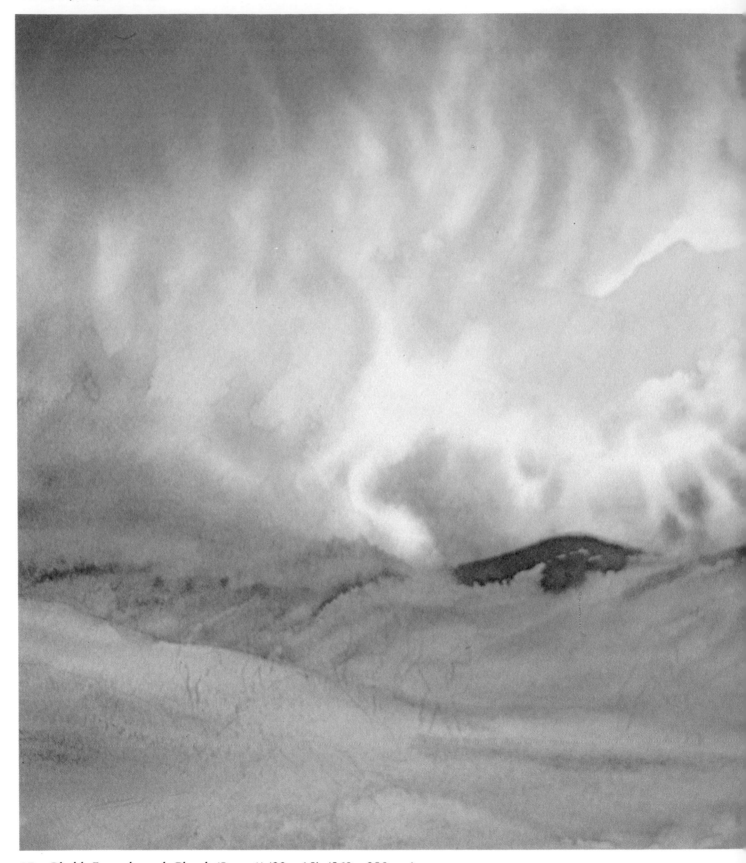

87 *Glyddr Fawr through Cloud (Stage 1) (22 x 15in/560 x 380mm)*

Glyddr Fawr through Cloud (87, 88) demonstrates even more intriguingly how mist manufactures mystery. The first stage was painted entirely wet-in-wet, with just a couple of crags indicated more clearly, centre right, after the background washes were almost completely dried. In the final stage the sunlit Glyddr Fawr was indicated, seen through a window in the drifting hill cloud. On the lower slopes of Snowdonia the backpackers trudge past the traditional cairn on their way down the mountain. Their grotesque shapes, distorted by equipment, disappear into the low cloud which makes their passage all the more mysterious. Unexpected, unfamiliar shapes can be made more strange, even threatening, by this veil of clinging mist.

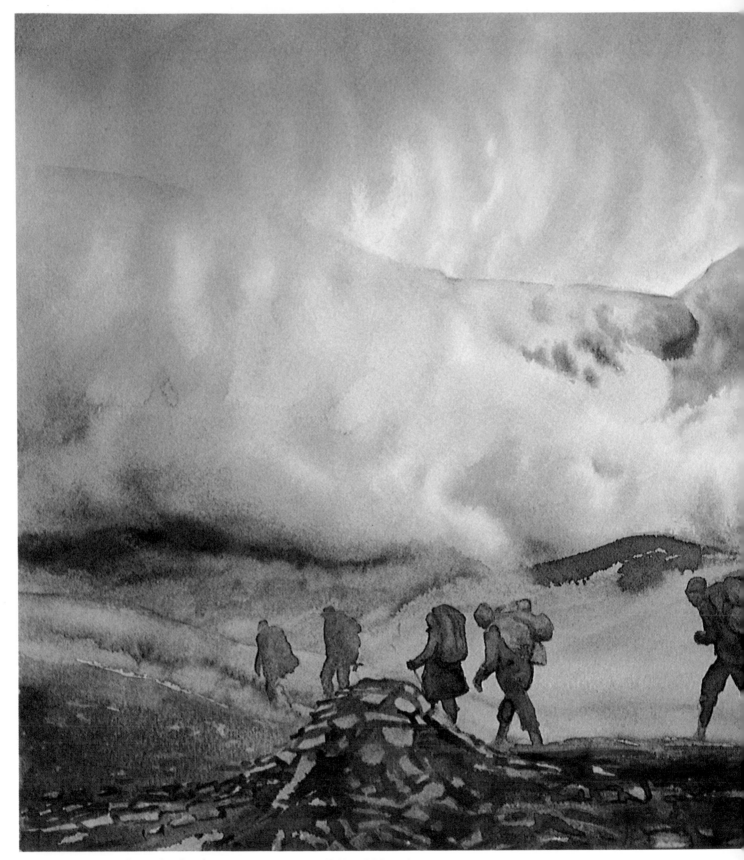

88 *Glyddr Fawr through Cloud (Stage 2)* (22 x 15in/560 x 380mm)

Morning Mist (89) is a very simple painting, but this apparent simplicity is quite deceptive. On the face of it, it is the archetypal misty scene encapsulated in its title; but its structure and mood – a combination of long, low-lying horizontals and fragile atmosphere – have amalgamated into something much more. Here is a painting where the whole is greater than the sum of its parts, where form and mood have combined to produce a magic that defies description. The location (a high plateau in North Staffordshire), the mist, the time of day, the stillness, the emptiness all weave a spell.

I must confess to a little subterfuge here. Wishing to leave many problems unsolved and enigmatic, I deliberately left the horizon, vague though it is, about halfway up the picture surface, contrary to the rules. Nothing very positive, nothing clarified, no questions answered precisely: but rather everything to create the romance and enigma beneath this tranquil surface. And an unusual red soil in the foreground, seeping pink reflections through the mist, adds to its appeal.

Winter Glow, Hope Valley (102) catches another magical moment. As the last golden light glowed on the mist, which was almost obliterating the small farm in the hollow, the slush along this moorland road glistened. In the twilight shadows the banks of snow bordering the road withdrew into shadows of mauve and heliotrope, with soft edges faintly gilded by the glow. The painting certainly has the *extraordinary* quality quoted in the dictionary definition.

Evening Mist, Hathersage (105) also has a special quality that appealed strongly to me as I sketched it: the lovely valley slowly filling with mist as thick as cotton wool. The contrast between the chilly mist and the warmth of the setting sun created a striking atmosphere that I was impatient to paint. I hope I have conveyed the remarkable effect it had on me at the time.

Seeing a breathtaking subject in ideal conditions is a magical experience for a painter, whether or not he manages to capture the quality in his painting of it. Such a subject was *Above the Mist, Rannoch Moor* (56) – a rare moment. More conventional was *October Afternoon, Goyt Valley* (78) perhaps because it represented an archetypal experience of landscape – the epitome of an English autumn. Tall trees in sunlit gold and rust, a sparkling stream, great boulders enclosing gilded pools – it had everything. I hope the painting conveys something of the thrill I felt at the time, a stimulating memory still.

Sparkling Sea, Canisp and Suilven from Achmelvich (108) is another that exemplifies the magical subject. I can still recall my excitement as I stood amongst the heather and watched the light play upon the sea, while the mountains moved across the sky as the clouds scudded past. Such moments compensate for all the grey days when one prays for a gleam of light to create a little more variety of tone and colour in the landscape.

Sometimes the magic can be produced by the action of technique or a 'happy accident'. As I have

89 *Morning Mist* (15 x 11in/380 x 280mm)

commented already, the latter happens only when working really wet, so there is an added inducement to do so. *Fresh Snow Falling on Stair, Newlands* (90) is a good example. *Sudden Snowstorm at Lingcove Bridge, Upper Eskdale* (77) is a very dramatic demonstration of the use of salt on wet pigment to simulate falling snow, but the Stair subject has a

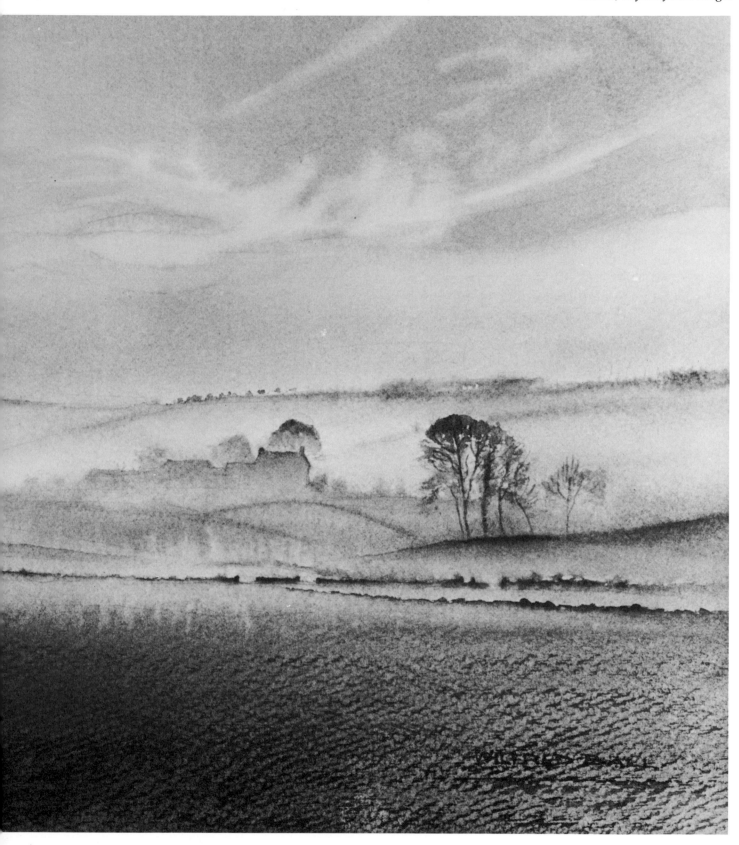

gentler mood and captures a particularly nostalgic kind of memory. We can all remember, I'm sure, such a beguiling experience. As the winter afternoon fades into twilight and windows begin to light up here and there, the heavy sky is suddenly full of dancing snowflakes – huge, soft, clinging snowflakes that brush the face so gently one hardly notices their touch.

Soon the fresh white carpet muffles even our footfalls and we are in a magic world of softness and silence. The experience holds its own magic, but so does the technique which enables us to recreate it.

The method was exactly the same as the one for *Lingcove Bridge*, but this time I made a particular effort to isolate individual snowflakes rather than

create the flurries which made the Eskdale painting so dramatic. I felt I must aim at the much gentler effect which the individual flake induces. For this reason I tried to scatter the salt crystals singly, as far as possible. As you will see, I failed to manage this on the left-hand sky area where a sprinkle of salt make a great cluster of flakes. Sprinkling was obviously too hit-and-miss for the effect I wanted, so I actually picked up the crystals one by one and dropped them into the wet paint in a more isolated fashion. This can be seen particularly clearly against the dark wall in the foreground.

The salt technique more than any other is capable of producing magic, because the way it works is like a conjuring trick: wait for a few minutes and hey presto! You will observe, however, that behind its successful use is a great deal of experience, learned through trial and error. It took me quite some time to discover the best kind of salt to use. Ordinary table salt is too fine to be effective. The largest sea salt crystals are too big and create white explosions, yet one does need crystals if one is to isolate individual flakes. The packet I used for the painting under discussion is labelled *Pure Crystal Table Sea Salt*.

A place in itself has no magic. It is when the landscape is transmuted by a particular time of day and a special atmospheric effect that it becomes enchanted. One is lucky to be able to recognize it, momentary as it may be, let alone understand it and fix the details and quality in the mind's eye. A sketch can but capture the bare bones of the experience, and only a trained eye and fertile imagination can recreate it. Such moments are rare, even for one who has a long and varied experience of looking at landscapes. There are no rules about finding them, though you may have realized from the frequency of 'early morning' and 'evening' in the titles of my paintings that these are the times when something special is likely to present itself.

Rare though these enchanted moments may be, they remain etched on the memory. But have you the skill to capture them on paper? Only a thorough understanding of the medium can open the 'charmed magic casements' that lead to the recreation of such experiences. When the way is found, however, it can help you to transform many an unremarkable subject into something special. By applying a remembered effect to a promising subject which yet seems to have something missing, you may well produce that artistic whole which is greater than the sum of its parts. I consider this to be the ultimate challenge in watercolour painting. Not only must you be able to recognize the magic and define it, but also possess the skills necessary to avoid losing it. It is something that is very easy to lose, so do not despair if this happens a few times – it is inevitable. And one victory is worth all the defeats put together.

Finally, I hope these paintings go some way towards emphasizing how important it is to have aims beyond the mere representation of objects. Time of day, seasons, the marvellous light effects that the weather can add, the apt use of emotive colour, the imaginative

90 *Fresh Snow Falling on Stair, Newlands Valley* (15 x 11in/380 x 280mm)

deployment of such other elements as may convey a convincing mood, all these can be mingled in a visual poetry that stirs the emotions. The observer must be persuaded that he is looking at an interesting place, at a particularly significant moment, when its

appearance is heightened by the light and mood chosen by the painter. It is the painter's responsibility to make sure his choices are informed by experience and careful observation of all the many visual effects from which he will try to select the best alternatives.

7
Finishing Touches
Step-by-Step

91 *On Summer Lodge Moor, Swaledale (Stage 1) (15 x 11in/380 x 280mm)*

Very few paintings are completed entirely in the wet technique, though this book contains a number of examples which were. In my own case, I begin my paintings wet, putting in the finishing touches when dry or almost dry. The tendency of soft-edged shapes to recede and clear ones to advance is too effective and convincing a phenomenon to be ignored. Atmospheric perspective would be lost without it. It depends on the type of subject and its mood whether I go wet almost all the way or introduce dry details comparatively early. To demonstrate this, I have chosen a number of paintings which illustrate different moods and have photographed them at various stages of completion.

All of them show a first stage which is wet and one or more other stages which become progressively drier. I have tried to recall the main technical procedures I was concerned with in each case and also the chief aesthetic considerations.

Demonstration 1 *On Summer Lodge Moor, Swaledale*
(15 x 11in/380 x 280mm)

Technical aims: To complete the subject in two stages, one wet, one drier, using masking medium to protect

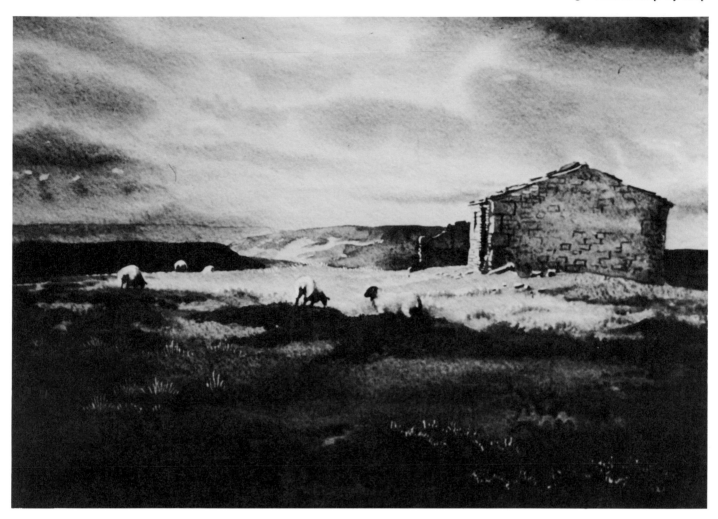

92 *On Summer Lodge Moor, Swaledale (Stage 2)* (15 x 11in/380 x 280mm)

detail while treating the rest in broad wet-in-wet washes.
Artistic aim: To show the richness of colour of moorland when sunlit in September.
Palette: Yellow Ochre, Raw Umber, Burnt Sienna, Alizarin Crimson, Cobalt Blue.

Stage 1 (91)

Having masked the backs of the sheep and the sunlit stones on the derelict shooting cabin, I used a pen to put masking medium for the highlights on the foreground clumps of heather. When I had sponged the entire surface with clean water I covered the whole foreground with Yellow Ochre and used the same colour to tint the left-hand side of the sky. The clouds were put in wet-in-wet with a mixture of Cobalt Blue and Burnt Sienna, strengthening the blue for the heavier cloud at the top right corner and the low strata above the distant hills.

Then I mixed a green for the shadowed part of the foreground, into which I touched Burnt Sienna for those lovely moorland grasses that change colour as autumn approaches. Eventually, I even had to add touches of Crimson to equal their rich reds. The basic forms of the clumps of heather were indicated with a dull purple mixed from Cobalt and Crimson. By this time the sky was drying and I was able to paint the

distant hills in varying strengths of blue-grey, leaving the blaze of light in the centre to describe the folds of the far slopes over in Wensleydale. With a much stronger colour I painted the nearer hills to the left and right of the cabin with the intention of creating a vigorous tonal contrast with the sunlit grasses and the backs of the sheep.

This stage had now dried and I painted the stone cabin with the same blue-grey I had used for the distant hills, strengthening the wash with dull greens and warm browns to add local colour as well as to emphasize the dark edges.

Stage 2 (92)

I dampened the foreground again, as I realized the detail that remained was chiefly soft-edged. Also I needed to strengthen the warm colours of the grasses to indicate the richness of their developing winter hues when they are sunlit. The Yellow Ochre of the area of sunlit grass was therefore warmed with a little pale Burnt Sienna. Even the red grasses were further emphasized before I added strong, warm greens and purple-grey to point up the modelling on the heather banks. This was strengthened particularly in the nearest foreground.

When the washes had dried, I rubbed off the masking medium. A few details emphasized the large

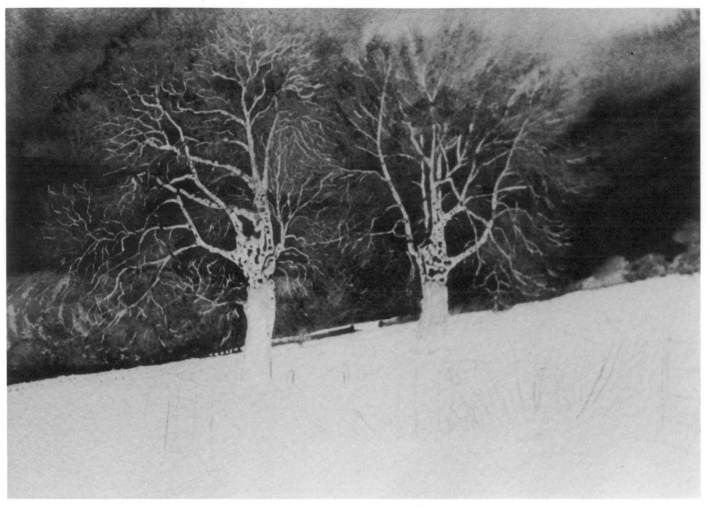

93 *Sunlit Trees, Tinkersley, North Derbyshire (Stage 1) (22 x 15in/560 x 380mm)*

stones in the cabin walls, then I washed a little pale yellow over the sunlit stones on the left-hand wall. After completing the darker tones on the sheep, the painting was finished by using a pale reddish purple for the sunlit bits of heather. The richness of colour illustrates very well why I love the heather moors in winter as much as in summer.

Demonstration 2 *Sunlit Trees, Tinkersley, North Derbyshire*

(22 x 15in/560 x 380mm)

Technical aim: To demonstrate the use of masking medium in preserving complicated detail against a dense background.
Artistic aim: To illustrate one of my favourite phenomena – the sparkle of sunlit twigs against sombre winter woodland.
Palette: Yellow Ochre, Raw Umber, Burnt Sienna, Cobalt Blue.

Stage 1 (93)
I drew in the twigs with a pen charged with masking fluid, then used a brush for the trunks and thicker branches. A flock of seagulls below and beyond the left-hand tree were similarly masked, as were the stalks of dead vegetation against the foreground walls.

Only the upper part of the paper was wetted to begin with, as I wanted to ensure that I could control this most significant stage of the action. To emphasize the blaze of light from above I used very strong greys made from Cobalt Blue and Burnt Sienna to depict the storm clouds blowing up on the right, and the dark hill on the left. As it dried I added even stronger colour to ensure

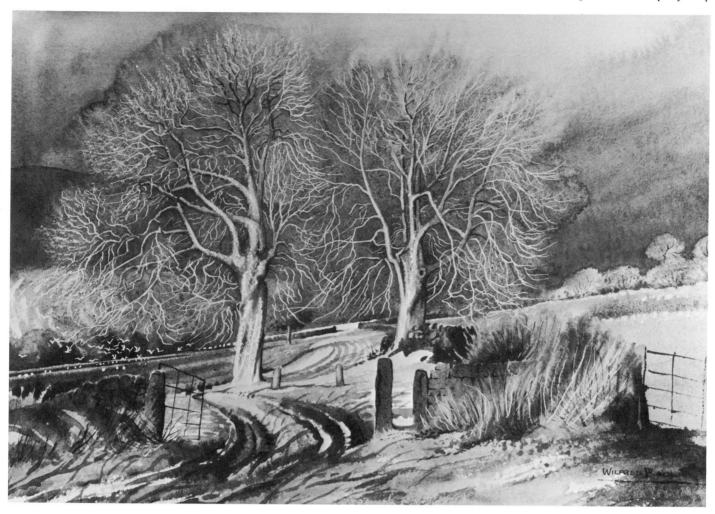

94 Sunlit Trees, Tinkersley, North Derbyshire (Stage 2) (22 x 15in/560 x 380mm)

the greatest possible tonal contrast with the sunlit trees. The tree area was treated with Yellow Ochre which ran into the drying background at just the right time to produce those characteristic soft edges which emphasized the basic masses of foliage. To the right and left, the shapes of sunlit hedgerows and trees were produced by a similar reaction created by wet yellows against the drying dark background. In places the yellow was strengthened with Raw Umber.

Stage 2 (94)

The entire rest of the surface was painted in a wash of Yellow Ochre, leaving the small areas of snow and the water in the central ruts as untouched paper. Into this wash, greens and browns were brushed to describe folds in the ground. Umber and Sienna were added to the foreground clumps of vegetation. As the paper dried I used stronger greys to emphasize the ploughed field on the left, the gateposts, the ruts and the walls. Some green was touched into the posts to suggest mossy stone.

By now the paper was dry and I was able to rub off the masking medium. Pale yellow was used to tint the sunny twigs, while Raw Umber and greens added modelling to the trunks. A cool blue-grey indicated the rainwater in the ruts between the gateposts and the shadowed slopes of the snow. Finally I suggested the two metal gates and the flickering shadows across the grass.

111

Demonstration 3 *After the Rain, Crummock Water*
(22 x 15in/560 x 380mm)

Technical aims: To exploit the method of tilting the paper to allow the wet pigment to run in order to emphasize a great swathe of light bursting through the cloud. To demonstrate the effectiveness of a limited palette.

Artistic aim: To capture one of those marvellous moments of sunlight immediately after rain, for which the Lake District is justifiably famous.

Palette: Yellow Ochre, Burnt Sienna, Cobalt Blue.

Stage 1 (95)

The figures and sheep were protected with masking medium, then I brushed water over the whole of the surface, carefully leaving the roof of the barn and the foreground track dry. I quickly tinted the foreground with Yellow Ochre, then a grey mixed from Cobalt Blue and Burnt Sienna was painted into the two dark areas of the sky. While this was still wet I dropped a large wash-brushful of clear water into the top of the sky, adding a smaller amount immediately to the right to widen the area of light. When I tilted the paper this water streamed down through the pigment as far as the far edge of the lake, which I had earlier blotted off to protect it from encroachment by the sky pigment. Even so, a little colour seeped in as you can see. I strengthened the sky on the right, and just before it was dry I put in a dark brown for the mass of trees beyond the barn. Before this had completely dried I lifted a little colour from the upper edges of this foliage with a damp brush, to give the effect of light beginning to catch them.

After this stage had dried I put in the misted bulk of Rannerdale Knotts with the same colour mixture as I had used for the sky. Where the light cut across it on the right I blotted off most of this colour. The dark slope in the middle distance was coloured in with a graduated wash using all three colours of my limited palette.

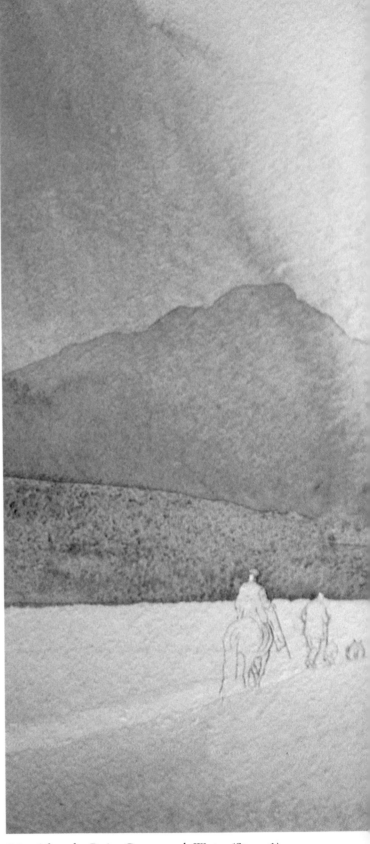

95 *After the Rain, Crummock Water (Stage 1)*
(22 x 15in/560 x 380mm)

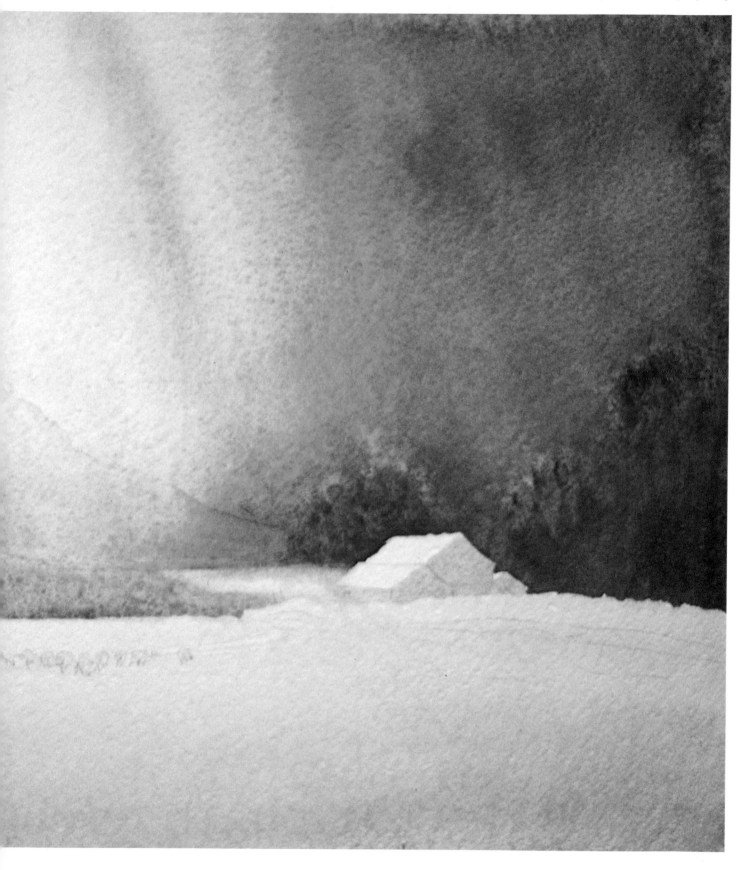

Stage 2 (96)

First I completed the background by painting in the dark formation on the left, a few warm strokes on the gentle slope of moorland, then the trunks of the trees. Now I was able to dampen the whole of the foreground which I modulated with suggestions of dull green, grey and Burnt Sienna, the latter for the strong clumps of dead reeds. I was careful to put a suitably dark mixture into the area of the dip in the track so that this would eventually emphasize the sunlit backs of the sheep. The shadow on the wall on the right was painted when the paper was fairly dry, so that I could leave a few flecks of light to indicate gleams on wet stones, particularly on the top edge.

The track was then tinted in with broken colour to suggest the stones. Then edges were strengthened by shadows. Finally, the distant curve was brought into focus by strengthening the strip of grass down the centre of the track.

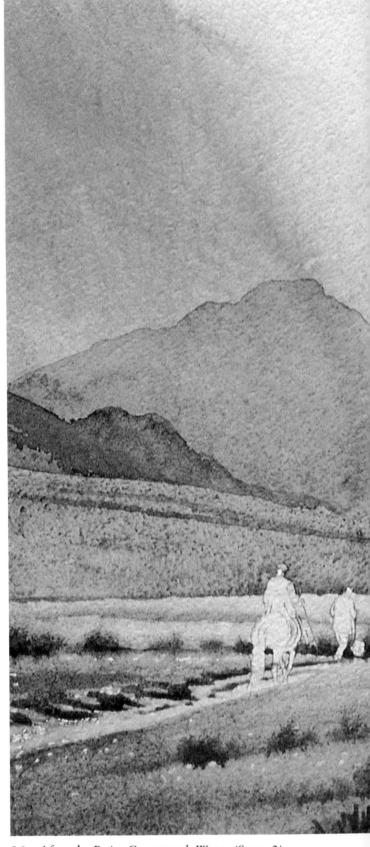

96 *After the Rain, Crummock Water (Stage 2)*
(22 x 15in/560 x 380mm)

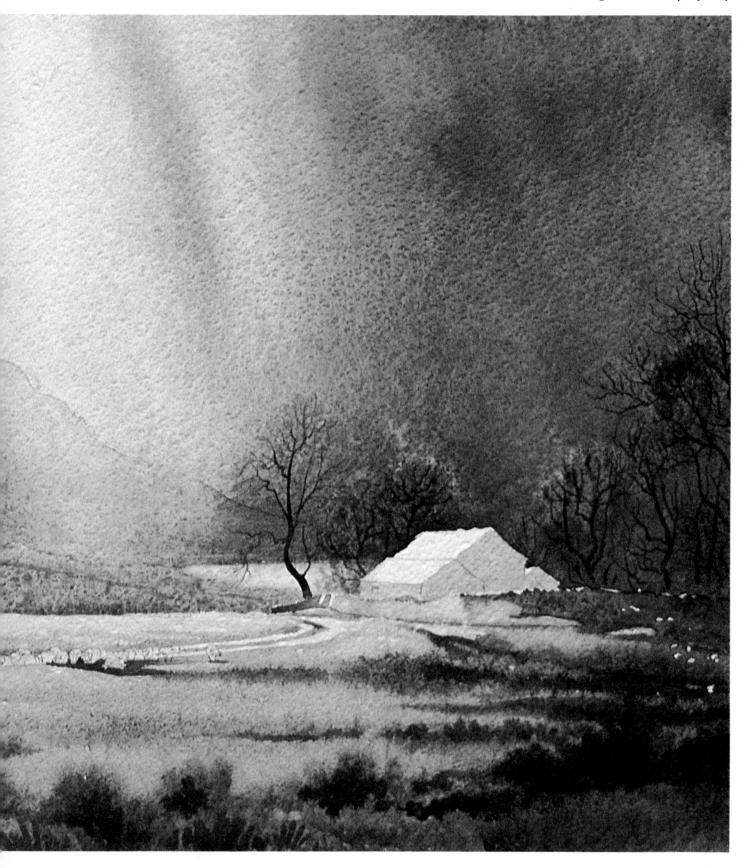

Stage 3 (97)

Having rubbed off the masking medium I quickly touched in the detail on the horse, the figures and the sheep. This left only the barn. Finally, with a thin brush I put in the vertical strokes of Burnt Sienna to suggest the habit of growth of the reeds. I'm afraid this was a mistake, as this detail is unduly prominent, and the earlier vague shapes were more effective, I feel. One rarely gets through a painting without making at least one error of judgment like this, even after meticulous planning in the design stage.

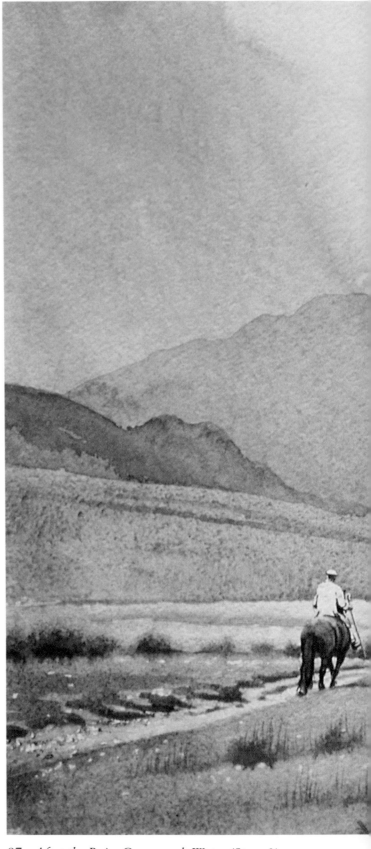

97 *After the Rain, Crummock Water (Stage 3)* (22 x 15in/560 x 380mm)

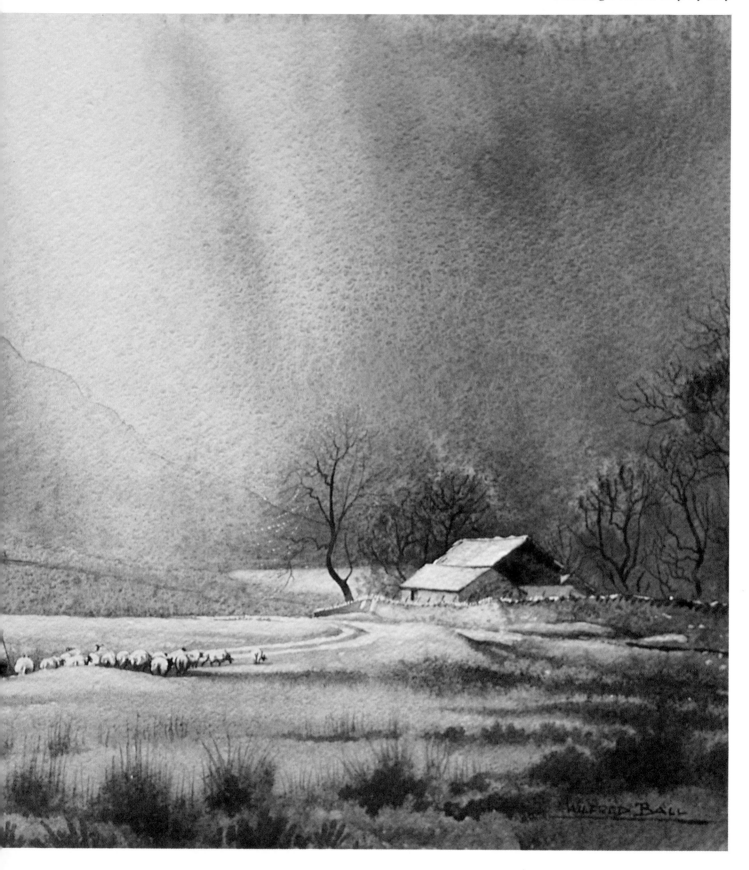

Demonstration 4 *Autumn Mist, Holymoorside*
(22 x 15in/560 x 380mm)

Technical aims: To explore the enhanced effect of atmospheric perspective produced in mist and to complete the subject almost entirely by wet-in-wet techniques. To demonstrate further the use of a limited palette.
Artistic aim: To examine the atmosphere of mystery which thick mist can suggest.
Palette: Yellow Ochre, Burnt Sienna, Cobalt Blue.

Stage 1 (98)

Rather than sponge water over the paper, I brushed on a really wet wash of Yellow Ochre into which I could paint the other background colours necessary as a basis for the colour composition. First I put in pale grey at the top of the sky merging into the yellow lower down. A slightly stronger grey represented the vague forms of distant trees. Pure Burnt Sienna was used for some of the foreground foliage and the rusty, dead bracken on either side of the path. A dull green was used for the grassy path curving back into the centre of the composition. While the sky was still wet I took out the pigment from the faint shape of the sun with a soft cloth wrapped around my forefinger.

98 *Autumn Mist, Holymoorside (Stage 1)*
(22 x 15in/560 x 380mm)

Stage 2 (99)

Detail was put into the distant tree in the centre with a thin brush while the paper was still damp. A slightly stronger grey was used for the hazy trees on the left before a wash of the same grey was used over the foreground to emphasize recession. Stronger grey was used for the trunks and branches of the foreground trees. On the left of the path the bracken was strengthened, also to emphasize recession.

99 *Autumn Mist, Holymoorside (Stage 2)*
(22 x 15in/560 x 380mm)

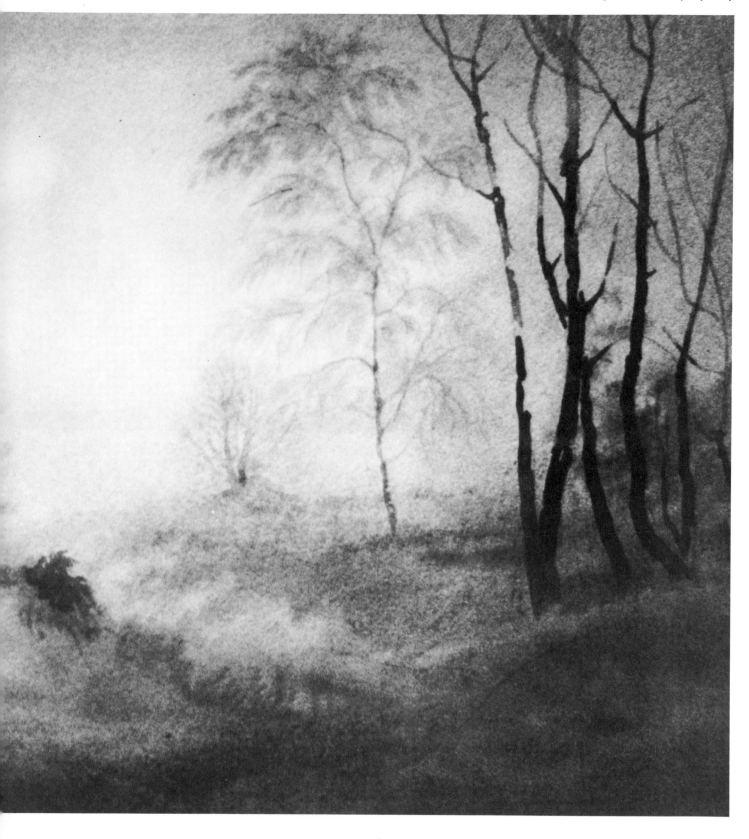

Stage 3 (100)

By adding Burnt Sienna to the greys I had been using I was able to produce a rich, warm grey to emphasize the form of the clumps of bracken in the foreground and on either side of the pockets of mist along the path. Along the upper edges of these clumps more precise indications of the fronds were put in to identify the bracken. Finally, twiggy branches were put in on either side to drive the trees I had already painted further back into the picture space.

There is no doubt that the final result gave distinct emphasis to the effect of recession. However, I felt that if I had used rather less aggressive tones in the foreground I would have produced a more poetic atmosphere. As a demonstration of the effectiveness of a palette reduced to only three colours it was completely successful.

100 *Autumn Mist, Holymoorside (Stage 3)*
(22 x 15in/560 x 380mm)

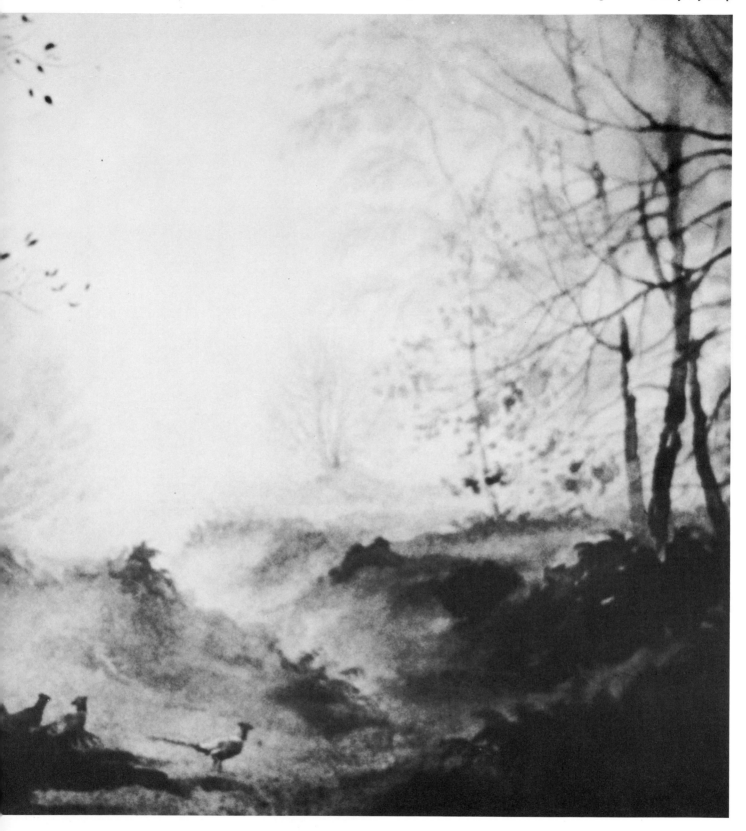

Here are two other paintings that deal with the phenomenon of mist. *Misty Evening, Thulston, Derbyshire* (101) demonstrates that misty scenes are not necessarily drab in colour. Here beneath the rich, golden glow in the sky, the foreground is strong in tone, the maturing elderflowers and the poppies adding to the colour. But at the far side of the field of ripe barley the low-lying wisps of cold, evening mist are beginning to shroud the lower parts of the distant trees.

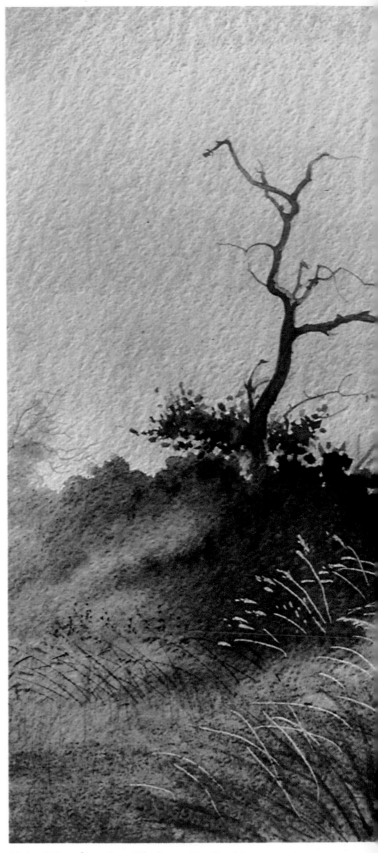

101 *Misty Evening, Thulston, Derbyshire*
(22 x 15in/560 x 380mm)

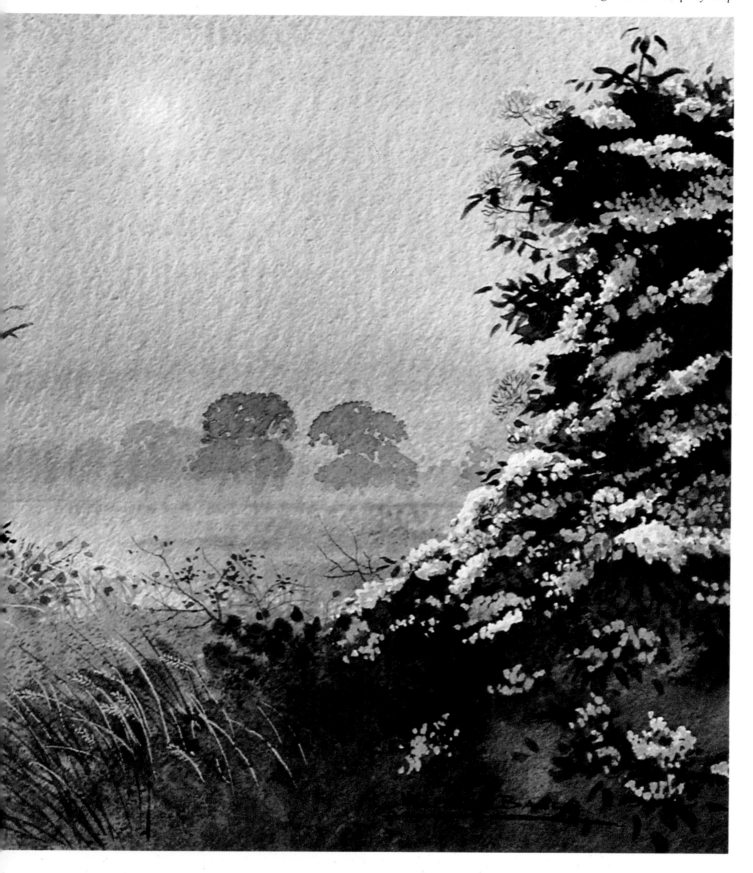

Finishing Touches Step-by-Step

Winter Glow, Hope Valley (102) illustrates the same time of day, but in winter instead of summer. Shortly before, there had been a magnificent sunset, the kind that winter seems to specialize in. Within minutes, however, a thick clammy fog was filling the hollows and rising up to obliterate the last rays of the sun. The painting demonstrates an attempt to depict these last twilight moments. There is a subtle use of complementary colours – yellow and purple – where the golden glow of the sun through the mist contrasts with the mauve shadows on the banks of snow alongside the road, and the ridges of half-frozen slush on the road surface itself. So mist is not necessarily cold and grey. It can clearly be seen that the majority of the picture space in both these paintings was treated wet-in-wet.

102 *Winter Glow, Hope Valley*
(22 x 15in/560 x 380mm)

126

Demonstration 5 *Evening Mist, Hathersage*
(22 x 15in/560 x 380mm)

Technical aim: To demonstrate how control of a large wet-in-wet painting can be achieved by painting it in sections, re-wetting it as necessary, to retain the effect of a completely wet-in-wet painting.
Artistic aim: To illustrate the phenomenon of objects rising out of dense, low-lying mist.
Palette: Yellow Ochre, Burnt Sienna, Cobalt Blue, Cadmium Red.

Stage 1 (103)

I began by holding the paper under the bathroom tap and then draining off the surplus moisture. After washing Yellow Ochre into the central sky area I used a mixture of pale grey mixed from Cobalt Blue and Burnt Sienna to paint horizontal streaks of cloud, stronger near the horizon. By dabbing with a finger wrapped in a dry cloth I dried out the shape of the sun, then painted a halo of Cadmium Red around it, using the same colour to tint the upper parts of the horizontal clouds. Red kept seeping into the orb of the sun, but I persisted with the dry cloth until it stopped; then I covered the shape with yellow.

After washing in some faint green on the curving hill on the left I used a very strong grey to put in the dark trees along its crest as well as the ones to its left and just below it. As the paper was beginning to dry by now I had to drop in a little clean water in the spots where I was trying to simulate pockets of hill fog. The background hills were painted in with a stronger mixture of the warm grey I had used for the clouds. By now the paper was sufficiently dry to achieve edges clear enough to suggest their shapes accurately.

103 *Evening Mist, Hathersage (Stage 1)*
(22 x 15in/560 x 380mm)

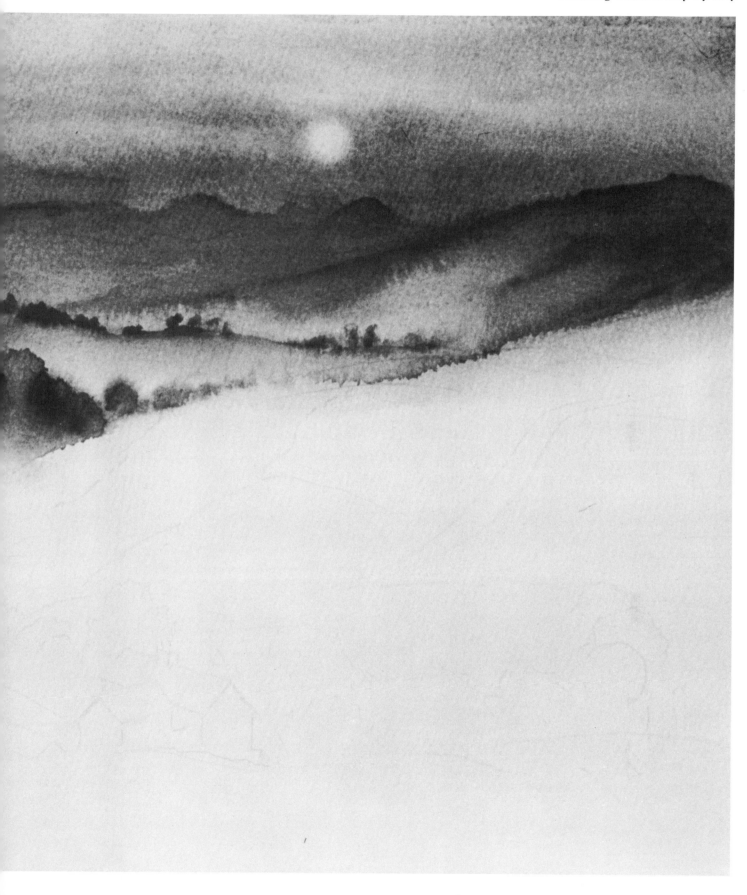

Stage 2 (104)

I allowed the pigment to dry thoroughly before re-wetting the rest of the paper. Mixing a little Burnt Sienna into the green I had already used, I tinted in the grassy slopes of the hill on the right as well as the slope on the near left, allowing the colour to merge into the clear water representing the main misty hollow at the bottom of the valley. Using greys I painted in the faint trees at the far end of the valley, then strengthened the mixture, as well as adding a little green, to put in the trees running up the slopes of the central hill. Stone walls were vaguely indicated as well as the sides of the road rising up the slope to the right. With a damp brush I took out sufficient colour to produce an effect of light on the upper part of the road.

The area just beyond the farm had been kept wet by adding a little moisture as it began to dry out, so I was able to touch in the trees rising above the mist in this area. By adding the moisture with a brush I had been able to keep the shape of the farm building dry and clear of any other colour that seeped into the mist beyond it.

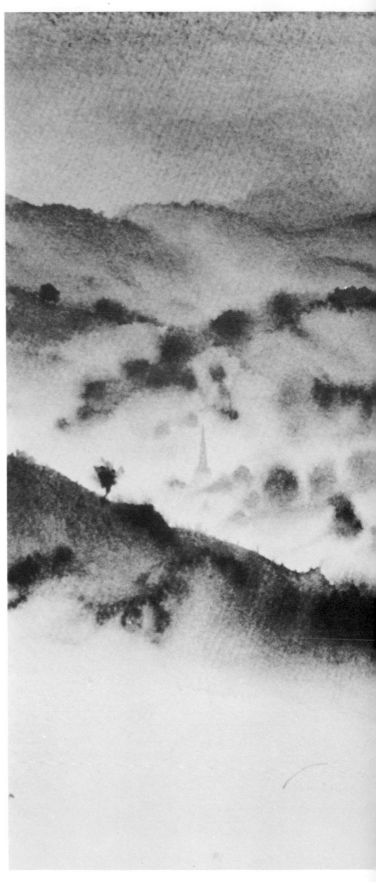

104 *Evening Mist, Hathersage (Stage 2)*
(22 x 15in/560 x 380mm)

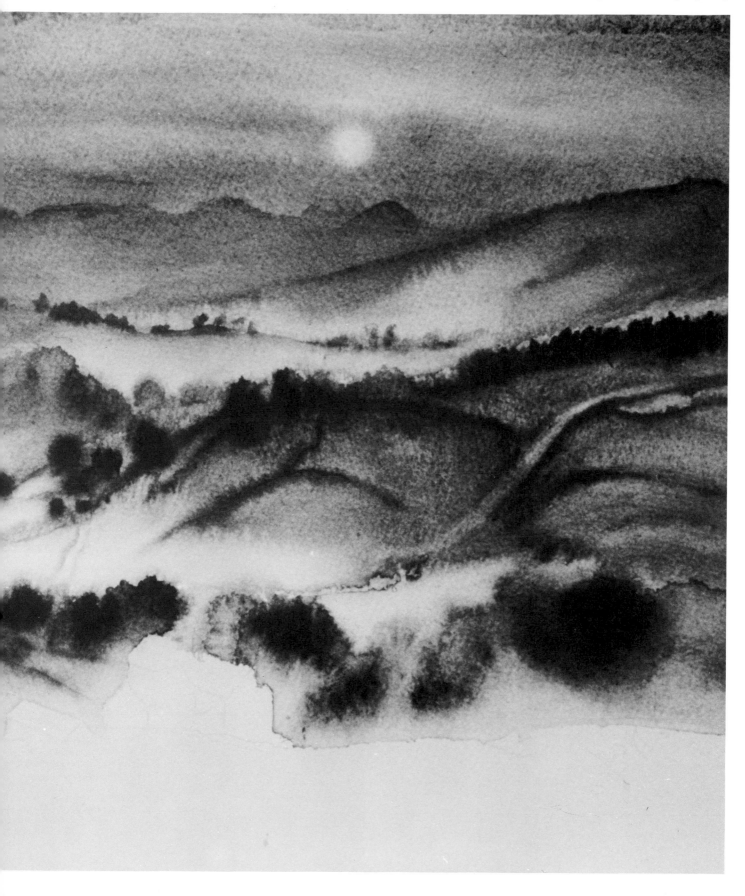

Stage 3 (105)

Reinforcing the area of mist around the farm with more clear water, I painted the foregound field with a strong, warm green that bled into the mist. A darker grey was added to suggest the undulations in the field. While the surface was still damp I put in the large foreground tree on the left. Only the shapes of the farm buildings were put in after the paper dried, and even there the mist was allowed to obliterate the lower parts of the buildings by touching a wet brush into them and allowing this to seep up into the pigment.

I have no doubt that I could have managed to complete this subject with one wetting, if I had so wished, but I would have had great difficulty in keeping adequate control while working under such pressure. For example, as each stage progressed I was able to put stronger pigment into the shapes of some of the clusters of trees as they dried, so as to produce a tonal variation indicating which trees were above the mist and which were partly obliterated by it. Only by being able to concentrate entirely on such a manoeuvre, without other distractions, can one use sufficient judgment concerning the amount of pigment to be applied in view of the precise stage of gradual drying out of the surface.

By allowing the stages to overlap and keeping the surface sufficiently moist at all times, no hard edges have developed, and by these methods even a painting as large as full Imperial could be tackled entirely as a wet-in-wet subject.

The final effect of a valley filled with low-lying mist like cotton wool was just what I had been seeking.

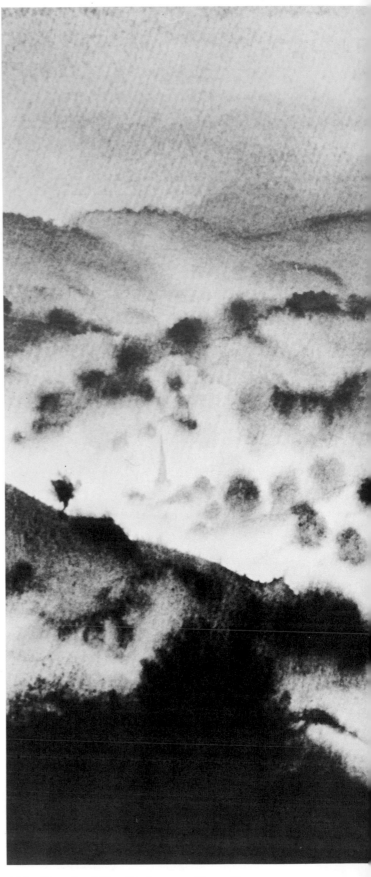

105 *Evening Mist, Hathersage (Stage 3)*
(22 x 15in/560 x 380mm)

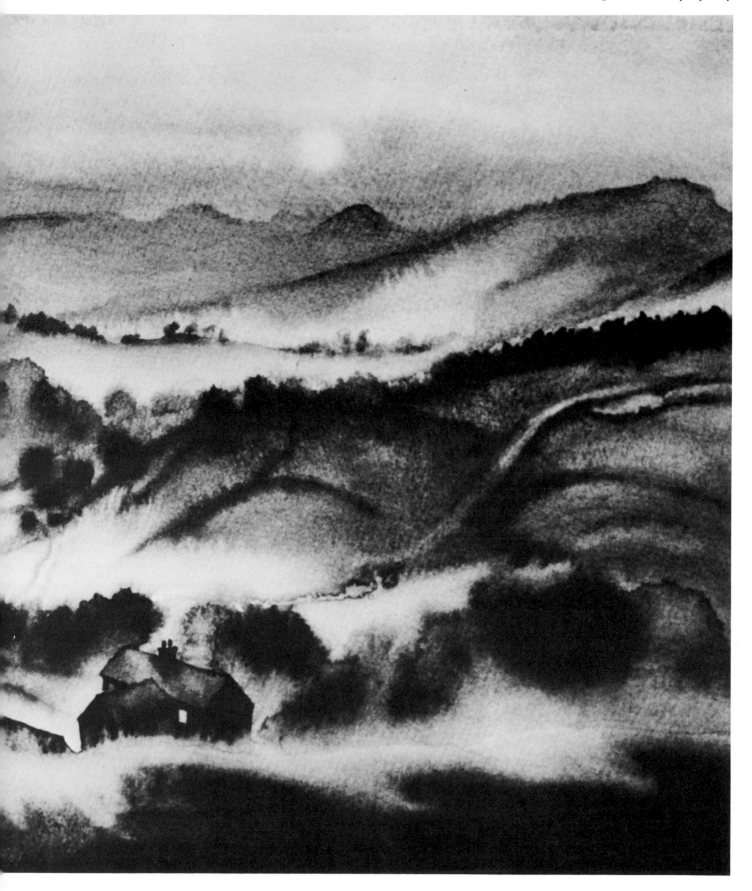

Demonstration 6 *Sparkling Sea: Canisp and Suilven from Achmelvich*
(22 x 15in/560 x 380mm)

Technical aim: To demonstrate the use of wet-in-wet techniques within separate washes.
Artistic aim: To create an aesthetic tension between sparkling highlights and surrounding shadows.
Palette: Yellow Ochre, Raw Umber, Burnt Sienna, Cadmium Red, Alizarin Crimson and Cobalt Blue.

Stage 1 (106)

Sunlight through broken cloud produces the most marvellous effects in mountain country; but the cast shadows do not always dispose themselves favourably, so one often has to re-compose them more suitably for maximum effect.

I began by using a pen with masking medium to create the texture of the heather and the curving rhythms of the long grasses. Having wetted the sky area and brought the moisture down over the mountains, I was careful not to wet the brilliantly-lit sea at the top right. Some warm colour was put into the top of the sky and the bottom right before I painted the clouds with my usual grey, weakening it a little for the long horizontal clouds near the horizon. The fluffy clouds behind Suilven were created by touching a small brushful of clean water into the damp wash. I ran the same brush along the base of the upper cloud, the moisture pushing the pigment up into a stronger edge, so as to emphasize the rays of light slanting down below it. The rays themselves were produced by using a damp, stiff-bristled brush. By now the paper had almost dried out. Any sky which is as detailed as this is likely to take up the whole of the first stage of any wet-in-wet painting, before the paper needs wetting again.

106 *Sparkling Sea: Canisp and Suilven from Achmelvich (Stage 1)* (22 x 15in/560 x 380mm)

Stage 2 (107)

It was necessary to preserve some precise edges in this stage, so I decided to paint it in a series of separate washes. A wash of the same grey I had used for the clouds was painted over the two mountains and the foothills below them. Into this I brushed pale Yellow Ochre to suggest sunlit slopes. Finally, some parts were strengthened with an even darker grey, as on the right of Suilven and on the headlands, also to the right.

The foregound hillside was treated in the same way. A wash of Yellow Ochre covered the whole of the slope except for the light shapes of stones. Into this basic wash I dropped greens and then Alizarin Crimson for the banks of heather. A strong, warm green was mixed from Cobalt Blue, Raw Umber and a little Cadmium Red. This was used for the lower parts of the heather clumps. A strong grey was later added to this to emphasize the dark, shadowed spaces between the clumps.

When these two washes had dried I painted in the water. I used the warm colour with which I had tinted parts of the sky, mixed from Yellow Ochre and a little Cadmium Red, to put a peach-coloured wash over the whole of the sea except the highlights, which were left as untouched white paper. After this had dried I used dry brush work to create the effect of sparkle on the sea in the foreground. The colour used was the same blue-grey I had used for the background hills.

This method of dropping amounts of lighter or darker colours into a basic wash enables one to produce the necessary light and dark modelling without destroying the fairly precise edge of the wash.

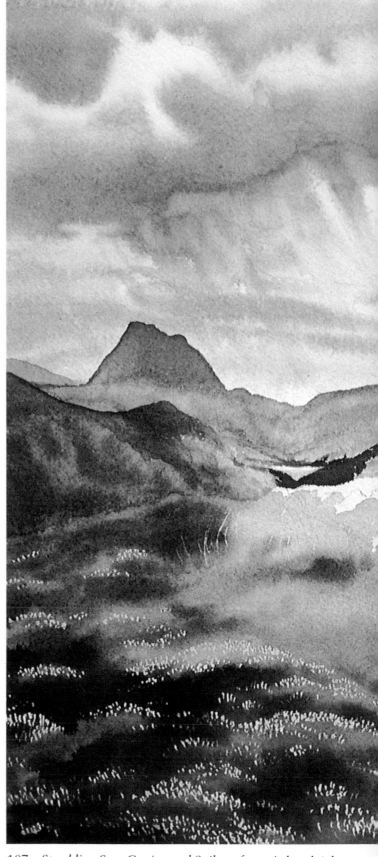

107 Sparkling Sea: Canisp and Suilven from Achmelvich (Stage 2) (22 x 15in/560 x 380mm)

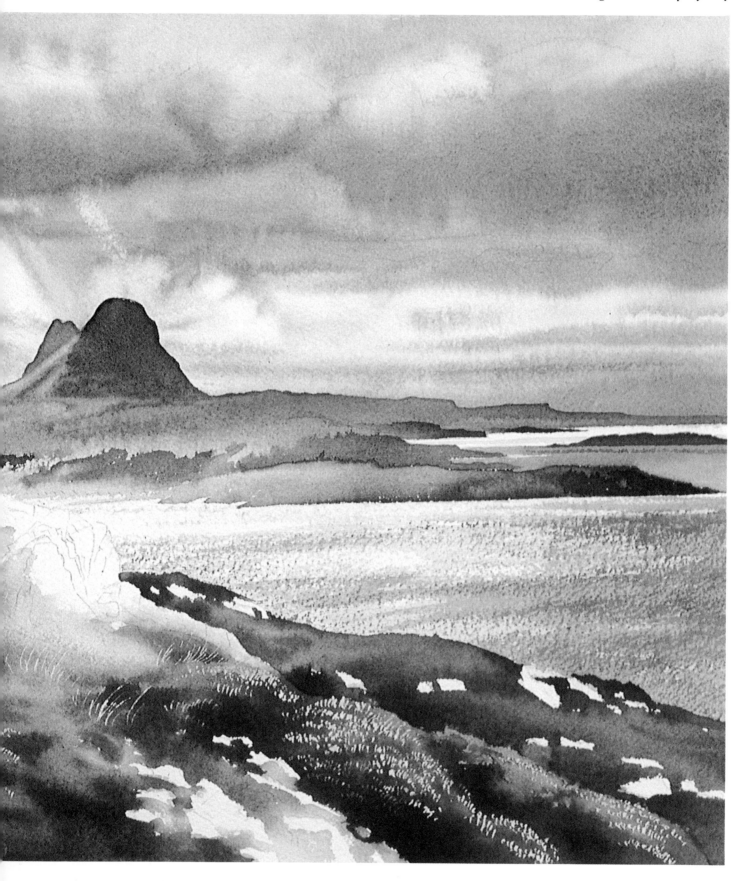

Stage 3 (108)

Now I was able to remove the masking medium and embark on the finer details. Using the strong, warm green I had mixed earlier, I painted in the lichen on the limestone rocks at the crown of the hill, strengthening it in places with a dark grey. The light stones on the lower slope of the hill were modelled with tones of the same grey, before cool grey was washed over the right-hand slope next to the sea, thus muting the stone outcrops as well as emphasizing its dark contrast with the glistening sea.

Now I mixed a mauve tint from Cobalt Blue and Crimson in order to wash over the detailed highlights on the heather blossoms, which had been uncovered when I rubbed off the masking medium. Finally, I tinted in the long grasses with pale Yellow Ochre and Raw Umber. The man and his dog were an afterthought. They served both to give a sense of scale and, by contrast, to emphasize the light on the gleaming water.

108 *Sparkling Sea: Canisp and Suilven from Achmelvich (Stage 3)* (22 x 15in/560 x 380mm)

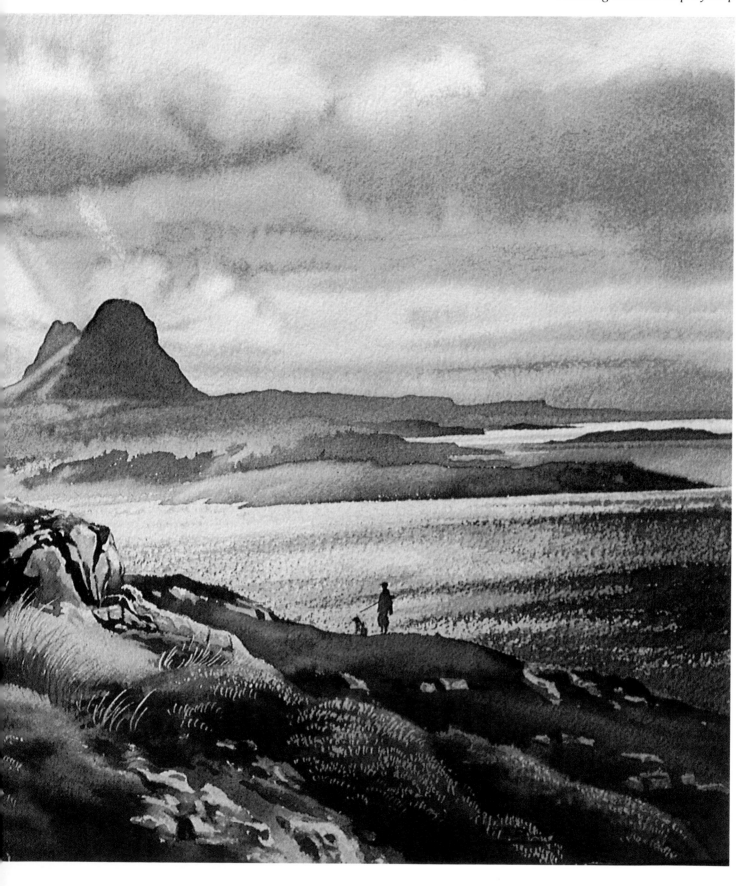

Gallery

This group of additional paintings (*109-122*) further illustrates the problems and procedures with which this book has been concerned.

Summary: Keeping control by understanding the medium

1 *Understand the importance of painting on heavy paper*. Light paper will buckle when wet and destroy control of the masses, as the pigment flows into the hollows. Even stretched paper undulates when very wet.

2 *Choose your subjects carefully*. Like all techniques, wet-in-wet has its limitations and is obviously not suited to all subjects. Although most skies and backgrounds can be well painted by this method, it is important to be selective if you wish to use it for the whole of the painting or the major part of it.

3 *Capitalize on the technique*. The interesting and most exciting effects will not be created if you do not paint really wet and subordinate detail to overall effect. Decide on the mood of your painting before you begin and be prepared to allow other less important qualities to fall by the wayside if the water and pigments insist.

4 *Do not regard the subject as sacrosanct*. A likeness to the particular place is, of course, essential; but the likeness does not rest in tiny details but in an overall impression. After all, the landscape itself is constantly changing according to the weather and the seasons. You can allow changes, therefore, on your paper, as part of a parallel phenomenon, so long as the place does not lose its identity.

5 *Learn to understand the medium thoroughly*, by experiment and usage, and then you will know what it can and cannot do. Through this you will learn to control the apparently uncontrollable. Learn to make the unpredictable a positive benefit.

6 *Remember to use strong mixtures* when painting on a wet background as this wetness will dilute the colour considerably.

7 *Aim at portraying effects rather than things*. It is how light and the weather transform those things that makes them remarkable.

8 *Remember that all the really crucial decisions have to be taken before you begin to paint.*

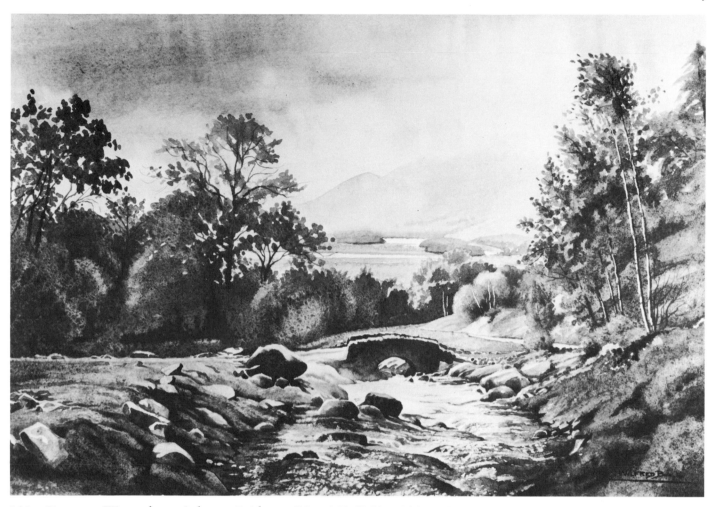

109 Derwent Water from Ashness Bridge *(22 x 15in/560 x 380mm)*
I saw this celebrated view one grey October day when it rarely stopped raining. It was an excellent opportunity to paint a really wet sky, tilting the paper so that the pigment drifted down in a reasonable simulation of the drizzle, the low cloud obliterating the summit of Skiddaw. The modelling on the screen of trees beyond the bridge was painted almost entirely wet-in-wet, the birch trunks having been put in with masking medium beforehand.

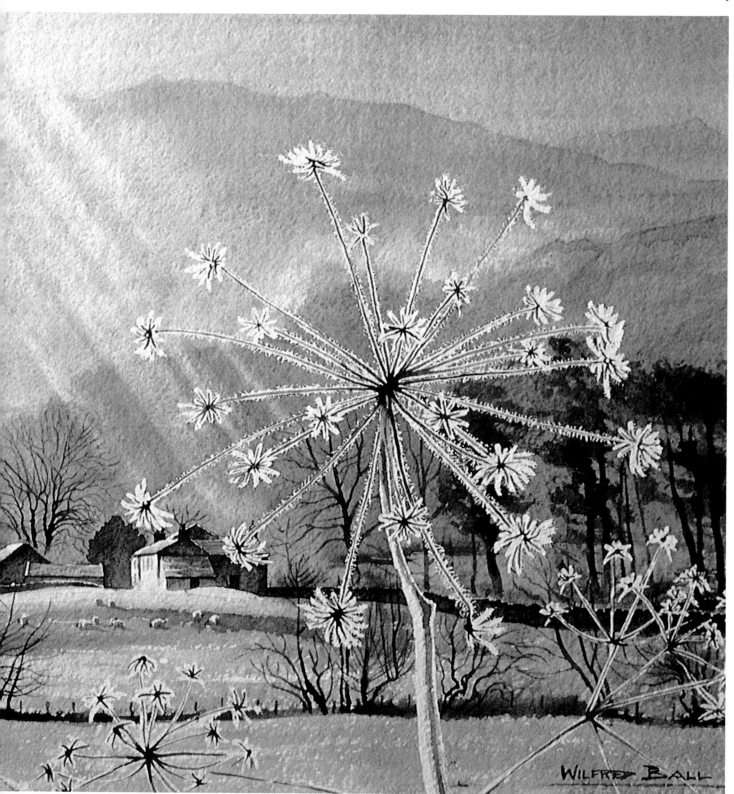

110 Frosty Morning, Thorneythwaite Farm, Borrowdale *(22 x 15in/560 x 380mm)*
This subject was especially chosen to demonstrate the use of masking medium in producing the most complex and delicate detail against an atmospheric background. Here the dead seed-heads are covered with thick hoar frost. Having masked off the detail, using a pen to apply the medium, I was able to paint the background with a large wash brush quite uninhibited by the need to preserve detail.

111 Autumn in Cheedale *(22 x 15in/560 x 380mm)*
In this painting my attention was focused on the brilliantly back-lit leaves of the tree in the foreground. These circumstances produce a brightness and luminosity which far exceeds that which is seen from the front when foliage is in full sunlight. It was important, therefore, to use touches of pure pigment on clean paper. Here again, masking medium provided the solution, allowing me to brush subtle and subdued misty washes over the distant background and then rub off the medium when all had dried. The uncovered leaf shapes were then tinted with pure Gamboge.

112 Early Morning, Ford below Waterfall Cross *(15 x 11in/380 x 280mm)*
The interest was chiefly in the cottages silhouetted against the lemon yellow light of the early morning sky, the chimney smoke indicating how still the conditions were. However, the rest of the landscape was treated wet-in-wet so that I could touch pale Cobalt Blue along the course of the stream. It ran into the Ochres and Umbers of the trees and undergrowth, which marked the line of the stream, to give an excellent impression of low-lying mist.

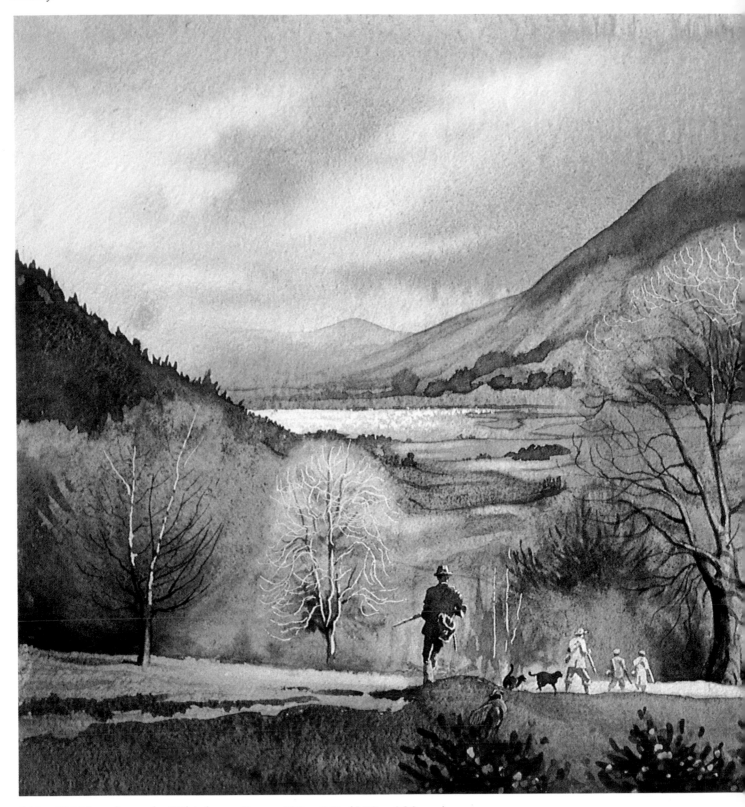

113 Skiddaw from the Whinlatter Pass *(22 x 15in/560 x 380mm)*
Beyond the sunlit timber in the foreground the low cloud had covered parts of the dark, overshadowed mountain.
The sky was put in first, wet-in-wet, with a little pink just over the distant horizon, and the grey wash was carried
down over the mountain and the part of the lake which was not silvered by the sun. When this was dry, the
stronger pigment emphasized the final mountain shape, a wet brush touching the crest in places to lose some
edges in the mist.

114 Early Morning on the Skirfare at Litton *(22 x 15in/560 x 380mm)*
The sky, background hill and distant trees were painted wet-in-wet, some pale Yellow Ochre being dropped into the lower part of the sky to indicate the weak sunlight forcing its way through the early morning mist. In the river a series of ribs of wet limestone were just clear of the water surface and brilliantly lit by the rays of the low sun. These horizontal highlights were protected by masking medium before the water was painted in very loosely.

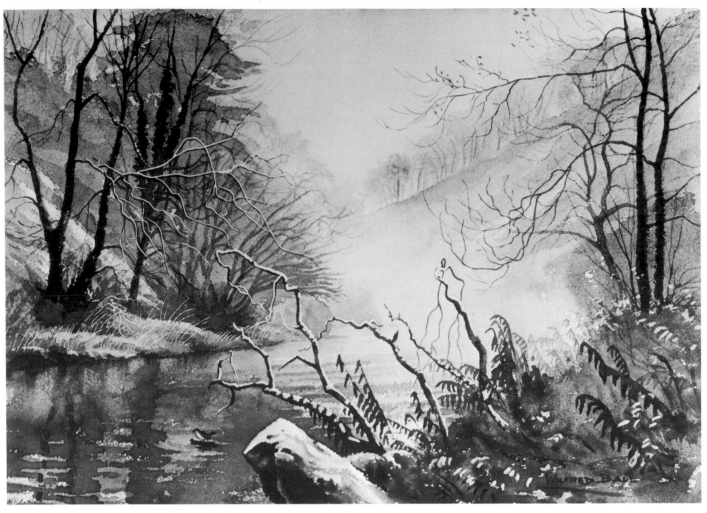

115 Frosty Morning in Wyedale *(22 x 15in/560 x 380mm)*
I was able to protect the frosted twigs and foreground vegetation with masking medium before painting the whole of the picture surface with wet-in-wet washes. Clean water was used to create the effect of low-lying mist on the water and to soften the distant slopes and the misted trees.

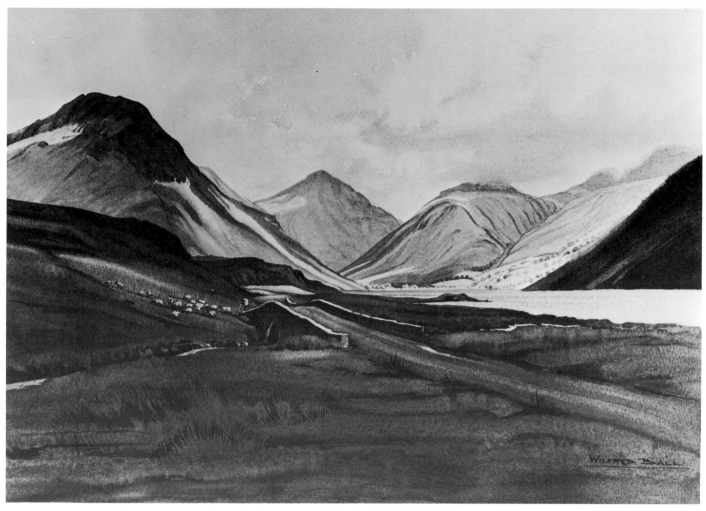

116 Shadows in Wasdale *(22 x 15in/560 x 380mm)*
The whole of the area in front of the lake was washed over with a fairly strong grey mixture. While it was still wet, local colour – greens, Ochre and Burnt Sienna for the dead bracken – was touched into the mixture to produce the necessary detail and modelling of the ground. The sheep and the light on the bridge parapet were protected by masking medium.

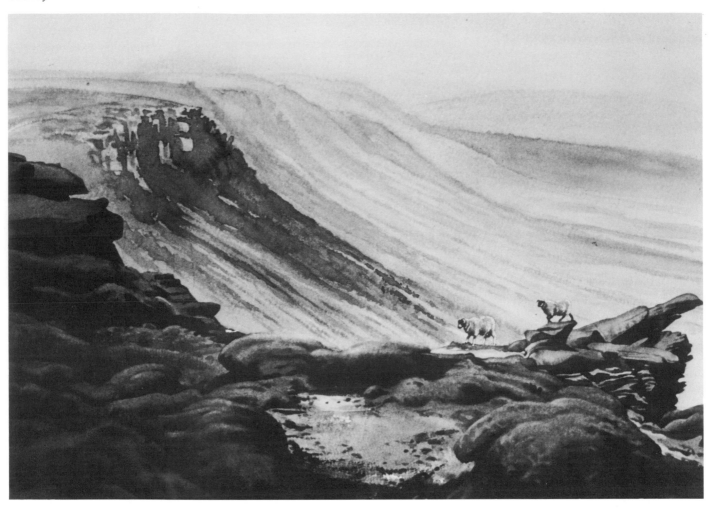

117 September Morning on Kinder Edge *(22 x 15in/560 x 380mm)*
The sun was beginning to drive away the morning mists which veiled the horizon and the further slopes below the edge. Wet-in-wet washes of blue-grey and creamy Yellow Ochre were ideal for creating this effect. When these washes had dried, the details on the nearer promontory were suggested with a drier wash before treating the foreground even more boldly.

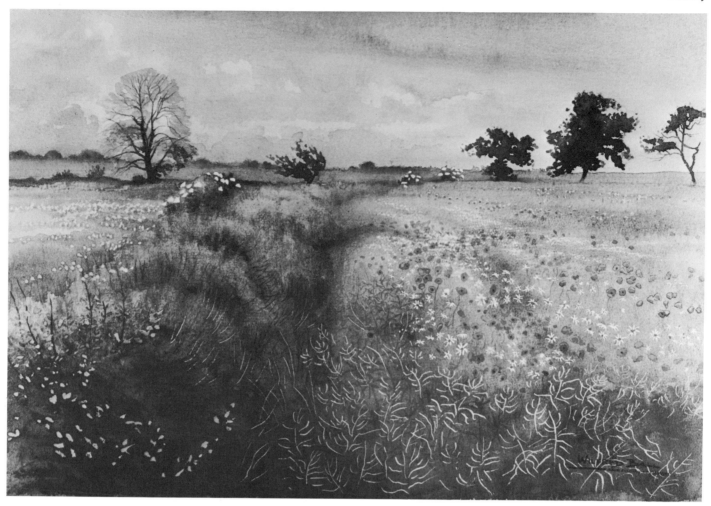

118 Corner of a Poppy Field *(22 x 15in/560 x 380mm)*
This is another example of the effectiveness of masking medium in coping with a complexity of detail. The blue-grey pods of the rape plants, the scarlet poppies, the large dog-daisies and the elderflowers in the hedgerow were all covered with the medium before great wet washes of subtle colour mixtures were flooded over the whole of the field.

119 First Light, Gunnerside, Swaledale *(22 x 15in/560 x 380mm)*
Surprisingly, the most colourful sunrises and sunsets can be seen during the winter. I could not resist this subject, with the hillside cottages dark against just such a warm winter morning sky. The whole of the foreground slope was painted wet-in-wet. Warm greens, Ochres and Umbers were touched into the grey wash to suggest the folds in the ground. The shapes of the fluffy white thistle seed-heads, just caught by the first light, were protected by masking medium from these fluid washes.

120 Derwent Water from Applethwaite *(22 x 15in/560 x 380mm)*
Painted entirely in blue-grey and lemon yellow, this economical colour scheme was quite adequate to depict a cold, misty morning in the Lake District. The whole of the sky and background was painted wet-in-wet, before clearer shapes were picked out as it dried.

121 Burning off the Heather, Stanage *(22 x 15in/560 x 380mm)*
The sky and great plumes of smoke were an ideal subject for a bold wet-in-wet wash, with great sweeps of warm colour put in with a large wash brush. As this covered most of the paper, only the foreground and the simple figures were left to be put in after it had dried.

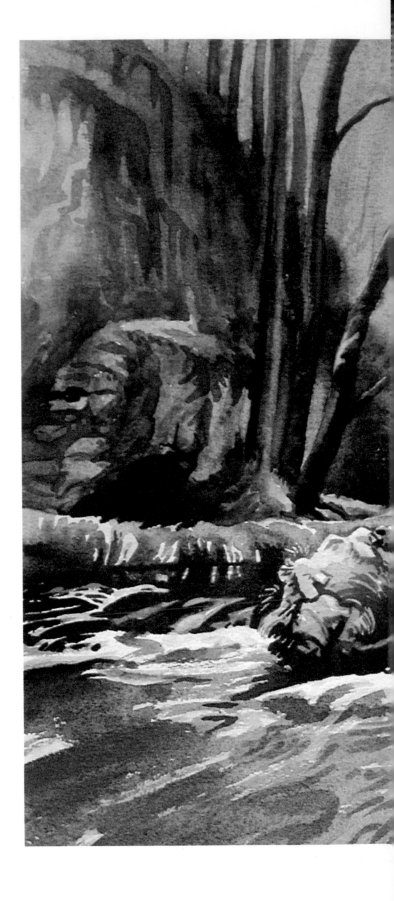

122 Footbridge below Ilam Rock, Dovedale *(22 x15in/560 x 380mm)*
The background slopes of the dale were painted in wet washes of subtle greys, the far trees being faintly suggested as the washes dried. However, the main visual impact is from the weight of water sliding over the low weir. It required careful control of the wet pigment to produce this effect of weight, as well as the satin-smooth sheen of the curve of gun-metal grey water.